Michael Findlay

THE VALUE OF ART

MONEY, POWER, BEAUTY

Prestel

MUNICH · LONDON · NEW YORK

Revised paperback edition
© Prestel Verlag, Munich · London · New York, 2014
For the text, © Michael Findlay, 2014
Original hardcover edition published 2012
All images reproduced by permission. See page 208 for a full list of credits pertaining to artists' rights and photography.

Prestel, a member of Verlagsgruppe Random House GmbH

PRESTEL VERLAG	PRESTEL PUBLISHING	PRESTEL PUBLISHING LTD.
Neumarkter Strasse 28	900 Broadway, Suite 603	14-17 Wells Street
81673 Munich	New York, NY 10003	London W1T 3PD
Tel. +49 (0)89-4136-0	Tel. +1 (212) 995-2720	Tel. +44 (0)20 7323-5004
Fax +49 (0)89-4136-2335	Fax +1 (212) 995-2733	Fax +44 (0)20 7323-0271
	www.prestel.com	

Prestel books are available worldwide. Please contact your nearest bookseller or
one of the above addresses for information concerning your local distributor.

THE LIBRARY OF CONGRESS HAS CATALOGUED THE HARDCOVER EDITION AS FOLLOWS:
Findlay, Michael, 1945-
The value of art : money, power, beauty / Michael Findlay. – 1st
English edition.
pages cm
ISBN 978-3-7913-4638-0 (hardback)
1. Art—Economic aspects. 2. Art—Collectors and collecting–
Psychology. I. Title.
N8600.F55 2012
701—dc23
2011051076

BRITISH LIBRARY CATALOGUING-IN-PUBLICATION DATA:
A catalogue record for this book is available from the British Library; Deutsche Nationalbibliothek holds a record
of this publication in the Deutsche Nationalbibliografie; detailed bibliographical data can be found under:
http://dnb.d-nb.de

Editorial direction: Christopher Lyon & Ryan Newbanks · Copyediting: John Farmer
Proofreading: Nicole Lanctot · Index: Cheryl Lemmens
Design: Mark Melnick · Typesetting: Duke & Company, Devon, Pennsylvania
Picture research: John Long · Production: Nele Krueger & Friederike Schirge
Origination: Reproline Mediateam, Munich · Printing and Binding: C&C Printing, China

Verlagsgruppe Random House FSC® N001967
The FSC®-certified paper Chinese Golden Sun has been supplied
by Yanzhou Paper Industry CO., LTD.

ISBN 978-3-7913-4913-8 revised paperback edition

For my brothers, Robin and John Findlay

Contents

PREFACE TO THE PAPERBACK EDITION

Since *The Value of Art* was published in 2012, I have been surprised and gratified by the generous comments from collectors, curators, and fellow art dealers as well as the readers I most welcome, those outside the professional art world.

A small section of this book analyzes the gyrations of the art market from the financial crisis of 2008 to recovery in 2010. The publication of this paperback edition gives me the opportunity to get current. In the last three years the fortunes of celebrity artists such as Damien Hirst and Takashi Murakami seem to have dimmed, although a sculpture of giant steel tulips by Jeff Koons fetched over $33 million at Christie's in 2012. Work by late twentieth century artists such as Roy Lichtenstein and Jean-Michel Basquiat is definitely in favor: at Christie's in May 2013, a 1963 Lichtenstein made $56 million and a Basquiat $49 million. And to prove there is no such thing as too much hype, Sotheby's sold a pastel version of Edvard Munch's much-caricatured *The Scream* in 2012 for very nearly $120 million.

The gallery scene is even more active and, although prices are not made public, there have been sales made privately on a level to rival the auction houses and in greater quantity. When it comes to paying top dollar, taste is turning conservative, shifting toward works with historical merit rather than topical celebrity. The art market is cyclical in nature and it changes shape to accommodate economic realities.

Art fairs continue to thrive as social tsunamis. The Acquavella booth at this year's Art Basel Hong Kong was packed with a constant stream of art lovers, many of whom only looked at our paintings by Picasso, Warhol, and Basquiat through the lenses of their cameras or smartphones. Many serious collectors now avoid the "VIP" openings because they are too crowded for them to see the works.

While this book aims to take the mystery out of the commercial value of art and explore collectors' motives, my real agenda is to encourage every reader to enjoy works of art for pure pleasure.

ACKNOWLEDGMENTS

This book draws on my life's experiences as an art lover and collector, an auction-house specialist and art dealer. Throughout my journey I have been educated and informed by true connoisseurs in all those categories: the passionate collectors John and Kimiko Powers and Herbert and Adele Klapper, outstanding dealers including Richard Feigen and Bill Beadleston, and the compleat auctioneer, Christopher Burge. I am particularly grateful to William Acquavella, whose remarkable career demonstrates daily that quality, probity, and profit in art dealing are not incompatible.

I have learned from three generations of artists in exchanges both commercial and personal, ranging from relatively decorous studio visits to boisterous all-nighters at Max's Kansas City. Those that shared their work and ideas with me are too numerous to mention, but some have suffered me in and out of their studios and lives for almost five decades, particularly Bridget Riley, James Rosenquist, Billy Sullivan, John Willenbecher, and the late Gerald Laing.

Roberta Maneker, my first professional reader, gave me excellent advice, and her son Marion Maneker was an early supporter. I owe much thanks to Morton Janklow and Michael Steger at Janklow and Nesbit for having faith in this book; and I am indebted to Ryan Newbanks, Stephen Hulburt, Samantha Waller, and John Farmer at Prestel for their enthusiasm and hard work, as well as to my editor Chris Lyon.

The unflappable John Long managed all the illustrations, and I am particularly grateful to Dorothy Kosinski and Barbara Windom for their help with images. My student researchers Alixandre Greenberg, Elsie Heung, and Sarah Horton all deserve well-paying jobs in the art world.

I could not have embarked on this book without the support of my family: my son Bob, my daughter Beatrice, and in particular my talented wife Victoria Findlay Wolfe, who as an artist and quilter lives the creative process daily, which is a joy to share.

A collector has one of three motives for collecting: a genuine love of art, the investment possibilities, or its social promise. I have never known a collector who was not stimulated by all three. For the full joy and reward the dominant motivation must be the love of art but I would question the integrity of any collector who denies an interest in the valuation the market puts on his pictures. The social aspect is another never-ending regard. From Rome to Tokyo, our interest has brought unexpected and unbelievable experiences, and friends as full of vitality, imagination and warmth as the art they collect.[1]

———

EMILY HALL TREMAINE, 1908–1987

Introduction

THE THREE GRACES

Zeus had three daughters who have been represented throughout the history of Western art as the Three Graces and appear in sculpture and painting from the ruins of Pompeii to the glories of the High Renaissance. These three maidens, standing in close proximity, usually naked, have been celebrated by artists as diverse as Raphael, Peter Paul Rubens, Antonio Canova (fig. 1), Edward Burne-Jones, Paul Cézanne, Pablo Picasso, and Sigmar Polke.

The Three Graces, also known as Charities (from the Greek, *karitas,* meaning love) were named in order of birth: Thalia, Euphrosyne, and the youngest, Aglaea. Their combined function was to preside over banquets to entertain the gods and their guests. Each has unique qualities, and I appropriated their names to illustrate that the value of art has three components. Thalia is the goddess of fruitfulness and abundance, representing Commerce. Euphrosyne is the goddess of joy; she represents Society. Aglaea is the goddess of beauty, which, being in the eye of the beholder, is the Essential (or intrinsic) value of art.

All works of art have the potential for commercial value, social value, and essential value. But none of those values are constant; all are enhanced or diminished by the fluctuating mores and tastes of different times and cultures.

In the nineteenth century French art lovers were called *amateurs,* from the Latin *amare* (to love). The definition in English has degenerated to imply a nonprofessional, but at one time there was no contradiction between amateur and connoisseur. An amateur was simply a person who engaged in a particular activity for pleasure, not profit. Thus, we might

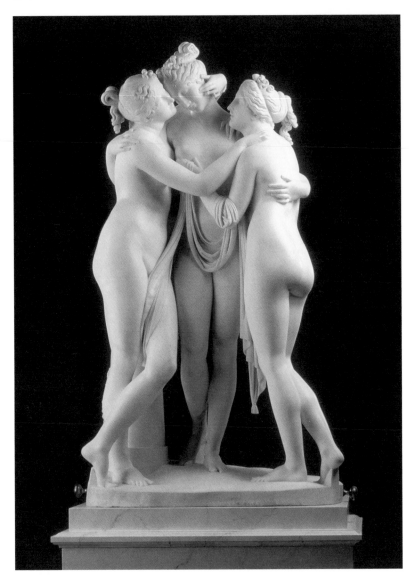

Fig. 1
ANTONIO CANOVA
The Three Graces, 1814–17
Marble
68 × 38¼ × 22½ in.
(173 × 97.2 × 57 cm)
Victoria and Albert Museum,
Great Britain

consider Cézanne to be an amateur painter; his great patron, the marga-rine king Auguste Pellerin, an amateur collector; and Émile Zola, when he wrote about art, an amateur critic.

While I expect this book might be of interest to today's professionals in the world of art, I have written it for those of us who are, at least at heart, *amateurs*.

THE VALUE OF ART

"AS A GENERAL RULE, WHEN SOMETHING BECOMES USEFUL, IT CEASES TO BE BEAUTIFUL."[2]

———

THÉOPHILE GAUTIER, 1811–1872

I | Thalia

THE COMMERCIAL VALUE OF ART

WHAT DETERMINES THE COMMERCIAL VALUE OF ART?

Like currency, the commercial value of art is based on collective intentionality. There is no intrinsic, objective value (no more than that of a hundred-dollar bill). Human stipulation and declaration create and sustain the commercial value.

The reason that many people continue to be astonished or enraged when they hear that a particular work of art has been sold for a large sum of money is that they believe art serves no necessary function. It is neither utilitarian, nor does it seem to be linked to any essential activity. You cannot live in it, drive it, eat, drink, or wear it. Even Plato considered the value of art to be dubious because it was *mimesis,* an imitation of reality.

If you gave most people $25 million and the choice to spend it on a six-bedroom house with spectacular views of Aspen or a painting by Mark Rothko of two misty, dark-red rectangles, the overwhelming majority would choose the house. We understand the notion of paying for size and location in real estate, but most of us have no criteria (or confidence in the criteria) to judge the price for a work of art. We pay for things that can be lived in, driven, consumed, and worn; and we believe in an empirical ability to judge their relative quality and commercial value. No matter how luxurious, such things also sustain the basic human functions of shelter, food, clothing, and transport.

Art predates money. Thirty-two thousand years before the dawn of recorded history *Homo sapiens* painted the walls of caves in what is now southern France and northern Spain with sophisticated images involving

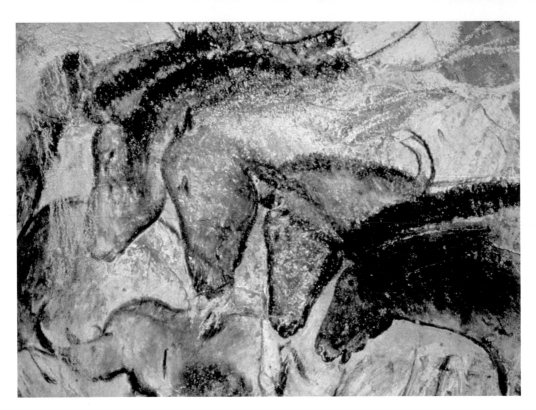

techniques of drawing and coloring that are far from our current defini-
tion of "primitive" (fig. 2). Since their discovery in the late eighteenth
century, experts have argued over their meaning. Susan Sontag believed
that "it was incantatory, magical; art was an instrument of ritual."[3]

Since time immemorial we have covered the walls of our caves, huts,
and castles with images conveying specific information, particularly of
the "this is us" variety. Millennia passed before such images, transport-
able or not, came to support commercial value.[4]

There are two distinct markets, which are interrelated and some-
times overlapping: the primary market for an artist's new work and the
secondary market for works of art that are second-hand (or third- or
twentieth-hand).

The Primary Market
The primary market provides direct payment to the artist for his or
her skill and time, plus the cost of bringing the product to the market.
Michelangelo on his back covering the Sistine Chapel ceiling, Claude
Monet in all weathers painting in his beloved garden, Jackson Pollock
crouching over the unstretched canvas on the floor of his freezing cold

barn: all hoped to sell their work, so they might pay their rent, eat and drink, hire assistants, and send their children to school. In the last 150 years the role of art dealer evolved, providing premises for the work to be exhibited and bringing it to the attention of buyers. The dealer is paid either by buying directly from the artist and selling at a profit (while assuring the artist of a steady income), or by taking the work on consignment from the artist and earning a commission when the work is sold.

Usually the artist and dealer get together to decide the initial price of the work before it is offered to its first buyers. When I entered the art world in 1964, work by young artists having their first exhibitions might be purchased in the range of $500 to $10,000. At that time in New York there were relatively few dedicated collectors willing to look at emerging artists, and dealers had to encourage them with prices that

Fig. 3
JOHN BALDESSARI
Quality Material, 1966–68
Acrylic on canvas
68 × 56½ in. (172.7 × 143.5 cm)
Private Collection

were modest even for those times. For six months in 1968 a new paint-
ing by John Baldessari, *Quality Material* (1966–68, fig. 3) hung behind my
desk priced at $1,200. There were no takers. It sold at Christie's in May
2007 for $4.4 million.

A body of new work by any artist is usually consistent in theme, but not
necessarily in scale. What makes one painting or sculpture more or less
expensive than another in this primary market is usually size. Although
the artist's audience has not yet rendered an opinion about which type
of work is better or more desirable than any other, and the artist may feel
some smaller works are better than some larger ones, usually size wins
out, and the smallest works are usually the least expensive. The larger the
work, the higher the price, with the exception of paintings and sculptures
that may be too large for domestic installation and require the kind of
space usually found only in institutions, office buildings, shopping malls,
and casinos. Such works may be proportionately less expensive because
they are harder to sell.

Fig. 4
RICHARD SERRA
Bellamy, Siegen 2001

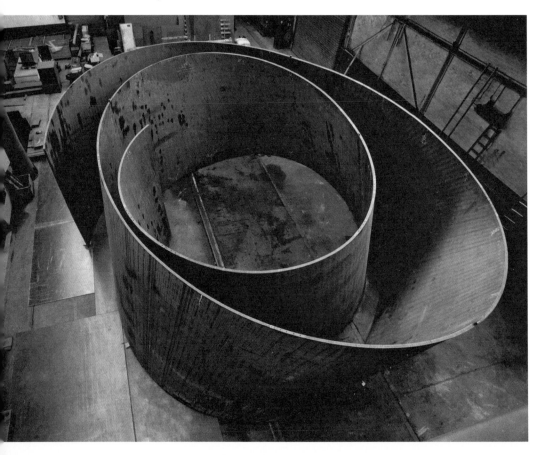

Depending on the medium used by the artist, there may be a cost of manufacture to consider. In 1895 Auguste Rodin had to pay Le Blanc Barbedienne Foundry in Paris when he cast his *Burghers of Calais* in bronze. Today Richard Serra has to pay Pickhan Unformtechnik in Siegen, Germany for fabricating his vast steel *Torqued Ellipses* (fig. 4). These costs are passed on to the first buyers of the work. Many artists create sculpture in editions. If there are five or ten copies of a sculpture, the primary market price will be less for each one than for a unique work of similar size, medium, and appearance by that artist.

Aside from these casting expenses, the cost to the artist for materials used in painting and drawing, though perhaps not insignificant, is not a consideration when it comes to pricing the works. Oil on canvas is generally known to be a highly durable medium. Short of direct trauma, it can withstand handling and extremes of temperature and humidity, as well as sunlight. Not so works on paper, which are usually priced lower to account for their greater fragility. This has led to the notion that works on paper are inherently worth less than paintings, despite the fact that the secondary market in some cases has placed a higher value on works on paper than on oils by certain artists, such as Edgar Degas and Mary Cassatt.

Another rule of thumb with the primary market of works on paper is that those with color, be they rendered in oilstick, gouache, watercolor, or crayon, will be priced higher than works that are monochromatic: graphite, charcoal, or sanguine.

When it comes to making lithographs, etchings, silkscreens, and other types of editioned works on paper, costs can be considerable. Printmaking is an art that involves not only the creative talent of the artist who conceives the image, but the skill of master printers using sophisticated and expensive equipment.

The Secondary Market

Other than the purchase of new work either directly from the artist or the artist's dealer, all art purchases, whether of Dutch Old Masters, nineteenth-century English seascapes, Impressionist paintings, or Cubist masterpieces, are secondary-market transactions.

Once an artist achieves a degree of stature, a secondary market in his or her work is inevitable during the artist's lifetime. How is the com-

mercial value of an art object decided in the secondary market when it is resold by the first owner? Most things we buy are worth less once we have used them. A car usually is, as are clothes we give to charity. In addition, appliances and electronics have less value when succeeded by newer models. When the real-estate market booms, the second owner of a home may pay more for it than the first, but in a stable market the second-hand house is likely to be worth less than a new one of the same size, design, materials, and location.

Once art passes out of the hands of the first buyer, its commercial value is largely determined by the principle of supply and demand, but it can be managed by the artist's primary dealer. When making a primary-market sale, I am sometimes asked if I will resell the work when and if the client so decides. I usually agree. By doing this dealers can participate in the pricing of secondary-market works by artists they represent.

Some art dealers, both those with galleries and "private" dealers, (sometimes operating out of their homes), represent no artists directly but buy and sell work by living artists. They may not have any direct relationship with the artist but may be very knowledgeable about the work, and by promoting it they are usually contributing to the solidity of that artist's market.

Even in the primary market, the relative availability, real or imagined, of a particular artist's work is key. The art dealer rarely says, "Andy's studio is packed to the gills with hundreds of paintings just like this one, so take plenty of time to choose the one you want." Rather: "I'm not sure if there will be any more like this; he's painting very slowly, and we've sold the few others we had to very important museums and collectors."

A little history. When I entered the art trade in the mid-1960s, there were only a few living artists whose works regularly appeared in the secondary market. They were mostly modern European masters like Picasso, Joan Miró, Marc Chagall, and Salvador Dalí. Very few midcareer American artists, even those with major reputations, appeared at auction, and virtually no younger contemporary artists did. The postwar American generation of Abstract Expressionists was well established (Jackson Pollock, Arshile Gorky, and Franz Kline were already dead), and the paintings they did in the late 1940s and 1950s were in demand by the mid-1960s, mostly sold by secondary-market dealers. Only rarely did their works

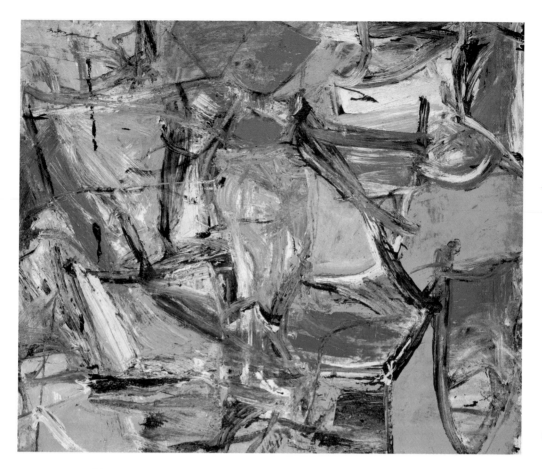

Fig. 5
WILLEM DE KOONING
Police Gazette, 1955
Oil, enamel, and charcoal
on canvas
43¼ × 50¼ in.
(109.8 × 127.6 cm)
Private Collection

come up at public auction. Exceptions include a 1940 painting by Willem de Kooning that was sold in the Helena Rubinstein auction at Parke-Bernet in April 1966 for $20,000.[5] In October 1965 a group of paintings, including works by Rothko, Franz Kline, Clyfford Still, Barnett Newman, and de Kooning, was consigned to Sotheby Parke Bernet by the taxicab mogul Robert Scull, who with his lean, well-coiffed, and miniskirted wife Ethel had turned his attention to the younger generation of Pop artists, including Jasper Johns, Robert Rauschenberg, Andy Warhol, Tom Wesselmann, and James Rosenquist. The sale of Scull's paintings totaled $211,450. *Police Gazette* (fig. 5), an abstract landscape by de Kooning painted ten years earlier, in 1955, fetched $37,000. Forty-one years later the *New York Times* reported that it had sold privately for $63.5 million. These examples notwithstanding, in those days auction houses generally avoided selling works by living artists with primary gallery representation.

This pattern ended loudly and finally in October 1973 with the second Scull sale at Sotheby Parke Bernet.[6] By then Bob and Ethel had made a

splash in the social columns by promoting themselves as Pop Art collectors. To their credit they were among the first patrons of this movement and purchased many works that have since entered the canon of modern art: *Target* (1961) by Johns; *Large Flowers* (1964) by Warhol; *F-111* (1964–65, fig. 6) by Rosenquist. They were criticized, however, for putting the work of these young, thirty-something artists on the auction block after having owned them only a few years. Thirty years later criticism was far more muted for a new generation of collectors profiting by bouncing recent gallery purchases into auction after barely months of ownership.

A confrontation between Rauschenberg and Robert Scull after the 1973 sale set the stage for the enduring tango (who is leading whom?) of artist and collector that has characterized the enormous growth of the contemporary-art market over the ensuing decades. Two paintings by Rauschenberg from 1958 and 1959 that Scull had bought from the Leo Castelli Gallery for hundreds of dollars each sold for $90,000 and $85,000 respectively. At the time the press reported an angry shoving match and caricatured Rauschenberg as embittered by his patron's profiteering. This narrative survived as art-world myth, and this much was true: the artist grabbed Scull and said, "I've been working my ass off for you to make that profit."[7] In fact, the altercation was mostly staged for a documentary film of the auction. Unreported by the press were the generous comments Rauschenberg made praising Scull's early patronage.

There was a third Scull sale in 1986 at the same auction house (by then called Sotheby's), divided into two evenings. Bob and Ethel had divorced and "his" and "her" collections were sold on separate nights. Rosenquist's *F-111,* now owned by the Museum of Modern Art, was sold

Fig. 6
JAMES ROSENQUIST
F-111, 1964–65
Oil on canvas with aluminum
Twenty-three sections,
120 × 1,032 in.
(304.8 × 2,621.3 cm)
The Museum of Modern Art,
New York. Gift of Mr. and Mrs.
Alex L. Hillman and Lillie P. Bliss
Bequest (both by exchange)

for a record $2.09 million. The Sculls had purchased this monumental eighty-six-foot, twenty-three-canvas masterpiece intact from Leo Castelli in 1965 for 45,000, thus preventing it from being sold section by section to several different collectors.

Bob's aggressive ego and Ethel's social pretensions made them easy targets in an art world still largely dominated by old money, but Bob's eye for the best works and his willingness to spend freely in spite of the mocking opinion of the art establishment put him high in the running as the patron saint of self-made patrons of contemporary art.

The price of art, whether sold in the primary or the secondary market, is governed by supply, demand, and marketing.

Supply

Veteran art dealer William Acquavella often tells his clients, accurately, "You can remake your money, but you can't remake the painting,"[8] meaning: you can earn the cost back, but if you miss the opportunity to buy the work when it is available, it is likely gone forever.

Real or imagined, rarity is the *ne plus ultra* when art is sold. Not only does it justify the price, it also suggests an exclusive club of ownership: "The only other one like this is in the Metropolitan Museum of Art." Considering the purchase of a work by a living artist, a collector might be told, "She's not going to make any more paintings like this one," although there are numerous instances of aging artists revisiting the themes of their fruitful youth, either out of nostalgia or penury. What can be counted on perhaps is that there will be no more paintings like that one *with today's date*.

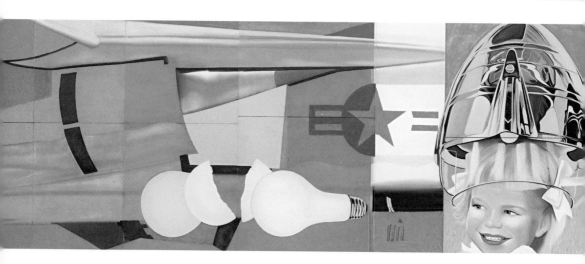

Claims of rarity also have to be examined carefully because not only do artists often explore specific themes in a variety of mediums (paint, pastel, pencil, print), but total output varies widely from artist to artist. Monet—who lived until he was eighty-six, painted virtually every day of his life, and produced 2,000 paintings—is considered to be prolific. Van Gogh died at thirty-seven having made 864 paintings, and Pollock died at forty-four having produced just 382 works on canvas. The most useful tool in determining just how many paintings an artist made of any particular type is the comprehensive listing of his or her entire output known as the catalogue raisonné, which translated literally means "critical catalogue."

Catalogues Raisonnés

Until the advent of the camera it was difficult to document and record accurately the full extent of any artist's body of work. Scholars of pre-modern art have to rely on documentary evidence, such as artists' hand lists and records, bills of sale, letters, known public commissions, and the like.

By the time of the Impressionists the camera was in popular use, and it became standard for artists to have their works photographed, albeit in black and white. This greatly enhanced the creation and use of catalogues raisonnés, which became an essential tool in determining supply. Most indicate the past and (as of the date of publication) present owners of each work listed. Thus, it is possible for the seller of a painting of water lilies by Monet to show a prospective buyer exactly how many of that type, size, and date were painted. A knowledgeable dealer will be able to

combine the information in the catalogue raisonné with his or her own knowledge of current ownership and infer how many (or rather, how few) of a particular type of work are ever likely to be sold.

The publication of a catalogue raisonné may have a strong effect on the value of an artist's work because it defines the supply empirically and provides the basis for reasonable assumptions regarding whether any particular work might be available. A painting designated "Art Institute of Chicago" is likely off-limits forever, whereas "Mr. and Mrs. Worthalot, Los Angeles," could be approached with an offer to buy.

Warhol called his studio the Factory, and he produced many seemingly identical works (in series, not unlike Monet). When Warhol died in 1987, he was highly celebrated, and paintings of his most publicized subjects (Campbell's soup cans, Marilyn Monroe) commanded high but not spectacular prices. The first two volumes of his catalogue raisonné appeared in 2002 and 2004 and cover just eight years of his work (1961–69).[9] Almost immediately prices increased, in part because it was evident that although there were indeed many images that he used over and over again, he varied color and size so that not only did each work now appear to be genuinely unique, but the actual number of works in any series (Flowers; Elvis; Dollar Signs) turned out to be less than many people supposed.

Art historian and magazine editor Christian Zervos began to catalogue Picasso's work in 1932 with the participation of the artist and died in 1970 having produced twenty-two volumes. Picasso died in 1973, and by 1978 a further eleven volumes were published by Zervos's successors.[10] Catalogues raisonnés themselves are not inexpensive. The complete set of "Zervos" sells for approximately $50,000. It is virtually indispensable for museums, libraries, and anyone who deals in work by Picasso. Not all artists are so lucky: Renoir died in 1919, and it was fifty-two years before the first volume of his catalogue raisonné was published.[11] This volume lists only his paintings of figures (no landscapes or still lifes) done between 1860 and 1890. No subsequent volumes have yet appeared. Modigliani has been favored with at least five catalogues raisonnés, only one of which is generally accepted as reliable.[12] Unscrupulous authors may, for a consideration, include a work of dubious authenticity, thus rendering the entire book suspect.

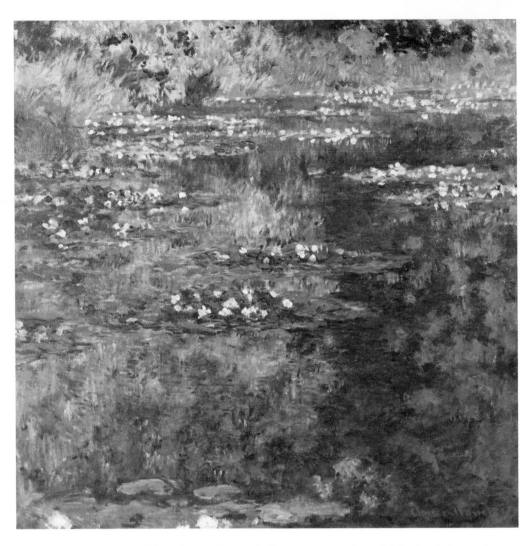

Fig. 7
CLAUDE MONET
Waterlily Pond, 1904
Oil on canvas
35½ × 36¼ in. (90 × 92 cm)
Musée des Beaux-Arts,
Caen, France

There is usually a period in every artist's work life that informed opinion considers to be better than the rest. Like the reputation of artists themselves, this opinion can of course change over time. For American buyers of French painting in the middle of the twentieth century the birth of Impressionism was considered to be the best period, and works by virtually any Impressionist artist dating from the early years 1872–74 commanded premium prices. These works are generally discreetly casual in composition, rural in subject matter, and painted with small brushstrokes. Now, forty years on, the "must-haves" by Monet and Camille Pissarro are their later paintings, which have vigorous large brushstrokes in strong colors and include scenes of urban life. Currently, 1982 is considered to be the late American artist Jean-Michel Basquiat's

best year. In forty years' time that opinion may change, but the number and nature of the paintings he did in 1982 will remain identified in a catalogue raisonné.

Presently, some of the most popular and expensive of all Impressionist paintings are the canvases Monet painted of his famous water lily garden at Giverny. Between 1904 and 1908 Monet created his highly prized series of seventy-nine paintings of that subject (fig. 7). Of those seventy-nine, three have disappeared, and twenty-seven are in museums that are unlikely to ever sell them. That leaves forty-nine in private collections. While some collectors cultivate the reputation that they will never sell, no one is immortal, and in time each of those forty-nine will come on the market. That, however, is a minuscule amount when compared with the considerable number of extremely well-heeled collectors extant and yet to be minted, for whom the ownership of such a work is a top priority.

Institutional Holdings

All works owned privately, even gifts promised but not yet given to museums, are in fact potentially available. Works that have been formally accessioned by public museums constitute the "Fort Knox" of works by that particular artist and are off the market. The more works by an established artist that are in public museums, the smaller the supply for the market and the higher the value of those that do circulate.

In many countries in Europe and Asia museums are owned or controlled by the national governments and are prohibited from selling. In the United States, with the exception of the National Gallery of Art in Washington, D.C., most museums were founded by private individuals and are run as not-for-profit institutions governed by boards of trustees. The Code of Ethics for the American Association of Museums has stringent guidelines for deaccessioning (selling) works that have been bought by or given to a member institution. An important provision states that "in no event shall they [proceeds from the sale] be used for anything other than acquisition or direct care of collections."[13]

The likeliest candidates for sale are donated works that duplicate what the museum already holds and works of such patent inferiority that they are never likely to be exhibited. Nevertheless, even sales by museums that conform to the guidelines often create controversy, the usual argu-

ment being that disposing of works that are currently unpopular may shortchange a future generation with different tastes.

A small number of institutions that might appear to be public are privately owned, and the owners may sell works in the collection. This was the case with the Norton Simon Museum in Pasadena, California, during Simon's lifetime. The vast majority of works in museums, however, are genuinely out of circulation.

The collector Tony Ganz, whose parents owned a legendary collection of twentieth-century art, tells of having a playdate with a school friend at the age of six. On entering the house he said innocently, "Where are your Picassos?" It is fair to say that only a small percentage of art lovers grow up in or around collecting families, and the notion is widespread that most or all art by well-known artists, particularly dead ones, is in museums.

What continues to amaze me is how quickly this sense of limited supply is reversed when collectors find themselves able to afford the great art they once saw only in books and museums. Many then assume that there are plenty of top-quality Monets, Picassos, Pollocks, or Warhols out there and that all it takes is their ability and willingness to put a digit and seven (or even eight) zeros on the table to have a van Gogh, "just like that portrait at the Museum of Fine Arts, Boston."

The next stage in their education is to find out the painful truth, which is that there are only four such portraits in private hands that might equal the one in Boston, all much smaller. Of these, one is in France and unlikely, for tax reasons, to surface; one is in a private collection in Osaka; the third is promised by its owner to a museum; and the fourth just might, if the collector is extremely patient, become available within the next ten years.

Behind the perception that most great works are in museums lies some truth, but with serious qualification. Historically, museums are often slow off the mark to acquire art of the present time, even as gifts. In the twentieth century there were many instances of museums turning down individual works or entire collections of great distinction. French Impressionist painter Gustave Caillebotte died in 1894 and left almost seventy great works by his fellow artists to the French nation with the stipulation that they should, within twenty years, be exhibited. This now-

famous bequest was refused not only in 1894, but again in 1904 and 1908. Eventually some of the paintings did make it into the Louvre (others went to the Barnes Foundation in Philadelphia). Decades later, in 1944, an extraordinarily diverse collection, including great modern paintings and Marcel Duchamp's most important works, were offered by the Los Angeles collectors Walter and Louise Arensberg to the University of California if they would build a museum to house the collection. The university would not, and after negotiations fell through with other institutions, including the Denver Art Museum, the Art Institute of Chicago, and the National Gallery of Art in Washington, D.C., the Arensberg Collection finally found a home at the Philadelphia Museum of Art in 1954. On the other hand, it is the museum's job to exercise curatorial judgment, and museums cannot afford to warehouse every gift just in case the artist survives the tests of time.

For three decades art-market commentators have been suggesting that the market supply of Impressionist paintings is dwindling. But this is not supported by the facts. Compared to the very considerable number of works that have been bought by private collectors, relatively few have been given to or purchased by museums that acquired most of their Impressionist collections prior to 1980. This means that virtually everything that has been sold, privately and at auction, in the last thirty years is in fact still capable of circulating, along with thousands of Impressionist paintings and drawings, as well as sculpture, still in the hands of families that acquired them forty years ago or more. In fact, there are far fewer post–World War II works of art available than nineteenth- and early twentieth-century works because many of the artists were not prolific and important works by Kline, Rothko, Pollock, and de Kooning were acquired already in the 1950s by American and European museums. A decade later European collectors like Count Giuseppe Panza di Biumo in Italy and Dr. Peter Ludwig in Germany built large collections of major works by Johns, Rauschenberg, Rosenquist, Lichtenstein, Warhol, Claes Oldenburg, and others that are now in the Museum of Contemporary Art in Los Angeles and the Ludwig Museum in Cologne. The supply of early masterpieces by these artists that are potentially for sale is significantly smaller than equally important works by Impressionist and modern artists such as Cézanne, Monet, Modigliani, Picasso, Matisse,

and Miró. When the overheated contemporary-art market tripped on its heels alongside the general economic downturn of late 2008, the apparently overlooked Impressionist and modern market swung back into view as new buyers looked for the type of blue-chip works of art that traditionally maintain value throughout recessions.

Demand

A reasonably sane, comfortable life can be sustained without the private ownership of fine art so the demand for it is voluntary and determined by means and desire, the latter being learned, not innate, and emphasized in some cultures more than others. The controversial contemporary Chinese artist Ai Weiwei is considered knowledgeable about his cultural heritage:

> [O]ne must remember that China, since ancient times, has held the value of art to be equal to that of philosophy—which is no small fact, given our relationship with Taoism and Confucianism. Art has a strong, multivalent tradition whether we're speaking in terms of the imperial court or of the noneducated housewife. And this is very different from art's role in the West.[14]

I would further separate the European from the American cultural tradition in this regard. Whether as institutions such as the Church or as individuals, Europeans have experienced a millennium of artistic patronage. Today, in many European countries the former homes of yesterday's lords, ladies, and robber barons are toured by a public eager to see the works of art they acquired and that became part of their lives. The much younger United States has no such tradition, and among the wealthy, art collectors represent a distinct minority.

A prescient Roy Lichtenstein took a jaundiced and mercenary look at art's role and the demand for art in mid-century America when, in 1962, still living in Highland Park, New Jersey, he painted *Masterpiece* (fig. 8). At the time the clamor for his work was barely audible, but subsequent decades have proved his witty message very far from flat.

Historically, when fortunes are made in America, disposable income is spent on multiple residences; domestic service; vehicles for land, sea, and air; jewelry; entertaining; and travel. Art is not high on the list. An

apocryphal tale has a prominent dealer presenting automobile pioneer Henry Ford with a book of photographs of available paintings by Old Masters and French Impressionists. The then-richest man in America pored over it with enthusiasm, said he would like to buy, and asked the price. Of the book.

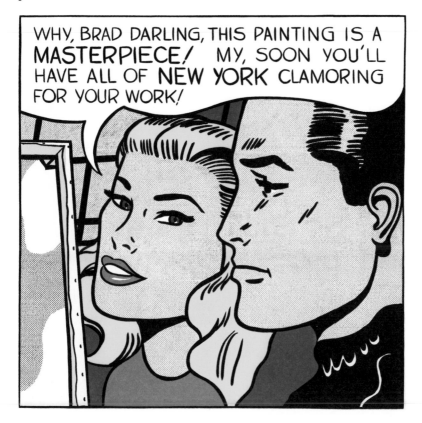

Americans continue to outrank all other nationalities in spending on art, simply because there are many more extremely wealthy people in America than in any other single country. Even though the percentage of extremely wealthy individuals in the United States fell by 18.5 percent during the global downturn in 2008, the Capgemini Merrill Lynch World Wealth Report in 2009 identified 2.46 million high-net-worth individuals (with investable assets over $1 million) in the United States vs. 1.202 million *total* in Germany, the United Kingdom, France, Switzerland, Italy, and Spain. Despite the sluggish economy, Japan boasts 1.366

Fig. 8
ROY LICHTENSTEIN
Masterpiece, 1962
Oil on canvas
54 × 54 in. (137.2 × 137.2 cm)
Private Collection

million HNWIs, with China far behind with only 364,000. Perhaps the most significant statistic in this report for the future art market is that the predicted HNWI growth rate in the Asia-Pacific region between 2008 and 2013 will be 12.8 percent, almost double that of the United States and Europe.[15] What matters, of course, is not just how many very rich people there are in any one country, but how they spend their wealth when it comes to nonessentials. Depending on the cultural history of the region, it may take more than one generation for the appetite for fine art to become as established as the appetite for jewelry, yachts, and private planes.

Throughout the second half of the twentieth century, there was slow but steady growth in the number of American art collectors, which swelled during each boom period and contracted accordingly when the art market slowed. Real-estate mogul Alfred Taubman bought Sotheby's in 1983, and many in the art world groaned that shopping-mall marketing tactics would prevail. He did, in fact, reach out to the new-money upwardly mobile and make them comfortable with the idea of buying art. Since the millennium, the ranks of American collectors have swelled again because of the glamorization of art collecting by the media, even more sophisticated marketing by auction houses and galleries, and the generally benign treatment of art as an investment by the financial press. The notion that buying art is a high-risk activity that requires education and exclusive access is dissolving as Wall Street traders with one-year-old collections are profiled in glossy magazines.

There have also been significant changes internationally. Russia and China, two countries with solid cultural traditions of collecting that were interrupted by the advent of communism, seem to have returned to the capitalist business model, now allowing the private ownership of fine art. A few Russian so-called oligarchs have made an impact, and there is considerable evidence that newly minted business moguls in China are developing an interest in modern and contemporary Western art. Indeed, a number of European and American galleries have opened galleries in Beijing and Shanghai since 2005. Overseas Chinese in Singapore, Taiwan, and Hong Kong started spending freely in this category in the mid-1980s, and while they were hit hard by the global credit crunch in late 2008, by spring 2010 auction records were being broken in Hong Kong for con-

temporary Chinese artists.[16] Most recently, oil-rich sheikdoms Qatar and Abu Dhabi have announced plans for spanking new world-class museums that will require significant shopping for Asian, Middle-Eastern, and Western masterpieces.

First World or not, countries that boast even a small wealthy class support *national* artists. In many cases the criteria for the elevation of the work combine subject matter, history, and possibly the relationship of the style of the work to local tradition. Virtually unknown even in his native Germany, Walter Spies (1895–1942) became a Balinese Gauguin, and wealthy Indonesians today pay in the million-dollar range for his dramatic landscapes of their country when it had a lot more trees. Depending on the country's economy, very high prices can be paid for work by domestic artists—but only by nationals of that country: the market is strictly local.

In a sense all art markets start out this way. Nations that enjoy maximum cultural and economic hegemony elevate their local artists into an international market where they may find a permanent niche or just visit for a decade or two. Quality and genuine innovation are, of course, necessary. Thus, the best French Impressionists, Viennese Secessionists, German Expressionists, American Abstract Expressionists, and British "School of London" artists, to name just a few groups, have semipermanent (nothing lasts forever) positions internationally to the extent that their work attracts significant audiences worldwide and continues to be sought by museums and private collectors. Good artists associated with important movements but not considered to be leaders might enjoy, like Cassatt, the lone American "French" Impressionist, a market almost exclusively national. The value of works by artists with predominantly domestic markets rises and falls in tandem with the fortunes of the native artist's country. This is particularly apparent with artists from Latin American countries such as Mexico, Venezuela, and Brazil.

While disposable income is a basic requirement to collect, the demand for one type of art or artist over another is determined by many varied factors. An individual's background, education, and early exposure to a particular type of fine art often define what he or she buys when the individual has the means to collect. Others collect what they believe will give them entrée into a particular social scene, be it sedately white-

gloved or obscurely avant-garde. Ideally, we should be guided only by our personal response to the art itself, but all too often collectors respond to what they read and hear.

At any given period current taste is determined by the mix of dealers, collectors, critics, and museum curators who constitute the "art world." Some know each other and communicate directly; others communicate through books, art magazines, and blogs. Power shifts from one sector to another as the culture changes. From the 1940s to the 1960s powerful critics like Clement Greenberg and Harold Rosenberg had avid audiences, and the artists they championed fared extremely well, for a time. In the 1970s the so-called blockbuster museum exhibition became ubiquitous after the hugely popular *Treasures of Tutankhamun* show that toured the world from 1972 through 1979. Following that success museums mounted variously themed exhibitions of work by names well-known by the general public: Gauguin, van Gogh, Monet, Picasso. These were replete with large-type wall texts, mellifluous audio tours, coffee-table catalogues, scarves, and jigsaw puzzles. These are taste-forming events for children and adults alike. In recent years it is often the collectors themselves who influence taste, as more and more of them shed anonymity and become involved in micro-managing the art world, building their own eponymous museums, commissioning artists, and even curating exhibitions. Many are profiled by the media and endlessly discussed as first names only by dealers, artists, and each other.

Marketing

Individual works of art, particular artists and historical styles, and art movements can go up in price as a result of increasingly skillful marketing by a combination of art gallery, auction house, artist, and art fair. A century ago most art dealers were glorified shopkeepers. Now some are themselves celebrity entrepreneurs. For most of the twentieth century auction houses functioned as wholesalers to the trade. Most buyers were dealers who relied on their own acumen to spot undervalued works that would benefit from being identified, catalogued, cleaned, framed, and re-presented to the retail buyer. Now the auction houses make and break the market reputations of midcareer artists whose work they promote with great fanfare. Christie's and Sotheby's no longer just

conduct auctions of collectibles. They have education divisions, sell real estate, and own and operate art galleries. Customers for any one of their enterprises are targeted for all of their products, be it a Cubist Picasso, a Malibu beach house, or a master's degree for their daughter. While much more focused in their goals, art galleries are also increasingly sophisticated when it comes to marketing. The Art Dealers Association of America, which has an invited membership and a strong code of ethics, organizes consumer-friendly public events, including art fairs and panel discussions.

The selling agents are not always the tastemakers, and sometimes even the artists and works of art seem to be merely pawns in a game directed not by the dealers or auction houses but by the collectors. Many buyers will sooner ape the buying choices of another collector than listen to a museum curator or a dealer. When Ronald Lauder paid a reported $135 million in 2007 for a painting by Gustav Klimt, his purchase was widely covered by the world press, and collectors who had previously been uninterested in Austrian and German art took notice.[17] A property developer from Dubai buys a house in Surrey, meets a neighbor on the golf course who happens to be a collector, and I get a call for "anything by Picasso up to $8 million."

New buyers, eager to emulate publicized collectors, start at the top, equate price with quality, and increase the demand for the most typical works by the artists, past or present, who are in the news. Prophesies are self-fulfilled, sometimes by careful design, and novice buyers may find themselves falling out of love with an object they were happy to pay a record price for when that artist seemed from the ear-splitting buzz, mostly generated by stakeholders, to be anointed.

Art Galleries

In the 1950s and 1960s even high-profile galleries announced their exhibitions with modest cards or posters folded for mailing. Small advertisements were placed in the *New York Times,* and a few hundred dollars might be spent on a quarter-page advertisement in an art magazine. A half-page might buy not only the advertisement but a good review. The notion of hiring a public-relations firm to promote an artist would have seemed not only absurd but self-defeating. Collectors then liked to dis-

cover new artists for themselves, and word of mouth was by far the most potent marketing tool. By the 1980s full-color catalogues replaced modest mailers, and advertising budgets grew, alas no longer guaranteeing good coverage; but it was not until the late 1990s that galleries unabashedly started hiring public-relations firms. Leading galleries are now very media savvy and keep themselves in the news by holding well-publicized openings and currying favor via exclusive dinner parties for tight groups of artists and collectors.

Auction Houses

Christie's and Sotheby's began to employ professional marketing agents in the late 1980s, when a booming art market filled their coffers. Up until then they relied on attractive, well-connected women to act as client liaisons with a variety of responsibilities, but basically making high-net-worth clients new to the auction process feel comfortable and providing them access to the specialists for advice. This role still exists and has expanded to high-end concierge services for overseas clients, as well as phone bidding. In addition, the auction houses now employ press officers, business managers, public-relations consultants, advertising departments, and event planners. Such events may include private dinners, cocktail parties, articles in glossy in-house magazines, lectures, and panel discussions—all focused on the sale of a particular item or collection and carefully constructed to stir the interest and earn the good will of buyers and sellers alike. Before the landmark sale of works by Picasso from the collection of Victor and Sally Ganz, Christie's chauffeured clients in limousines to the Ganz residence, where specialists provided a tour of the home and the works *in situ,* thus adding to the sense of privilege accorded the potential buyers. Since the late 1980s, it has been commonplace for both Sotheby's and Christie's to tour the world with selections from their upcoming auctions.

Auction-house marketing has the prime purpose of selling the auction house itself to future sellers, their most valuable constituency. In the process they hope to add value to the items they are promoting. In this celebrity age we are impressed with the renown of the former owner of a work of art, and auction houses make sure this is highly advertised. Often so much so that by the time the sale occurs many people truly

believe that they always knew "Mr. and Mrs. Irwin Goodperson" were collectors of unparalleled taste, despite the fact that the first they heard of them was when their newspaper of record rewrote Sotheby's press release and published it as news.

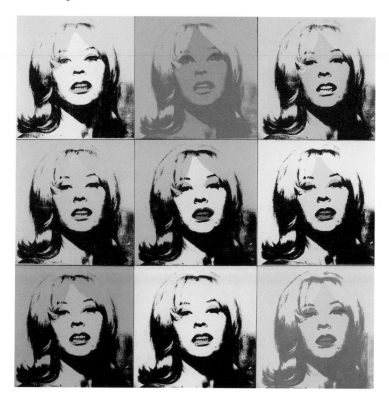

Artists

When it comes to contemporary art, direct contact with the artist often adds to the price of the work and is of course a social experience with memorable dinner-table conversation value for the buyer. Some artists are talented self-promoters.

The memoirs of collectors and dealers are filled with colorful stories of visits to artists' studios. In 1921 Monet received a distinguished young visitor, the son of a prime minister, a Yale graduate whose family owned vast shipyards. Intrigued, Monet opened up to the young man, who chatted amiably in fluent French. Finally, the visitor surveyed the studio twice, then swept his silver-topped cane around the room. "I'll take them

Fig. 9
ANDY WARHOL
Holly Solomon, 1966
Acrylic, silkscreen ink, and graphite on linen
Nine panels, each 27 × 27 in., overall 81 × 81 in.
(each 68.6 × 68.6 cm, overall 205.7 × 205.7 cm)
Private Collection

all," said Prince Matsukata from Tokyo.[18] Picasso allowed himself to be charmed by Chicago collector Morton G. Neumann, who presented him with a novelty wristwatch. Warhol was a superb self-marketer. In the 1970s he cajoled me to persuade my "rich friends" to commission him to paint their portraits, and his general factotum Fred Hughes organized fancy lunches at the Factory, where the would-be great could mingle with the almost-great and the formerly great with a view to being immortalized by coughing up $35,000 for a 40 by 40-inch canvas (fig. 9). Warhol encouraged me to persuade the sitters to add two or three more (same size, different colors) for only $15,000 apiece. In the 1980s uptown collectors became so enamored of dining with downtown artists that they started to buy up the neighborhood, and Tribeca was born.

Art Fairs

Major cities worldwide vie to host domestic and international fine-art fairs devoted to sundry categories: contemporary, Old Masters, Asian, works on paper, in any number of combinations. Many are invitational and have strict vetting requirements; others are tent shows where anyone with the price of booth rental can sell their wares, dubious or otherwise. Among the leading vetted annual fairs in Europe are TEFAF (the European Fine Art Fair) in Holland, Art Basel and Art Basel Miami Beach, and the Art Dealers Association of America art fair in New York. Attempting to cash in on the ancillary commerce and high-toned cachet that art fairs bring in their wake, cities like Hong Kong, Beijing, Abu Dhabi, Seoul, Moscow, and Los Angeles are joining the circuit with varying degrees of success.

Lasting anywhere from five to ten days, these fairs seek to attract both the same local collectors and international buyers who attend auctions and are lured by the same scent of opportunity, competition, and public spending. Hoping to attract new clients, participant dealers often save important works for exhibition at these fairs.

WHAT MAKES A SPECIFIC WORK OF ART VALUABLE?

I learned a lot about pricing in twenty years as an art dealer before I joined Christie's in 1984, but my sixteen years spent in the auction rooms

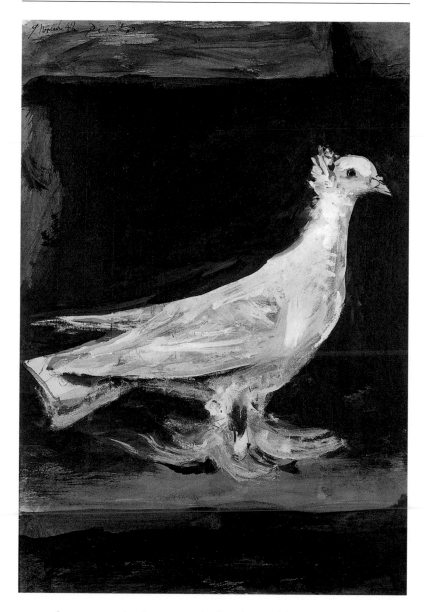

Fig. 10
PABLO PICASSO
The Dove, 1942
Gouache, brush, and pen and
ink on paper
25⅛ × 18⅛ in. (64 × 46 cm)
Private Collection

opened my eyes to the degree to which unknowable issues can determine prices paid (both low and high) that defeat analysis.

In 1997 an overseas client of mine building a major collection of Impressionist and twentieth-century paintings asked me to bid on a small gouache of a dove by Picasso in an auction at Christie's (fig. 10). The

client was not going to be reachable when the sale took place, but for him this was a small-ticket item, estimated at $180,000 to $220,000. He told me his wife liked it very much and that I should buy it. I said that he had to give me a limit. He was very reluctant to do that; he kept saying, "Just buy it." I insisted that he give me a limit and told him I thought it unlikely to go beyond $250,000. "Fine," he said, "$300,000, but remember, I want you to buy it!" I was confident I would get it until the bidding passed $200,000, and I could see there were still several bidders. Approaching $300,000, I was in a quandary and, against my better judgment, continued to bid up to $350,000. The hammer finally fell at $360,000 (with commissions, a total price of $398,500). The next day my client called me: "I am handing the phone to my wife," he said coldly, "so you can explain to her why she does not own that Picasso!" If he had been present at the sale, who knows what the final price would have been; he would certainly have been the buyer. Is it worth the price paid? Yes, if it is what your wife wants, you love your wife, and your funds are more or less limitless. No, if you expect to be able to sell it in the near or middle future for anything close.

Although auction houses like to say that an auction price represents what a willing buyer pays a willing seller, an auction result actually represents a unique set of circumstances at a specific point in time—not always a reliable market price. A missed flight, a child's cold, or a business reversal can make the difference between a new record for an artist's work and the failure of a much-advertised "masterpiece" to sell. Auction houses refer to unsold items as having been "bought in" or even "returned to owner" rather than the more damning "unsold." The adrenaline that the auction house hopes to inject into a sale by intensive marketing can lead to the well-known syndromes of Buyer's Remorse ("Why did I go so high?") and its opposite, Underbidder's Relief ("Thank God I stopped when I did!"), as well as Underbidder's Remorse ("It was so cheap, why did I stop?"). By the same token there are items in many auctions, including the most highly touted, that are bought by dealers who know they are undervalued.

Auction results are available online in various guises and combinations, one of the most popular sites being Artnet.com. Inexperienced collectors, as well as an increasing number of their advisors, only consult these

online statistics to determine the commercial value of what they deem to be somewhat similar works offered to them. Raw numbers, however, are useless unless interpreted with facts exclusive to each work of art, as well as the circumstances of the sale. To arrive at the market value of a work of art, the following five attributes must be known and weighed carefully:

- · Provenance
- · Condition
- · Authenticity
- · Exposure
- · Quality

Provenance

Once a work of art has entered the secondary market, it has achieved a history of ownership, called *provenance*—a French term for the history of ownership of a valuable object. When works are sold by private dealers, galleries, or auction houses, they are accompanied by a record that is basically a list of previous owners. These are sometimes identified by name or simply location ("Private Collection, Paris"), as well as by the names of art dealers, galleries, and auction houses that have bought and sold the work. Specific dates of auction sales and the years collectors owned the work are often included. In addition to provenance, the record should also indicate the work's exhibition history. Inclusion of a particular work in one or more important museum exhibitions enhances its reputation. So does any mention of it in books and magazines, particularly if it has been reproduced. Most important is the publication of the work in a catalogue raisonné.

Some aspect of a work's prior ownership may have more value to one buyer than another. When John Bryan became CEO of the Sara Lee Corporation, he inherited the tail-end of a corporate collection that been started by the company's founder, Nathan Cummings, a well-known private collector. When Cummings died, much of his collection was sold. Bryan made it a priority for Sara Lee to purchase back works with a Cummings provenance. For him and the prestige of the business, this provenance had added value, but this particular type of value is not necessarily transferable.

A distinguished exhibition history and inclusion in books do not on their own significantly enhance commercial value. Particularly luminous names in the provenance, however, can have a positive or negative impact on how much someone will pay for the work. A painting that once belonged to a distinguished museum is deemed to be more valuable than a virtually identical work with undistinguished ownership. This begs the often unasked question, Why, if the work is so important, does the museum not still own it? The names of collectors with reputations for great taste and acumen such as Louisine Havemeyer, whose collection forms the core of the Metropolitan Museum of Art's Impressionist galleries, may have a premium effect on the price of a work, just as works, equal in any other respect, that have been owned by the notorious, such as the Nazi war criminal Hermann Goering, may appeal to fewer buyers. Prac-

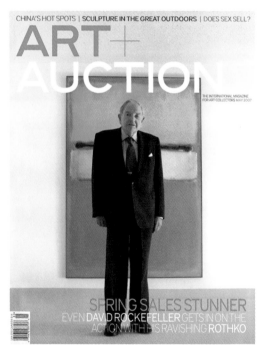

Fig. 11
ART + AUCTION **COVER**
May 2007
Cover courtesy *Art + Auction*
magazine, used by permission

tically speaking, infamous former owners usually disappear from a provenance unless there is significant published evidence of their former ownership. There is always the need for professional analysis of any record. Dr. Paul Gachet, for instance, is a positive name to find on any well-known work by van Gogh or Cézanne because he was their close friend and patron. It is also a name to arouse suspicion if the painting has no other claim to authenticity because Gachet was himself a painter and frequently copied the works of art he owned, sometimes including the signatures.

The degree to which an appealing provenance may actually increase the value of a work is very difficult to determine accurately, but in my experience former ownership by a celebrated collector, past or present, lends more value to a work of modest or interme-diate quality than a great work, which will achieve its value on its own merits. At most the added value might be 15 percent. There are excep-tions. Sotheby's sale in May 2007 included Rothko's *Untitled (Yellow, Pink,*

and Lavender on Rose), which belonged to David and Peggy Rockefeller. Because the proceeds were destined for charity, David Rockefeller allowed himself to be photographed with the work (fig. 11), and Sotheby's waged an extremely aggressive marketing campaign leaning heavily on the Rockefeller provenance. The painting sold for $72.84 million. The following evening, Christie's offered a Rothko similar in size and date, possibly less dramatic in color and definitely with a less-exalted provenance. It fetched a mere $29,920,000.

Condition

A condition report is a document itemizing the result of the physical examination of a work of art by a professional in the field, usually someone whose main occupation is the conservation and restoration of works of art similar in medium, period, and style to the work being scrutinized. The stronger the credentials of the professional, the more weight is given to the condition report. Art dealers and auction houses tend to produce succinct condition reports with one-line conclusions such as, "Overall good condition for such a painting of this period." Conservators who work exclusively for or with museums tend to produce eye-swimmingly detailed condition reports, the sheer length of which can alarm the neophyte. Conservators who work in the field, with private clients and galleries, as well as museums, tend to use less technical language and, most important, compare the condition of the object in their hands with the norm for that particular type of object, its age, and authorship, based on their wide experience. A certain amount of wear and tear and prior restoration might be expected with any Impressionist painting over a hundred years old, while similar conditions in a Minimalist painting dating from the 1960s might make it unsalable.

The impact of condition on value is often a function of the culture and changing taste. Fifty years ago American buyers of Impressionist paintings liked them to be bright and shiny, which sometimes led to them being overcleaned and heavily varnished. Many galleries and even major museums automatically relined these paintings, gluing a second canvas to the back of the original, often using heat and wax in the process. Today buyers of Impressionist works will pay a premium for paintings that are not relined and have only modest restoration.

The difference between a "good" and "excellent" condition rating might make a difference of 15 to 20 percent in the value of the work. Works in poor condition might sell for more than 40 percent below the norm for that artist, and if half or more of the work has been totally restored or repainted, it may not be salable. Certain *catalogues raisonnés* note works that may have been seriously damaged and repaired, and this published reputation will haunt the work forever. Fire, flood, and the mishandling that often accompanies theft are the major reasons for serious condition problems in paintings. Reputable dealers will not handle such works.

Increasingly, artists are using novel components in their work, some of them less enduring than others, such as the fluorescent tubes that constitute Dan Flavin's light sculptures or Damien Hirst's pickled animals. The ideological origins of fugitive art might be found in the intentional self-destruction of Swiss sculptor Jean Tinguely's twenty-five-foot-high assemblage of motorized, noise-making found objects in the garden of the Museum of Modern Art in 1960. In 1993 the Whitney Museum of American Art unveiled Janine Antoni's sculpture *Gnaw* (1992), which includes six hundred pounds of lard and six hundred pounds of chocolate. How much can the dealer charge for a work of art that may very well burn out or disintegrate within the lifetime of the primary buyer? In some instances the artist (in the case of Flavin, his estate) is willing to guarantee to replace the bits that wear out or break down. But what happens in fifty or one hundred years? It takes a dedicated patron (or a short-term speculator) to spend serious money on works of art that are impermanent or, in accounting language, nondurable consumer goods.

Authenticity

I am often approached by owners of works purportedly by well-known artists that are largely undocumented and have never been exhibited. "My great-grandfather knew Picasso in Barcelona in 1898, and he gave him this painting" is a favorite of mine, heard more than once. Usually the work has "always been in our family, never shown to anyone." Sometimes it is accompanied by a thick file of fading copies of documents by Swiss lawyers *or* Italian art historians (my apologies to both professions) attesting to the absolute authenticity of the work. Usually the painting

bears no resemblance to anything ever done by the artist. Close questioning typically elicits the information that the owner bought it knowing full well that it was doubted but had been convinced either by the seller or greed that "with a little research" it could be sold for millions. Sadly, unlike some traditions of Chinese paintings in which copies have value to the degree to which they maintain the spirit of the original, there are no degrees of authenticity when it comes to Western works of art of the last two hundred years.[19] An object is either deemed by the market to be right or wrong, worth something or worth nothing. A questionable work may be a copy of an authentic work, an outright fake, or simply misattributed. Responsible art dealers warrant the authenticity of everything they sell, as do the major auction houses, although it is worthwhile combing through the "Conditions of Sale" section of the auction catalogues to understand the obligation attached to phrases like "attributed to."

Not everyone cares to find out if their forebears bought the real thing. David Carritt was a legendary specialist in Old Master paintings who worked for many years at Christie's in London. He was renowned for spotting dusty paintings in family seats the length of the land and unmasking them as works by the likes of Giorgione, Tintoretto, or Titian and thus worth a fortune. One might imagine that the noise of Carritt's footsteps crunching the driveway gravel would be cause for great joy among the landed gentry, inspiring them to throw the doors open and uncork the best wine. Not always. Once in a while he found the towering gates closed, the welcome mat unrolled. Why? Because the owners were just as happy to enjoy their works of art as they always had, unvalued, anonymous, and dusty, rather than to deal with high insurance premiums, greedy heirs, and the National Trust looking for gifts.

Exposure

A piety frequently voiced by some private owners of great works of art is, "I am just the temporary steward of my collection," implying, rightly, that the works of art will in time find other owners. As will everything, in fact.

Even temporary stewards, however, control the right to expose their treasures to the public. Many collectors in a wide variety of categories are constantly subjected to requests from museums around the world to lend their works of art to what is always billed as an essential and impor-

tant exhibition. By and large American collectors are generous when it comes to making such loans. Apart from altruism one reason is that this is a country in which wealthy people pay their taxes and have no reason to hide what they own. In some other countries collectors are reluctant to admit that they own valuable works of art in case such admissions invite scrutiny by tax authorities, the opprobrium of an envious public, or both. Admittedly, it is now very much the fashion for American loans to be made anonymously, but even so most collections are known to at least a small group of other collectors, dealers, and curators.

When it comes to loans, there is often a synchronicity between social and commercial value. If your great Nice interior by Matisse is included in an exhibition planned by the Los Angeles County Museum of Art traveling to equally prominent museums in New York, London, and Berlin, the painting will not only be part of a valuable social experience, as hundreds of thousands of people worldwide will have an opportunity to see it, but this very exposure may well increase the painting's commercial appeal. If, indeed, you had any thought of selling the work, what better moment than after it had returned from a triumphant and critically acclaimed museum tour? Furthermore, if the curator of the show is desperate enough to borrow your work, she might agree to your reasonable request that it be illustrated full-page in color in the catalogue or even your less reasonable demand that it be put on the cover!

To be fair, many collectors do enjoy looking at the works of art they own, and the absence of a Matisse from above the fireplace for eighteen months is socially painful. But that pain is easily mitigated by the unbridled sycophancy that you and your spouse may enjoy at public receptions and private dinners in four major cities.

As an artist achieves recognition and as his or her body of work is exhibited, discussed, written about, and bought, some of it becomes more popular than others. It may be the artist's first mature endeavors that achieve popularity, as in the case of Picasso with his Blue and Rose Periods, guaranteed to pack exhibitions and sell coffee-table books. Or it may be the later paintings of an artist who died tragically young, as in the case of van Gogh and Modigliani.

Because popularity is in the hands of the public—those who go to exhibitions and buy books, calendars, and tote bags—only artists and

works of art that are widely circulated have a chance of becoming popular. Museums that own such works capitalize on the images for both commercial and educational purposes and, worldwide, the same works become more and more famous. This has been happening for a hundred years. Eventually, certain types of works become synonymous with the artist: van Gogh's self-portraits, Gauguin's Tahitian women, Monet's water lilies, Picasso's portraits of Dora Maar, Pollock's drip paintings, Johns's American flags, and Warhol's images of Marilyn Monroe.

Such works are said to have achieved iconic status, and in the art trade "iconic" is a very expensive word. Today's collectors may have started their art education in first grade by visiting the local museum or reading a book about famous painters, never imagining that one day they would have the means to collect. Now they vie to own the type of work that impressed them at an early age, and many would dig deep into their wallets for the opportunity.

When it comes to Western works of art of the previous century, we imagine that the favorites we know that are in the major museums and frequently reproduced are, in fact, the best. This is not always true. Once in a while a work long-held privately surfaces, and we say it has been discovered. In 1995, when treasures in the Hermitage Museum in St. Petersburg started to become available to travel to museums in the United States and Europe, people were astonished at the number of truly magnificent works that the press releases told us had been "hidden," which is rather like the classic headline in the British newspaper, "Europe Cut Off by Fog." Matisse's panoramic painting *The Dance (I)* (1909, fig. 12) at the Museum of Modern Art, extremely popular and a favorite of mine, is arguably not as powerful when seen next to *The Dance* (1909–10, fig. 13) in the Hermitage—and thanks to Mikhail Sergeyevich Gorbachev no longer hidden.

Whether widely known or rediscovered, works of art sharing the date and subject matter of the most popular by that artist achieve a premium value.

Quality aside, there will always be collectors who want what some call "signature" works by an artist. By this they usually mean works that bear sufficient resemblance to the most popular works by that artist, which can be identified by their friends and neighbors. Every dealer has had

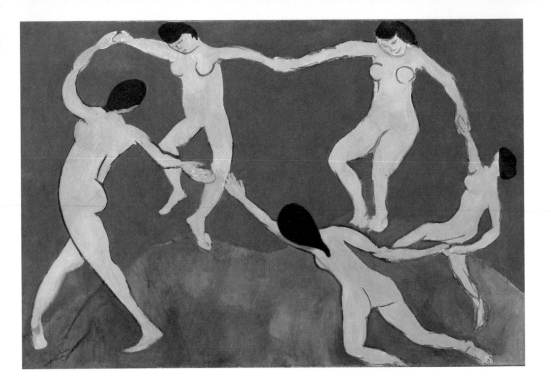

Fig. 12
HENRI MATISSE
Dance (I), Paris, Boulevard
des Invalides, early 1909
Oil on canvas
102½ × 153½ in.
(260.35 × 389.89 cm)
The Museum of Modern Art,
New York. Gift of Nelson A.
Rockefeller in honor of
Alfred H. Barr, Jr.

the experience of presenting a painting to a prospective new collector who has said, "But that doesn't look like a Picasso!" which simply means they have a limited knowledge of the artist's work and want a painting that can be identified at fifteen paces by their poor relations and wealthy neighbors.

Quality

By now it should be apparent that while there are many factors in the creation of the commercial value of a work of art, few are empirical and most are relative. None more so than quality.

No two persons looking at the same painting, sculpture, or drawing are having the same experience. Their eyes may receive the same information, but their brains process it in very different ways. Part of what we process in the split second that we lay our eyes on a work of art is what it may remind us of, consciously or subconsciously, and what we know about the artist if we recognize the hand. If you and I look at a painting of a red dog by Picasso, I may be drawn to it and declare it is top quality because it is a work by an artist I love of a subject that I like in my favorite color. You, on the other hand, say it is truly terrible because of the way you feel the artist treated women, because as a child you were bitten by

such a dog, and because red is your least favorite color. Neither you nor I may be judging the quality of the work in any commercial sense; we are bringing our own experiences to bear, and that is not only inevitable but part of the process of experiencing art.

What many people who spend a lot of time looking at art do agree on is what separates a successful work of art from one that may be merely interesting or typical. Mastery of the medium, clarity of execution, and authority of expression are vital criteria applicable to all works of art, regardless of style or subject. Artists themselves are not always the best judges of their own work, and financial need or simple egotism may spur them to offer for sale works of mixed quality. Not everything touched by a well-known artist is a masterpiece; some scraps are worth little more than an autograph. While van Gogh agonized over every painting he made and may have destroyed or painted over as many as he declared finished, Renoir, who painted every day of a much longer life, seems to have happily let his dealers sell even his most modest and unsuccessful daubs, as well as his many acknowledged masterpieces.

While the works of an artist who achieves great popularity may be of the highest quality, the body of work of most artists includes a range of quality. Picasso mastered many different methods of expression, and in

Fig. 13
HENRI MATISSE
Dance, 1909–10
Oil on canvas
102½ × 154 in. (260 × 391 cm)
The State Hermitage Museum,
St. Petersburg

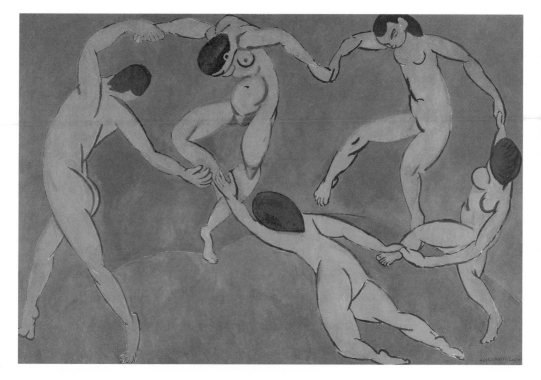

almost every period or style he produced works of mixed quality from the transcendent to the slapdash. This is often the case.

An eye for quality is easily trained by simply seeing as much as possible, in the flesh, by a particular artist and artists of the same school. Joseph Hirshhorn was self-educated, but he looked at a lot of art, and I took him to the studios of many artists whose work he was seeing for the first time and who had no track record. Time after time he selected, quite swiftly, the four or five best works in the studio.

The art market recognizes quality, and in the end there is a strong correlation between price and quality at all levels. No one has ever made a mistake by paying more in order to buy the best.

ART AND FINANCE

Corporate Art

Many major corporations sponsor museum exhibitions and art fairs. Well promoted to the general public, the involvement of the corporate world in art has dramatically increased in recent years, although actual collecting by corporations has decreased in favor of less controversial types of support.

In 1996 the German fashion house Hugo Boss enjoyed wide publicity when it inaugurated the Hugo Boss Prize, to be administered by the Guggenheim Museum in New York. The first winner, American Matthew Barney, received $30,000. That the same year JPMorgan Chase probably spent significantly more acquiring works by a number of artists but with far less fanfare. Most corporate boards want to dispense cultural largesse with as little controversy and as much positive publicity as can be purchased for the smallest donation. This "lowest common denominator" mentality is very different from that of individuals who inspire their companies to create corporate collections reflecting either their own personal taste or that of professional curators.

In the 1970s Meshulam Riklis, the colorful owner of McCrory Department Stores, aggressively bought art for himself and his companies. That a purchase he recommended would be turned down by the officers of the company he owned was risible. He enjoyed finding emerging artists and often commissioned works from them for his stores. Financially inven-

tive, he claimed that if a sculpture was actually attached to a retail outlet that he owned, he could depreciate its cost as a "sign" while, perhaps, it actually increased in value. Riklis chose everything himself, spent hours in galleries and studios, and thoroughly enjoyed haggling with dealers and artists.

Giant tobacco retailer Philip Morris employed professional curators to build a significant collection of contemporary art in the 1960s and 1970s. It also sponsored exhibitions and even published prints by leading artists. In the late 1970s Donald Marron, CEO of the asset management firm PaineWebber, began to buy emerging artists in SoHo not only for himself but also for his company. At first these works were hung in office corridors, but twenty years later they were assembled for a prestigious exhibition at the Museum of Fine Arts, Houston. When UBS acquired PaineWebber in 2000, it honored a promised gift of forty works to the Museum of Modern Art (Marron had been president of the board of trustees) and continued to maintain and strengthen the collection. This tradition of innovative corporate art buying in the United States was continued by CEOs like Peter Lewis (Progressive—insurance) and the late Don Fisher (The Gap—clothing), avid and experienced collectors. They know that an important corporate collection is much more than a commercial investment. It can make the workplace more interesting, enhance employee morale, and if the collection is exhibited and loaned, become a substantial public-relations asset.

Individuals like Marron, Lewis, and Fisher have the confidence to spend corporate funds on art because their experience as private collectors gives them the authority and knowledge to answer skeptics. The best corporate collections, while assembled with professional advice, are always the result of one person's will. Often, however, when an art-collecting company is sold or the leadership changes hands, faith in both the mission and the wisdom of the expenditures declines, the worst case being a sell-off of the collection.

As mergers and acquisitions increase, there are fewer strong-willed CEOs willing to spend corporate funds purchasing art. Boards that are answerable to holding companies tend to be timid when it comes to the acquisition of art. In my experience the more people involved in making a purchase decision, the less likely the decision will favor art that is innova-

tive and challenging (the kind that one day may be worth either very little or a lot). What many corporate boards will buy, however, is the idea that part of their allocated budgets for advertising and promotion be spent underwriting cultural activities with a proven ability to attract the attention not only of the public at large but also of wealthy individuals. The private events attendant on those museum shows, for instance, give their executives an opportunity to mingle with these potential new clients.

Overseas this might even extend to commercial art events such as an auction house's presentation of a selection of big-name paintings to Asian clients before they are sold in New York or London. I organized more than one such event for Christie's, including a very successful private view for American Express special clients in Taipei. American Express pampered their high-net-worth clients with a privileged exclusive reception, and Christie's had the opportunity to meet potential new art buyers.

Big-city museums provide local, national, and international corporations with ideal forums in which to strengthen their profiles among wealthy trustees. One way of doing this is to support brick-and-mortar development. Often, however, from the corporation's perspective, they derive more bang for their buck (their name writ large) by supporting a popular exhibition than by appearing alphabetically in chiseled gold on the wall of donors.

When it comes to the sponsorship of museum exhibitions, the involvement of corporations has been criticized as coercive. By choosing to sponsor one exhibition over another, they are said to be exerting curatorial control. For instance, a top investment firm might be willing to sponsor a Picasso exhibition, hardly likely to stir controversy, but not that of living artist whose subject matter might have potent political or sexual context.

Banks

Baron Leon Lambert, scion of a great Belgian banking family, vastly increased the profile of the Banque Lambert when at the age of twenty-eight he commissioned the well-known modernist architect Gordon Bunshaft to design a new bank headquarters in the heart of Brussels. Outside were sculptures by Jean Dubuffet and Henry Moore, and throughout the bank's offices and public spaces more art. Lambert himself occupied a vast pent-

house at the top of the bank and stepping out of his private elevator visitors were greeted by three tall standing women by Alberto Giacometti and room after room of modern and contemporary art (fig. 14).

Like Lambert, throughout the twentieth century the founders and owners of many European banks were themselves art collectors. The notion that works of art, though not necessarily liquid assets, nevertheless had real commercial value meant that in Europe at least, ownership of works of art contributed to the strength of an individual's financial position. Not so in the United States. Bankers believed in real estate and securities but not art. The story of Frank and Phyllis, a banker and his wife, is instructive in this regard.

Fig. 14
Entrance to the
private residence of
Baron Leon Lambert,
Brussels

In the late 1970s I made the acquaintance of this couple, and I became determined to interest them in collecting contemporary art—particularly the emerging artists whom I then represented. They had taste, money, and a fabulous apartment with wall space. The problem was that Frank could not believe that art had real commercial value.

The auction of Florence Gould's collection of Impressionist works at Sotheby's in April 1985 changed Frank's perception. This auction marked the start of the era of auction-as-public-circus. The works were top quality, and Gould herself was a very colorful figure. The advertising and promotion were significant. The star lot was van Gogh's *Enclosed Field with Young Wheat and Rising Sun* (1889, fig. 15), anticipated to bring as much as $5 million, which would at that time have been a record price for any work of art sold at auction.

In fact, it brought almost twice that amount, $9.9 million. The story was made more colorful because it was purchased by another formidable woman collector, Amalia de Fortabat, an

Fig. 15
VINCENT VAN GOGH
*Enclosed Field with Young
Wheat and Rising Sun*, 1889
Oil on canvas
28¾ × 36¼ in. (73 × 92 cm)
Private Collection

Argentinean concrete-company owner. The sale made the front page of the *New York Times*. On the crowded crosstown bus the next morning, I saw one man reading the article and muttering, "Ridiculous!" Other people were discussing it with various degrees of amazement. My phone was ringing as I reached my office. It was Frank, whom I had not heard from for several months. He was spluttering.

"Michael!" he almost roared.

"Yes, Frank, how are you?" I recognized his voice.

"Did you know a painting sold for ten million dollars!" he was still roaring.

"Yes, Frank," I replied, "I was at the auction and saw it being sold."

"Ten million dollars is a lot of money!" I could imagine Frank's fair complexion reddening as he roared again. I paused, not knowing quite what to say and not sure if he considered this a good or a bad thing that had happened.

"I'm going to come and see you!" he said, still roaring. And he did.

What galvanized Frank's interest was the sum of money involved. Finally, a work of art had grabbed his attention because it was being spoken

about in language he understood very well. If I had promoted van Gogh to him as an artist capable of reaching into the souls of his sitters, Frank would have nodded politely, coughed, and changed the subject.

But even the headline prices of the late 1980s failed to impress most of the banking community, with two important exceptions. Under the stewardship of David Rockefeller, the Chase Manhattan Bank, now JP Morgan Chase, started to build its art collection in 1959. The bank now boasts, as its website informs us, "30,000 objects in 450 corporate offices around the globe."[20] Rockefeller's mother Abby Aldrich Rockefeller was one of the three women who founded the Museum of Modern Art, and Rockefeller is currently chairman emeritus of the museum, having served as president, as did his brother Nelson and his sister-in-law Blanchette. He continues the family's mission to proselytize for modern art in virtually all areas of his personal, philanthropic, and business life. The bank's collection includes good examples of work by major names, as well as many by less well-known artists whose careers and income were given a boost by being included in the well-regarded Chase collection. Quite apart from and more important than the commercial value of the collection to JPMorgan Chase is its ambassadorial context on an international level. Parts of the collection tour local museums worldwide.

A quite different approach, perhaps with more easily quantified returns, is taken by Citibank's Art Advisory Service. For a relatively modest annual fee a collector has access to a team of in-house specialists who will help him or her to identify, source, and purchase works of art. Their advice encompasses matters of storage, shipping, and insurance; and if the client wishes to sell, they will take care of the details. The client pays an annual retainer plus "transaction fees for buying and selling works of art." This has been a very successful program. The benefit to clients is that if they are neophytes, they trust that a major bank will protect their interests, and if they wish to maintain absolute anonymity, that is guaranteed. The benefit to Citibank is that through the Art Advisory Service, they attract high-net-worth individuals; and once they have established a relationship with them as clients, senior private banking officers approach them about their other personal and business banking needs. Citibank also offers its clients the ability to borrow against the value of the art they own, a very significant departure from most American banks.

With its own advisory staff Citibank feels confident they know enough about current fair market values and movements in the art market to make prudent loans. Prior to this, there were one or two small banking facilities that would lend against works of art, but with fairly draconian terms that often required the works to be kept by the bank during the term of the loan.[21]

Most US banks, however, only lend against works of art if their borrowers have other assets. In any event, the most that a borrower might expect is fifty cents on every dollar of an agreed fair-market appraisal, with the bank holding title to the work of art for the duration of the loan.

In Europe, however, banks have long been more comfortable assigning real value to art on behalf of their clients because bank owners and shareholders are themselves more likely to be collectors. Judicious lending based on generations of expertise allows collectors to maximize the value of the art they own, and some banks partner with successful dealers for specific transactions. One or two well-established European galleries were helped in their early years by banks willing to accept a percentage of the dealer's profit in lieu of a payment schedule, thus reducing the financial pressure on a fledgling operation.

In the twenty-first century banks are global. As they discover that more and more of their private banking clients worldwide are collectors, they try to involve the art world to present themselves as culturally literate. Some, like Deutsche Bank, are emulating JPMorgan Chase and building their own significant collections, which are exhibited around the world to burnish the bank's name and reinforce its cultural credentials to an international community of high-net-worth collectors. Banks are involved with many of the top art fairs. Deutsche Bank and ING sponsor TEFAF, mentioned earlier, the largest and most prestigious annual art fair, which takes place in Maastricht, the Netherlands, every March and includes Old Master galleries, antiquities dealers, and the major jewelry firms, as well as Impressionist, modern, and contemporary exhibitors. UBS sponsors Art Basel in June and its progeny Art Basel Miami Beach in December. Like all major multinational corporations, banks like to sponsor prestigious museum exhibitions and send their senior directors to meet the lenders at the inevitable fancy dinner for the private opening. In addition to collectors who may have loaned works to the exhibition or

indeed the artist or artists whose works are in the exhibition, the invited include the museum's trustees and a smattering of well-to-do movers and shakers. Between courses there will be a few words of thanks from the podium, and inevitably this will include a speech from a very senior representative (sometime even the CEO) of the bank that has underwritten the exhibition. The speech usually manages to draw a parallel between the pioneering spirit manifest in the exhibition and the forward-looking mission of "our bank."

Nonbank Lenders

Art's lack of liquidity sometimes obliges sellers to borrow money against future sales. Most galleries and private dealers will either buy a work outright from a seller or accept it on consignment at an agreed price for a specific length of time. It is unusual for them to lend money to the seller. Auction houses will lend money to prospective sellers if the consigned works are of significant value. In the two major sale categories, "Impressionist and Modern Art" and "Contemporary Art," both Christie's and Sotheby's hold two major auctions in London and two in New York each year. At any given point in time a borrower may have his or her works put up for auction within a matter of a few months. The catch is that once the amount of the loan is agreed on, perhaps sixty cents on the dollar, the auction house can put it up with whatever estimate it wants and sell it for the amount of the loan in order to repay itself. If no one bids and the work is not sold, then the money is still owed and the property will be put it in another auction, probably with an even lower estimate. Sellers of exceptional works of art may also be in a position to negotiate a guarantee from the auction house that they will receive a specific minimum amount whether or not the bidding reaches that amount. In effect, the auction house is making a commitment to buy the property before the sale, and if the work sells for more than the guaranteed amount, the seller must share the difference with the auction house. Needless to say, Christie's and Sotheby's are enthusiastic about offering guarantees for top-quality works in a strong market, but far less so when the market slows down.

While auction houses use loans and guarantees to sellers to source property for their sales, they also extend credit to buyers to encourage them to bid. They have learned, however, to make sure that the buyers

are creditworthy. In 1987 Sotheby's entered into an agreement with the Australian collector Allan Bond, which provided that Sotheby's would lend Bond the money to bid successfully for van Gogh's *Irises,* with the painting itself as collateral. Bond's successful bid was $53.9 million, and Sotheby's loaned him $27 million. The seller was paid in full, but Bond's business empire collapsed, and he was unable to repay Sotheby's. In fact, he never took possession of the work, which subsequently was sold to the Getty Museum for an undisclosed price. Sotheby's subsequently discontinued the practice of lending to prospective buyers with the potential purchase as collateral.

In 2006 an independent nonbank service was founded in New York called Fine Art Capital. It has a staff of "loan officers" experienced in appraising art and offers loans to collectors, art dealers, and museums. The loans are secured by works of art owned by the borrowers. Their website proclaims, "Qualified clients can borrow $500,000 to $100,000,000 for up to 20 years and retain possession of their collection."[22] In 2008 the company gave up its independence and became Emigrant Bank Fine Art Finance.

Art Investment Funds

There is an adage among old hands in the art world that the emergence of art investment funds signals that a boom is over. This was true in the late 1980s and again in 2006–08. The wisdom is based on the fact that art investment funds are usually created by and designed to appeal to individuals with limited experience in the art market. And indeed, the setbacks that some parts of the art market suffered as a result of the global financial meltdown in the fall of 2008 were not predicted by the most recent crop of art-fund promoters. For them, the art market defied gravity, and they ignored its historically cyclical nature.

Strong prices, high-profile big spenders, and glittering openings make good copy. The media carries the message that "art is hot" far outside the art world, and people like me start getting calls from financial reporters anxious to file stories about one or another aspect of what is to them a novel phenomenon. These stories inspire entrepreneurs to use art to approach individuals, insurance companies, and pension funds with billions of dollars but no passports to the seductive world of art investment.

The basic premise of virtually all art funds is that you put up the money and someone else chooses and buys works of art that are warehoused until sold. Then the profits are shared. The organizers often have impressive business credentials, and they usually enlist some art-world names as consultants, sometimes even experienced dealers who may be privately skeptical but lured by the promise of fat fees or commissions. While many art funds use reduced risk as a selling point, art is not immune to the lack-of-crystal-ball syndrome inherent in all speculative investment. Booms—whether started by Colonel George Armstrong Custer's announced discovery of gold in South Dakota in 1874, the Internet-inspired dot-com bubble of 1985–2000, or the credit default swaps of 2004–08 —create very short memories and favor those lucky enough to get on the bus at the bottom of the hill and get off at the top.

Speculators are attracted to art as an investment because, as the noted cultural economist (the term itself is instructive) Clare McAndrew, of Trinity College in Dublin, observes,

> From an economic point of view, works of art have the interesting feature of being dual in nature. On the one hand, they are "consumer durables" or objects to consume as they are viewed, yielding an aesthetic and non-monetary viewing benefit. On the other hand, they are simultaneously capital assets that yield a return from their appreciation in value over time like other financial assets.[23]

This sounds very promising indeed—until art's relative lack of liquidity meets the carrying costs of art as durable goods and is combined with transaction costs higher than for most financial assets. Most art funds underestimate the time it will take to sell, the cost of selling, and the maintenance costs of as-yet-unsold art "holdings," let alone the cost of sourcing sought-after works. The art funds require their own well-paid experts who, no matter how solid their skills and reputation in the art world, still have to pay commissions to the dealers, galleries, and auction houses that do the actual buying and selling.

The auction house "buyer's premium" (the commission charged by Christie's and Sotheby's on top of the price hammered down by the auctioneer) remained at 10 percent until 1992. Since then it has crept up, and

now both houses employ a fairly complex sliding scale that starts at 25 percent for low-value sales. This is in addition to the commission charged to the seller. The traditional art dealer's brokerage fee was for many years 10 percent of the price paid by either the buyer or seller but not both, but when auction house fees started to rise, many dealers started asking for commissions of 12 percent. On top of that the investor is paying the art fund a commission to cover its costs and profit. Those costs include not only salaries but also insurance premiums and warehouse and shipping costs for the works of art. With profit for the art fund, say another 15 percent, the total premium is 35 percent. The maintenance and transaction costs for works of art in art funds can be vastly greater than investors are used to paying for other forms of asset management.

Unknown to most art-fund organizers today is the only one to have had great success, largely a matter of good luck with timing. In 1904 a young French financier, André Level, invited twelve friends to form an art investment fund he named, with intentional irony, La Peau de l'Ours, after a fable by La Fontaine in which hunters sell the skin of a great bear but were unable to catch it—a warning about speculation. The group bought work by artists such as Gauguin and Monet, who were still unfamiliar to many members of the public, as well as complete unknowns like Picasso, Matisse, and Vuillard, a total of almost 150 paintings. They made no secret of the fact that they were buying for investment; and after ten years, in 1914, they put up everything at auction. The return was approximately four times their investment. They gave 20 percent of their profits back to the artists. The sales focused attention on many of the younger artists, particularly Picasso, whose huge painting *Family of Saltimbanques* (1905, fig. 16), now at the National Gallery of Art in Washington, D.C., was the star of the sales. The principal reason for success was galloping inflation and the luck of scheduling the auctions before, and not after, Archduke Ferdinand was assassinated in Sarajevo. Thus started the war to end all wars, which would have put a considerable damper on the venture.

Less successful but often used as a positive example by creators of art funds is the long-term strategy of the British Rail Pension Art Fund established in 1975 with $100 million, which represented 2.5 percent of the pension fund's total assets. They chose Sotheby's to administer the

Fig. 16
PABLO PICASSO
Family of Saltimbanques, 1905
Oil on canvas
83¾ × 90⅜ in.
(212.8 × 229.6 cm)
National Gallery of Art,
Washington, D.C.
Chester Dale Collection

fund, and eventually 2,400 objects were purchased from galleries and at auction. The sell-off began in 1987 and lasted until 1999. The return was judged to be 11.3 percent compounded annually, but almost all of the gain came from the increase in value of just twenty-five Impressionist paintings. Former advisor Jeremy Eckstein, now consulting for new art funds, explained it this way: "We tried to diversify too much."[24] Which translates as: "We didn't know which horse would win so we bet on all of them." I imagine that in 1975 the Pension Art Fund managers were told that the art market was so diverse that their investment posed little risk.

Most dealers and collectors I know are skeptical of art funds, many of which are stillborn, while a few limp along until, as is inevitable, the art market reaches a plateau or even falls. Many financial specialists are less than enamored of these strange animals. In a letter to the editor of the

Art Newspaper titled "Art Is Not a Prudent Investment," Max Rutten of the Said Business School at Oxford University writes: "I believe a lot of funds will fail, consolidate and only a few large and diversified players will survive before art as an investment class will be generally accepted. In the process, many private and institutional dollars invested in art funds at this early stage, will end in a valley of tears."[25]

There were very few art funds left standing in 1991. After 2000 new ones started to emerge, but few survived the economic setbacks of fall 2008. As for tears, there were many. The online Distressed Debt Report for January 2009 announced that the bankrupt hedge fund SageCrest was suing art lender Ian Peck and his Art Capital Group for millions of dollars, part of a tangled web of suits, countersuits, and claims of fraud.[26] This is just one example of many such unhappy endings involving art funds.

Interestingly, the banks that have had the longest involvement with art, either through collecting or providing advice or loans, are often the least enthusiastic about art funds. In February 2005 Tom Werley, head of portfolio construction at JPMorgan Private Bank, was quoted in *Business Week* as saying, "We still view art as a core passion as opposed to solely as an investment." He went on to cite the difficulty of valuing art, its lack of liquidity, high transaction costs, and volatility as obstacles to investing in art purely for financial gain.[27]

The basis of this book is that the value of art is threefold: the possibility of maintaining or increasing its commercial value; the society of like-minded enthusiasts; and the private enjoyment of contemplating the work itself. An art-fund investor is paying a full price, make no mistake, and getting at best one-third of the bang for his or her buck—possible increased value. Treating works of art as no more than financial instruments robs them of their potential to achieve or maintain popularity through exposure and discussion and thus inhibits what helps them increase in social and commercial value. And how sad not to be able to show off and see what you own.

IS THERE A MEASURABLE ART MARKET?

The only detailed data for any art fund to base its models on is that provided by public auction sales. In an exhaustive survey of the 2006 global

art market, Clare McAndrew estimated the total art turnover globally to be $52 billion, of which only 48 percent was spent at auction. An astonishing $27 billion was spent in individual transactions, the details of which (name of artist, type of work, price paid) are unavailable for the kind of statistical analysis that art funds claim to perform. How can one measure and consequently predict activity in a market 52 percent of which is essentially invisible?[28]

While dealers and auction houses often compete with each other for the opportunity to sell particularly choice works of art, no entity regulates what comes up for sale. A record price for a Lucian Freud at auction might persuade one person to put theirs up for sale to cash in, but other Freud collectors will simply be glad they bought when they could afford it and groan that they have to increase their insurance. Usually the works of art sold publicly that grab the headlines come to sale because the owner has died, which as far as I can tell is an unregulated activity. Not only is the nature and timing of the supply unknowable and totally unpredictable but so is the demand.

In 1921, at Fontainebleau, Picasso made five very similar portraits of a woman's head, probably inspired by his then-wife Olga. Each is a pastel on paper, measures 25 by 20 inches, and is predominantly blue in color. Few people will argue that in 1989 the art market was at an absolute peak. Works that had been bought at auction two years before, albeit no longer fresh to the market, were being resold at auction for double. This continued until the sales of November 1990 showed some fissures, although there were still plenty of high prices.

In April 1989 Christie's auctioned the first of two of Picasso's Olga pastels it would offer that year (figs. 17 and 18). Equal in quality, provenance, and condition, each came to auction for different reasons. The price paid for the first was £3.52 million, at the then–exchange rate equivalent to $5,985,380. The next one appeared just seven months later in November. It was one of the stars of the much-publicized sale of a diverse, high-quality collection belonging to the legendary film director Billy Wilder. Amazingly, although the art market was still rising, Wilder's *Head of a Woman* (1921) sold for a million dollars less, $4.8 million. Almost exactly five years later, in 1994, the buyer put Wilder's pastel back into auction, this time at Christie's in London, and it sold for only $3,266,950.

The differential between the second and the third price for Wilder's Picasso is easily understood because the market dropped precipitously in 1991. By 1994 it was still in very early recovery; and coming back to auction after five years, Wilder's Picasso was not considered as fresh to the market as it had been after spending decades in the movie director's home. In fact, under the circumstances, it fetched a very good price because it sold over the high estimate of $2.8 million. But how to explain the relative failure at the first sale in 1989? I was in charge of this sale, so the blame is partly mine. My colleagues and I had estimated it at $5–7 million, which we considered to be perfectly justified by the previous April's price of almost $6 million against the exact same estimate for a

very similar work. Not only that, as part of a Hollywood big-name collection, it was advertised and marketed to the hilt. What went wrong?

Even though I was behind the scenes at all three sales, I can't enter the hearts and minds of actual and potential bidders, but this is what I think. In April 1989 only two people were in the market for such a work at the proposed level of $5–7 million. They bid against each other, and one of them won the prize. When Wilder's Picasso came up for sale, there was only one buyer left; and he or she had no competition and was consequently able to purchase the work against the reserve. During the buildup to a major auction, there is a plethora of largely self-generated positive buzz that inspires expressions of interest in various top lots from

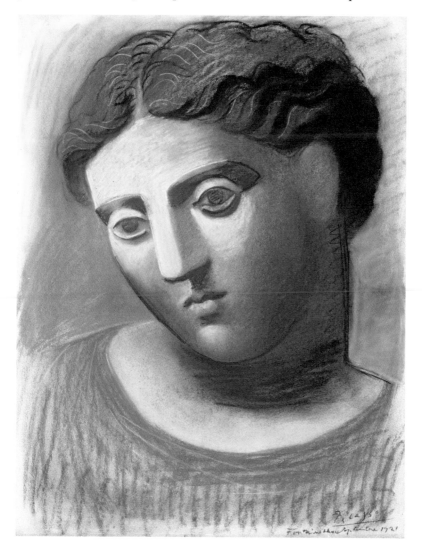

Fig. 18
PABLO PICASSO
Head of a Woman, 1921
Pastel on paper
25½ × 20 in.
(64.8 × 50.5 cm)
Private Collection

bona-fide buyers, many of whom decide otherwise at the last minute, thus confounding all predictions.

If Wilder's Picasso had in fact been held by an art fund, I am sure that the most sophisticated financial model, as well as the most experienced advisors at the time, would have urged putting it up for sale at $5–7 million to take advantage of the momentum and strength of the rising market. What was unpredictable was the specific demand for that specific work, regardless of its high quality, good condition, and sterling provenance.

Why then, did Wilder choose to sell at that time? At the age of eighty-two (he died in 2002 at ninety-five), he was in the process of completing his memoirs. He knew that if he died with the collection intact, it would be auctioned off with great fanfare after his death. He did not want to miss the action and envisaged the sale as the finale of his autobiography. He told me, "It's my last chapter, and I want to be there!"

ART INDEXES

If art funds suggest that the commerce of buying and selling unique works of art can be reduced to a purely investment purpose, there are a variety of index systems designed to track and predict not only the value of works of art based on analyzing auction results, but such psychologically charged phenomena as market confidence for contemporary artists.

Analyzing Auction Results

The first attempt to monitor the art market analytically was the *Times* Sotheby's Index launched with much fanfare in 1966 as a collaboration between the British newspaper and auction house. It was quietly put out of its misery in 1970 when all the arrows started pointing down.

The broader the scope of an index, the more accurate it is likely to be, although ultimately if you want to know if it is sunny or rainy, it is better to look out the window than listen to the weather report. Since most art indexes are born in boom markets, they will basically report that many things are up and some are down, which is why someone not previously interested in the art market is looking at the index in the first place. Like

the art funds they often support, art-market indexes flourish in times of boom and bubble and die silent and unmourned deaths when the art market flattens out.

A Princeton economist claims to have examined auction sales from 1652 to 1961 and determined that investment in art generated a return of 0.55 over that period.[29] In 2001 New York–based economists Jianping Mei and Michael Moses founded the Mei/Moses Art Index (fig. 19), which attempts to define the performance of categories of art based on

Fig. 19
MEI/MOSES FINE ART INDEX
As published in
Forbes Magazine,
December 24, 2001

what they term "original sales prices" subtracted from the most recent prices of works sold at Christie's and Sotheby's.[30] I am not sure how they deduce original sales prices. Virtually all works of art are sold originally by either the artists themselves or their dealers, and there is simply no way for Mei and Moses to access those numbers. Sergey Skaterschikov

publishes Skate's Masterpieces Peer Group with ratings and rankings for specific artists. Skate's website once advertised *Skate's Art Investment Handbook,* "first released in Russia after being written as a guide for Russia's newly wealthy . . . using a combination of proprietary editorial and aggregated statistical data . . . [it] describes a rational approach to investing in art with valuation drivers and market statistics."[31]

Economists might be interested in an analysis of the state of the art market, but the participants, if their motivations are purely financial, are only interested in the future. They want to be told what to buy by someone with professional credentials because that is how many of them approach all their investments. When I show a selection of paintings to seasoned collectors, they tell me what *they* like. Often when I am presenting works to new collectors, they ask me what *I* like. The assumption is that I have a nose for the best investment, even some kind of inside information. In Taiwan I ended up in a heated argument with a client who wanted me to recommend one of two drawings by Salvador Dalí, identical in virtually every respect, probably finished within minutes of each other, with just slightly different subjects and colors. The potential buyer was convinced that I knew which one would become the most valuable and that I was keeping this secret information for a more favored collector.

Some art economists, a new calling perhaps, believe that auction results are indicative of the art market as a whole. This is a fallacy. The dynamics of supply and demand in the auction market are very different from those in the private market, and the private market is larger than the auction market. How accurate could any suggestion of current, let alone future, performance be when only a fraction of vital data is available? Even raw auction data is virtually useless because there are subtleties of choice that cannot be factored. For instance, to a statistician the same 1920 painting by Léger sold two or three times at auction in a five-year period would seem to be a sound indicator because it allows one to track the absolute price of the same object at different intervals. Whatever the reading, it will be substantially different, and probably less bullish, than if three similar paintings by Léger from 1920 were sold over the same five-year period. Why? Because buyer resistance at auction to works that have been recently sold at auction is significant. This has nothing to do with any inherent quality of the work itself and varies in degree from buyer to buyer.

Even when the same work of art is offered at public auction several times, it is dangerous to extrapolate market trends from the results, which may have more to do with the relative appeal of the work to different audiences in different countries, as well as all the individual circumstances of attendance and attention that dictate auction results, rather than any general direction for either that artist's work or the art market.

Fig. 20
PIERRE BONNARD
Portrait of a Young Woman,
c. 1905
Oil on canvas
19⅛ × 16½ in. (48.6 × 41.5 cm)
Private Collection

Between 1988 and 2012 Pierre Bonnard's *Portrait of a Young Woman* (c. 1905, fig. 20) came up for auction no fewer than eight times. At Christie's New York in 1988, in a rising market it was offered as part of the

highly publicized Goetz Collection with an estimate of $300,000 to $400,000 and sold extremely well for $528,000. One year later the new owner tried to take advantage of the fact that Japanese buyers were keenly supporting the Great Art Rush of '89 and consigned it to an auction in Tokyo with an estimate equivalent to $588,000 to $756,000. It failed to sell. Undeterred, the owner then offered it at Cornette de Saint Cyr's auction in France in March 1990, and again it did not find a buyer, despite the still-bullish market. The art market fell fairly noisily in 1991, so it is no surprise that this painting failed for the third time in a row that year at Briest and a fourth time in 1992 at Ader, Picard, Tajan in Paris; it was estimated at $377,000 to $565,000. Then came a nine-year hiatus during which perhaps memories of the work's failure grew dim, and the owner was persuaded to present the work at Christie's in London in 2001 with a more modest estimate of $165,000 to $247,000 (about half the estimate at the 1989 Goetz sale). It did, finally, find a buyer for $205,561. This buyer took it back to Christie's in London in 2008, where it was estimated at $490,000 to $686,000 but sold for only $478,000, including the buyer's premium. Four years later *Portrait of a Young Woman* failed to charm yet another suitor and was sold at Sotheby's in London in June 2012 for $257,046. In eight tries over fourteen years, in America, Europe, and Asia, this Bonnard never sold for more than half what the buyer paid in 1988, when it was "fresh" from the Goetz Collection.

While I believe it is dangerous, misleading, and frankly impossible to make predictions about the future performance of work by specific artists or schools of art, general patterns in the modern era do emerge. After 1945 the global art market settled into a series of cycles. Prices would gradually increase for five or six years, rush to a peak for the next two or three, then dip fairly abruptly only to start all over again. The last cycle like this began in the early 1980s, reached a high in 1990, and dropped precipitously in 1991. Recovery began in 1995, was steady through 2002, and was then followed by six boom years and an abrupt correction in late 2008 prompted by the international credit crisis. The amount of increase and decline varies in each cycle. Between 1987 and 1989 some works of art seemed to be doubling their value each year, but between 1990 and 1991 many lost up to half their value. The overall increase from 1945 through 2000, flattening out the valleys and peaks, was about 12 percent

per year. If you were obliged to sell when the market was down or lucky to sell when it was high, then of course your gain (or loss) would be greater.

Fig. 21
GERALD LAING (left) and PETER PHILLIPS
British sculptors, with *Hybrid Research Kit*, April 1, 1966

Trend Analysis

In 1965 two British artists living in New York created a work of art they called *Hybrid* (fig. 21). The art market was small but buoyant, new buyers were attracted to styles sloppily labeled Pop and Op, and there was a

definite hunger to find out "what's next." Gerald Laing and Peter Phillips mounted a tongue-in-cheek operation to poll the art community of dealers, collectors, curators, and writers in order to determine what art they actually would like to be "next" and then give it to them. They created an ingenious kit of colors and shapes with which, along with a questionnaire and personal interviews, they gathered, in a thoroughly deadpan manner, the combined views of the movers and shakers in the contemporary art world. Six months later they unveiled *Hybrid* at the Kornblee Gallery in the form of a three-dimensional object made of 23.6 percent brass, 17 percent plastic, 28.6 percent aluminum, and 30 percent Plexiglas. It was red, white, and blue. The 52-inch version was $1,100, and the desk-sized version, $150. The show was sold out, bought by serious collectors, at least some of whom understood that it was ironic commentary.

ArtTactic, a London-based art-market research and advisory company founded in 2001, does not claim to predict but digests and analyzes publicly available information about particular artists and their work, including auction results, as well as exhibition histories and important collections. They produce "risk ratings" and publish a "Heatmap" based on a survey of two hundred collectors, advisors, dealers, and auction-house experts (sound familiar?), who are asked to rate their "feelings" about the markets for specific artists as either positive, neutral, or negative.[32] My father was the sports editor of a national daily newspaper in the United Kingdom. He had a strong professional and personal interest in horse racing. At one time he employed eight handicappers whose tips filled the back page every day; each used a different "scientific" method. Despite the fact that he had these advisors on staff, the better part of his own income always seemed to end up with his bookie. I have little faith in crystal balls disguised as charts.

Newcomers to the art world, particularly those with faith in financial markets, are particularly susceptible to charting the fortunes of art and artists. For $5,000 a year they can subscribe to Art Market Research, an online service luring novice collectors with "free sample indexes." A glossy magazine started in 2010 uses a more sophisticated approach. The *Art Economist* combines noncritical profiles of artists with a monthly list of three hundred "top-earning" living artists, in order. The March 2011 issue offered "insight [regarding] iconic works that have jettisoned [*sic*]

Cattelan to a coveted spot among top yielding artists."[33] Of course, this has nothing to do with the actual incomes of the artists. The list simply totals auction results.

Consumer demand can be tracked and predicted accurately when what is being bought are many of the same, whether they are Honda Civics or Peruvian olives. The more dissimilar each item is, the less reliable the information for purposes of analysis. Collectors may look for works of art in categories such as, "I'd like to buy a van Gogh landscape," but what they actually buy is unique, like no other. With respect to a particular living artist, it may be interesting to know that people are talking about him or her, but this may reflect a strong marketing effort and have nothing to do with what is being bought and for how much, the full extent of which is only known by the artist and his or her dealer and not shared (other than in a general positive light) with art-market analysts. Self-generated buzz usually has a short life span and is insufficient, on its own, to sustain an artist's reputation. Also, what an artist makes tomorrow may be vastly different from what he or she makes today. In 1970, after becoming well-known as a card-carrying first-generation Abstract Expressionist, Philip Guston shocked the art world by unveiling new paintings that were ominous invocations of Ku Klux Klansmen and, at the time, attracted very few buyers.

BUYING ART IS AN ART, NOT A BUSINESS

Indexes and analysis flourish when the art market is at a peak, not unlike Sutter's Creek during the Gold Rush of 1848, which attracted not only prospectors but a greedy supporting cast of assayers, saloon-keepers, and prostitutes. There were two thriving newspapers until the staff of both headed for the hills with their pans. Called variously booms or bubbles, depending on your degree of optimism, upward trends in the art business create ancillary services that are adapted from other industries. In the late 1980s auction houses started to recruit business managers with MBA degrees. Before that the management of any department (Old Masters, English Furniture, Contemporary Art) was something the department head did if there was any time left over from persuading sellers to sell and buyers to buy. When the market softened in 1991, some of the busi-

ness managers were out of a job and again, in late 2008 Christie's and Sotheby's shed employees not essential to their core business.

People who start collecting art during a boom period may imagine that they have found a place with golden apples on every bough. They can buy paintings that will decorate their homes, impress their friends, and appear to go up in value on an annual basis, if not monthly. If they don't really like or understand art, they can put their money in an art fund and enjoy the ride—better dinner-table conversation than mutual funds. They can check the art financial pages to see how they are doing, indexes that look just like the Dow Jones, and most of the arrows are pointing up. And all of this with borrowed money. When the stock market drops, the system that supports and reports it stays in place, but when the art market slows down after a boom, many of the art funders, art lenders, art advisors, and art indexers look for other jobs, and it is left to the artists, art collectors, and art dealers to carry on until the next cycle picks up steam.

Many of the collectors who have the wealth to build great art collections have accumulated that wealth by dint of their acumen in various financial markets. While some employ advisors, few if any invest in art funds or make their collecting choices based on indexes. Having built a solid relationship of trust with an established dealer, they find out what is in the market privately, follow what comes up at auction, frequently visit galleries and museums, and generally participate in an eyes-on manner rather than by seeking guidance from statistics. As their tastes change or better examples of what they like become available, they may sell in order to improve their collection, but few will sell simply because value has increased.

I do not believe any buyer is immune from feeling pleased to find out that what he or she bought for what seemed a lot at the time is later worth multiples of their purchase price. For a true collector, however, that should be a bonus on top of the excitement and joy of looking for, looking at, and owning art, not the *raison d'être*.

In the 1960s more than a few artists made fun of the burgeoning art-investment fever. Where are they now that we really need them? Swiss artist Daniel Spoerri signed personal checks in the amount of ten Deutschmarks and sold them as works of art for twenty Deutschmarks.

California sculptor and all-around troublemaker Edward Kienholz made watercolor drawings with the price prominently stamped across their face (fig. 22). These were signed and dated but also certified by him with a visible fingerprint. The first buyers paid the face amount. Other drawings spelled out commodities (*One Dozen Eggs*), and the first owners paid the artist, directly, with that commodity for that drawing.

Updating this wry commentary is emerging artist Caleb Larson. His work *A Tool to Deceive and Slaughter* is a small black plastic box that the owner is expected to keep connected to the Internet. This work of art is programmed to list itself on eBay every week, forever. The first owner paid $6,350. Should subsequent sales provide a profit to the seller, the "device" pays Larson 15 percent.[34]

Fig. 22
EDWARD KIENHOLZ
For $132, 1969
Watercolor and stamped ink on paper in metal frame
12¼ × 16¼ × ½ in.
(31.1 × 41.3 × 1.3 cm)
The Museum of Modern Art, New York. The Judith Rothschild Foundation Contemporary Drawings Collection Gift (purchase, and gift, in part, of The Eileen and Michael Cohen Collection)

FOR $132.00

KIENHOLZ 69

ART APPRAISALS: PURPOSE AND METHOD

When your property taxes are assessed, you want the appraised value of your home to be low, but when you are applying for a home-equity loan, you would like it to be high. Your need for a particular evaluation of a painting in your collection is similarly dependent on the circumstances of whether you are selling or insuring, donating or inheriting. In fact, there is only one fair current market value that applies to all these circumstances.

Whether it is your buyer, your insurance company or the Internal Revenue Service, you or your appraiser have an obligation to justify that value.

First let us consider the different ways that dollar amounts are attached to works of art.

Gallery Price

You walk into an art gallery, see a video by newcomer Josephine Meckseper or a nude painted by Lucian Freud and ask the price. Whether the answer is $15,000 or $25 million, you have a right to expect that it is based on actual sales of similar works by that gallery or other dealers or at auction. If you are in a reputable gallery, they will be able to discuss why the work is priced as it is. Seasoned collectors practice raising their eyebrows in anticipation of saying, "That high!" before even asking for the price.

Obviously there is a profit margin to be considered when a dealer sets the gallery price, but experienced dealers know that asking a high price for a "B" painting might draw a crowd but rarely fools the market.

Many buyers of work by living artists in the primary market assume the gallery can discount the quoted price by 10 percent. This is not always the case. Such prices are agreed between the artist and the dealer, and they may consider the price to be appropriate and not negotiable. Buying something for less than a listed amount does not guarantee a fair price.

Today savvy collectors never say, "What is the price?" but "What are you *asking* for this?" signaling that if they do have a real interest they will make an offer. The more expensive an item, the tougher the negotiation, but there is no guarantee that the price will in fact drop. In the secondary market the dealer selling the work may have little control over the price because the work may be consigned by an owner not interested in negotiating. Conversely, the dealer might own the work and be content to wait until someone is prepared to pay what he or she believes it to be worth.

Auction Estimate

Virtually every work offered for sale at auction is accompanied by a published estimate. This is not a single value but a range, such as $800–$1,200 or $10–15 million.

The function of this estimate is twofold:

· To indicate to potential bidders what the auction house considers to be the value of the work based on their knowledge of the market.

· To protect the seller's reserve, which is the minimum price the auctioneer will accept as a bid. By law it cannot be higher than the low estimate (it is sometimes below the low estimate). The reserve is not divulged, but experienced bidders know it is unlikely that, competition aside, they can buy the work for substantially below the low estimate.

For unique, usually high-ticket, items the auction house prints, "Estimate on Request" rather than any specific figures. This means two things: one, they don't know what it will sell for; and two, whatever number or range of numbers they had in mind when the catalogue went to press is likely to change in the weeks leading up to the sale based on discussions with potential bidders. If a novice collector wants to request the estimate, he or she may be told, "At the moment we think it might bring $30 million." If a dealer or veteran collector makes the same request, the response might well be, "What do you think? How much will you pay?"

Once the catalogues have circulated, the auction house listens to what people are saying about their estimates, particularly what the core of potential buyers is saying. They also monitor how much serious interest is shown in each item. This may cause them to adjust their sights as the sale draws near. Good clients might be told that a certain work has so much interest that they should disregard the published estimate or, alternatively, make even a very low bid for another work because there is such little interest that the owner may have been persuaded to lower the reserve.

All in all these presale estimates cover such a wide range for any particular work of art that they are fairly useless from an appraisal perspective. It is the result that matters, regardless of what was printed or discussed before the sale. To add to the confusion there are actually three prices involved in every auction sale.

I. HAMMER PRICE: You stick your paddle up at $1 million for an exquisite still life by Bonnard at Christie's, and Christopher Burge's ham-

mer falls. The amount of $1 million is announced as the hammer price. In fact, this number is irrelevant because you, the buyer, will pay much more, and the seller will most likely receive less.

2. BUYER'S PRICE: The buyer has to pay all of the hammer amount plus what the auction houses call a buyer's premium, which sounds better than "commission" or "profit." This buyer's premium on your Bonnard will consist of 25 percent for the first $20,000 ($5,000) and 20 percent between $20,000 and $500,000 ($96,000) plus 12 percent for anything over $500,000 ($60,000), making your total bill not $1 million but $1.161 million. This is the price the buyer pays, plus any and all applicable taxes.

3. SELLER'S PRICE: Every catalogue published by Christie's and Sotheby's has pages of fine type that spell out "Conditions of Sale," mostly for the purpose of covering their potential liabilities. Buyer's premiums are spelled out in detail, but the seller is also charged a commission by the auction house, and this is not spelled out but referred to somewhat obliquely: "Once your property has been evaluated Sotheby's representatives . . . will provide information regarding seller's commission rates and other charges." In fact, the seller's commission is negotiable from a high of 10 percent plus charges for shipping and photography to just zero. For property of great value auction houses are prepared to waive the seller's commission, but most consignors do not fall into this category and end up paying between 6 and 10 percent of the seller's commission. The price received by the seller of the Bonnard, assuming the latter, is $940,000. Christie's total net on the sale is $225,000, which is 22.5 percent of the hammer price, 19.3 percent of what the seller is paid, and 23.9 percent of what the buyer received.

Fair Market Value

In the United States, when art is inherited, there is often a tax consequence, and when you give your Pollock to the Los Angeles County Museum of Art, your income tax may be reduced. In both cases the taxpayer is required to furnish an accurate appraisal of the fair market value at the time of inheritance or donation.

The IRS has its own Art Appraisal Service, staffed with professional appraisers, which is advised by an Advisory Panel of men and women from museums and art galleries. I have served on the panel since 2001.

According to the IRS, fair market value should represent the price that would be paid by a willing buyer to a willing seller. Whatever number is attached to the work by the taxpayer's appraiser, some evidence is required to back it up. Such evidence would be the identification of sales at public auction of similar works or copies of invoices from private sales by art dealers of similar works. Since the latter transactions are by name and nature private, most of the evidence furnished is auction-sale results.

A collector in California once boasted to me that a Cubist Picasso he owned must be worth $10 million because at the time Sotheby's had just sold a very similar work for that amount. He pressed me to agree with him, but I demurred; and finally, as diplomatically as possible, I pointed out to him that the work sold at auction was a large portrait of a woman, oil on canvas of sterling quality with an impressive provenance and in excellent condition. What my client owned was a small gouache on cardboard, an unresolved still life with significant restoration. In fact, what they had in common was the artist and date, little else.

No two works of art are absolutely identical, although prints and casts of the same sculpture can be so close that the appraiser has to use a combination of experience and information to interpret the available evidence of actual sales to arrive at an accurate fair market value appraisal.

Insurance Value

It is not uncommon to insure works of art with numbers slightly higher than fair market value, bearing in mind that depending on the type of policy you have, the insurer may, if there is a claim, argue that the insured amount is excessive.

The rule of thumb I have always followed when preparing an appraisal for insurance purposes is to identify the maximum amount that the owner would require to go into the market and replace the particular object. This is usually not more than 20 percent higher than fair market value.

Different kinds of insurance can be purchased for works of art. All are based on appraisals by professionals, but if there is a claim, either loss or damage, the amount that the insurance company is willing to pay may be absolutely fixed as the appraised amount, whether or not the value of the work has risen or fallen since the date of the appraisal; or the insur-

ance company may be able to argue in favor of less liability based on the (lower) market value of the work at the time of the loss or damage. In cases involving works of significant value, negotiation, mediation, and sometimes litigation become expensive and time consuming for both the insured and the insurer.

A frequent cause of contention is the percentage amount of lost value that occurs when a particular work of art is damaged in a particular way and competing experts are appealed to by both sides. A client of mine once foolishly attempted to attach a hanging wire to the back of his colorful painting by Miró and instead of inserting the screw eyes into the frame, he put them into the stretcher bar of the painting itself, and one protruded through the front of the canvas. However, it made barely a pin-hole at the extreme edge of the painting. A competent conservator could have easily made it undetectable to the naked eye, and no more than 5 percent of the value would have been lost. My client, nevertheless, chose to give the painting to an inept conservation studio that did a great deal of unnecessary work. They removed the painting from its original stretcher and lined the original canvas with a second canvas backing using a heat-based process that flattened the surface of the painting. In the end the painting was worth about 40 percent less than it had been. Often the degree that value is diminished cannot be ascertained until restoration is complete.

Insurance companies specializing in art coverage are familiar with all scenarios, and most claims are paid smoothly and quickly. But even Lloyd's of London can be scammed by the unscrupulous. I had dealings with an ophthalmologist from Brentwood, California, named David Cooperman who loaned a Monet and a Picasso to an exhibition called *Los Angeles Collects* at the Los Angeles County Museum of Art. Not long before, I had furnished him with an insurance appraisal indicating a value of $2 million for each work. He told the museum he wanted the works to be insured for a total of $20 million, which they did. Museums borrowing from private collectors usually insure at whatever amount the lender wishes, but their documents include strongly worded disclaimers. After the exhibition Cooperman presented only the first page of the loan form as proof of value when he asked his insurance company to increase the values for the two paintings. A little while later he reported that they

had been stolen. The LAPD called me the day after the theft because my name was on the original insurance appraisal and asked me what the works were actually worth. "We know he did it, but he's probably destroyed the paintings, and he'll get away with it," a detective blithely told me over the phone. Cooperman's insurance company paid up, and for a while, he did get away with it. Several years later the FBI recovered the paintings from a warehouse in Cleveland owned by a suspect they were tailing in an unrelated case. Cooperman went to jail, but the $20 million was long gone. The insurance company that accepted the phony appraisal was backed by Lloyd's of London, and the litigation between the two insurance firms lasted twenty years.

Accurate appraisals of fair market value or for insurance purposes can be obtained from the Art Dealers Association of America.

"Art, which should be the unique preoccupation of the privileged few has become a general rule; what did I say? A fashion; what did I say? A furor . . . Artist-ism."[35]

————

FÉLIX PYAT, 1810–1889

II | Euphrosyne

THE SOCIAL VALUE OF ART

Art is a provocation for many forms of social behavior, from the primitive to the sublime. I have witnessed the scene many times, the hunter holding his dinner guests spellbound (his wife less so) with his tale of trapping the elusive prey. Eventually it is sighted, then tracked for days or weeks on end. At the final moment all seems to be lost; but, no, skill and endurance win out, and the trophy painting is brought home to the acclaim of family, friends, and fellow hunters. As I smooth the snowy tablecloth, play with my dessert, and eye my watch, I imagine we are re-enacting the archetypal social event. We might as well be naked in a cave chewing a mastodon's rump around a roaring bonfire as Fred Flintstone embellishes the tale of its capture.

Less primitive perhaps, and more congenial, but to First-World sensibilities in the twenty-first century possibly too egalitarian, was a social event of 1285 celebrated in 1855 by Frederic, Lord Leighton's sensational seventeen-foot-long canvas *Cimabue's Madonna Carried in Procession* (1853–55, fig. 23). This painting shows a cross-section of local citizenry joyfully accompanying what is now known as the Rucellai Madonna (itself fifteen by ten feet) in its journey from the artist's studio to the Church of Santa Maria Novella. It would be hard to imagine such a degree of public interest in the installation of any commissioned work of art today; besides, insurers would probably insist that it not be carried on the shoulders of local notables. Leighton died in 1896, just before the subject of his greatest work was reattributed to Duccio.

Fig. 23
FREDERIC LEIGHTON
Cimabue's Madonna Carried in Procession, 1853–55
Oil on canvas
91¼ × 205 in.
(231.8 × 520.7 cm)
The Royal Collection

FIRST ENCOUNTERS

If we were lucky enough to have had parents or teachers who managed to convey a genuine enthusiasm for art to us at an early age, it is possible that regardless of what we do for a living or whether we can afford to collect art for ourselves, we are unafraid to duck into any museum or gallery and find something to enjoy. It is also likely that we will be drawn to the company of people with that same easy kinship with works of art.

On the other hand, many grow up without having been exposed in any positive way to art. Fearing they don't have the knowledge or language to understand and discuss it, they consciously or unconsciously avoid approaching art and the company of people involved with it.

My interest was inspired by Anthony Kerr, a fairly traditional painter of English landscapes who taught at my boarding school. At the age of twelve he divided those with any gift for making art from the rest, which included me. He sent us, "the rest," to museums and galleries with the simple instruction to find objects that interested us and to come back and tell him and the class what they were and why we liked them. Needless to say, this was a social activity. Going to museums meant a day of freedom in London, and that was fun in itself. We chose whom we went with, so the company was friendly. We shared our interest in the classroom when we got back, another social experience. Kerr never quarreled with our choices—only the quality of our scrutiny. Little did I know at the time that these pleasant experiences punctuating my "real" education initi-

ated an interest that not only provided me with a career but a life filled with fascinating people.

There are many whose introduction to art is not so fortunate. Collectors have told me that they hated art in college and were completely baffled by it, particularly modern and contemporary art. What made them change their minds? How come one day they got it? The answer often involves social contact such as, "This cute boy asked me for a date and took me to a museum."

In the very early 1960s the art-book publisher and well-known collector Harry Abrams had a friend in the publishing business, John Powers, who ran Prentice-Hall. Harry loved contemporary art almost as much he loved proselytizing. He became determined to share his passion with John, who was at first nonplussed by modern art. Exasperated, Harry sent a group of large, colorful paintings by Alfred Jensen to John's office as a long-term loan (fig. 24).

Some time later, visiting Prentice-Hall, Harry saw the paintings, still wrapped, in a corridor. "I don't know where to put them," said John, but actually he had plenty of space; he just didn't particularly understand them.

Harry grabbed the paintings, found the company cafeteria, and hung them himself. "The result was amazing and immediate," John told me many years later. "Everyone in the company had an opinion; some liked them, some loathed them, some were puzzled, and some were delighted. But everyone spoke up, and the effect on morale was great. Overnight I became a convert to the power that art has to move people and to bring them together." John Powers, with his wife, Kimiko, became one of the great early collectors of work by Johns, Rauschenberg, Warhol, Rosenquist, Oldenburg, and many others. Just as important, he in turn became an untiring apostle for contemporary art, particularly in the business community. He even tried to convert his own mother with me as the instrument. I barely had two feet in the business myself, but John persuaded me to devote every other Wednesday morning to taking his mother and her two elderly friends to museums and galleries. We had great fun and talked about everything under the sun, sometimes even what we were supposed to be seeing. This was before the invention of the single greatest deterrent to the understanding and enjoyment of art, the recorded lecture. Instead

of friends and strangers enjoying works in museums, turning to each other in agreement or disagreement, making up their own minds and expressing their own ideas and opinions, I now see tribes of zombies clutching audio guides. They shuffle from one "selected for audio" painting to another, diligently soaking in the words ghostwritten for the museum's director (or better still, a well-known actor) to record. I was visiting an exhibition and talking to a curator in the galleries when he was aggressively shushed by a visitor trying to listen to the man's own taped tour. Served him right. As I was navigating from finish to start (often the best way to see a crowded exhibition) the exhibition *Picasso: The Early Years,*

Fig. 24
ALFRED JENSEN
The Integer Rules the Universe,
Per II, The Positive Sure Draws
the Negative, 1960
Oil on canvas
75 × 49 in. (190.5 × 124.5 cm)
Private Collection

1892–1906 at the Museum of Fine Arts, Boston, I saw an elderly lady swirling around and shouting above the sound of her audio guide to her friend, "I've no idea what I'm supposed to look at, but it sounds good."

In February 2011 the Metropolitan Museum of Art announced it was venturing into the field of "visitor engagement," which apparently means wiring itself for Wi-Fi "so that patrons will eventually be able to read and watch videos about art museumwide on their phones and tablet computers."[36] So very much more entertaining than looking at motionless and silent paintings on the walls.

Nothing beats the real thing, and those of us fortunate enough to have been dragged or sent to museums when we were children at least had the opportunity to see art in the flesh, as opposed to printed illustrations, slides or, even worse, online pixilated images. Stipulating that

he did not want works from his collection ever reproduced in color, the eccentric Philadelphia collector Dr. Albert Barnes sought to prevent people from confusing printed with painted color. No matter how skillfully engineered, the true color, texture, and scale of a work of art can never be faithfully reproduced on paper or computer screen. Learning about art without experiencing the object itself is as futile as trying to learn to play baseball from watching television and never touching a bat, ball, or glove. You can get the general idea and some of the principles, but you will never have any idea of how it feels to play. When I stand or sit with a painting, sculpture, drawing, or print, or particularly if I wander through a museum's permanent collection or curated exhibition, I am a first-hand witness. The thoughts and feelings that come to me are more powerful and complex than if I am sitting at home with a book or at my computer staring at a simulacrum.

Ideally interest in art starts with a social experience. The very privileged few might, as youngsters, have engaged in conversation around the dinner table about the family's latest acquisition. More than likely you were taken to a museum as a class outing in either primary or middle school. If you had a particularly engaging and talented teacher, a spark might have been lit then and perhaps smoldered for many years before your interest ignited in later life. Teachers themselves uninterested in art or lacking faith in the ability of students to think for themselves can make art into something baffling or boring for the rest of the student's life.

The interaction between a teacher and a group of students is essentially social, as is the interaction among the students themselves. For the properly managed class clustered around a painting or sculpture in a museum, the art can come to life. Reduced to a recitation of facts and other people's opinions, it can die.

Visiting the permanent collection of the National Gallery of Art in Washington, D.C., I came upon several groups of mid-teen students in groups of four or five, standing adjacent to, but not looking at, various individual works of art. They were in uniforms, and I pegged them as private-school students. Two teachers were circulating between the groups monitoring their activity. Curious, I feigned interest in one of their selected paintings, listened, and watched. It was apparent that one

student in each group had been given the task of preparing a brief talk about the work.

The speaker mumbled haltingly through an agonizing litany of biographical facts and art historical clichés, her listeners shuffled, looked at their feet, and rarely, without any apparent interest, glanced at the dynamic, shockingly vivid, and violently colored early painting by Wassily Kandinsky on the wall in front of them. I cannot imagine a better way to ensure a lifelong lack of interest in art and museum-going.

A couple of years later I found myself moving through the galleries at the Seattle Art Museum and ahead of me heard very young voices raised in excitement. Turning a corner, I saw about twelve eight- and nine-year-olds cross-legged on the floor in front of a large painting by Rothko, rectangular fields of glorious color. To the side was their teacher, a young woman who was trying to get the highly vocal children to talk one at a time. Why were they so excited? She was asking them a series of simple questions:

> What do you see?
> What does it look like?
> What does it make you think of?
> How does it make you feel?

The kids were having great fun competing to express their ideas about the painting. They were not using artspeak, and I don't think they had any idea about who painted it, when it was done, or what it was called. They had no need: they were completely engaged, fully enthralled.

Other than in our own homes we are rarely alone with a work of art, and because we are essentially social beings whatever we take away from looking at a work of art becomes validated when we communicate that with someone else, whether they agree or not. Alone in another city, killing a couple of hours at the museum, we see something outstanding, something that speaks to us; and we take a photograph of it or buy a postcard, as a memento but also to remind us to share the experience.

More often we visit with a friend, spouse, parent, or child. I pull my daughter toward my favorite Matisse, and she just wants to look at the weird Dalí. My wife, an artist, often sees the structure of a work of art much more clearly than I, and I find this exciting and engrossing. Some-

thing I rave about she barely looks at, and then she spends minutes star-
ing at a work by an artist I always overlook. We talk, and learn.

FAMILY, LEGACIES, AND THE PERSONAL MUSEUM

Sometimes an individual's passion for collecting may not only change
his or her own life, but it can determine that of his or her children. Born
in 1896, Sidney Janis was a successful shirt manufacturer who designed
a two-pocket short-sleeve shirt that became extremely popular in the
1920s. With his wife Harriet he developed a passion for modern art, and
in 1948 he sold his business and opened a gallery that quickly moved to
the top of the field exhibiting, and at various times representing, Pol-
lock, de Kooning, and other leading Abstract Expressionist artists—and
a decade later some of the next generation, including Oldenburg, Dine,
and Wesselmann. He was succeeded in the business by his children and
grandchildren. Like many highly successful art dealers, he built a personal
collection that rivaled that of his clients. Unlike the collectors who seek
immortality by building their own museums or who insist that existing
museums build eponymous galleries to house their collections, Sidney
and Harriet gave 103 works from their collection to the Museum of Mod-
ern Art in 1967 with few strings attached. His trenchant definition of a
true collector was "a man who has to buy paintings whether he can afford
them or not."[37]

Some consider themselves lucky to have been born into collecting
families, but others resent competing with works of art for their parents'
attention. Later this resentment may be mollified when the collection
is inherited. Wise collectors involve their children in what they do, visit
galleries, and talk to dealers together, and even take them to auction sales.

One thing that a collection guarantees is attention. Aging collectors
may have outlived their friends and live far from their grandchildren,
but they will always be assured of frequent visits from curators, dealers,
and auction-house people, whose motives may be mercenary but who
are willing to listen over and over again to the well-polished stories about
meeting famous artists and legendary gallery owners.

One way that a wealthy individual can attempt to survive the vicissi-
tudes of history is to fund a gallery within a noted museum or even create

his or her own museum. John Paul Getty, whose eponymous institution opened in 1954, put it succinctly: "I would like to be remembered as a footnote in history, but as an art collector, not a money-laden businessman."[38]

California seems to spawn such mauso-museums: Occidental Petroleum founder Armand Hammer and the canned foods magnate Norton Simon both established institutions in their own names in the Los Angeles area. The establishment of such institutions is often preceded by a lengthy and elaborate courtship with one or more existing museums that try but eventually fail to promise enough to satisfy the donor's cravings for immortality. Financier Eli Broad built the Broad Contemporary Art Museum as the centerpiece of the Los Angeles County Museum of Art after indicating that he would give the museum the bulk of his extensive collection. In January 2008, one month before it opened, Broad decided to retain permanent control of his works. His reason was his desire to have all of his collection on view all of the time, one frequently made by collectors who build their own museums. Few major institutions, if any, will accept such a stipulation for a gift, regardless of how lavish and desirable, because they want the flexibility to lend works to other museums for specific exhibitions and to change the installation of their permanent collections.

Some collectors build museums in their own names in an attempt to guarantee a favorable review of their lives. Henry Clay Frick delivered the Frick Collection on Fifth Avenue in New York to posterity—a wonderful small museum, formerly his home, filled with great objects and great art. Thus, we might forget the shooting death of seven unarmed striking steelworkers in Pittsburgh in 1892 at the hands of Frick's three hundred hired guns, or even his own death from syphilis. Of a slightly different order was rayon magnate Samuel Courtauld's gift to the British nation of his home and collection of French Impressionist and Post-Impressionist masterpieces. Though he required less absolution than Frick, he also established an acquisition fund for the Tate and the National Gallery. Courtauld was a quick study, as evidenced by the fact that his shopping days were relatively few: he made most of his amazing purchases in just six years, between 1923 and 1929.

One great institution founded in 1937 with the gift of a personal collection modestly eschews the name of the donor. Andrew Mellon pointedly

asked that his name not crown his collection so that others collectors would not be deterred from giving to what is now the National Gallery of Art in Washington, D.C. His son and daughter, Paul Mellon and Ailsa Mellon Bruce, continued this philanthropy, adding to the collection throughout the twentieth century.

In the first decade of the twenty-first century an unprecedented number of personal museums are at various stages of planning and completion, not only in principal cities that can deliver an audience (Paris, New York, London, Venice, Moscow, Lisbon, Miami) but also in regional areas like Bentonville, Arkansas, where Wal-Mart heiress Alice Walton has housed her growing collection of American art in a museum set in vast parklands, whose cost the *New Yorker* reported as "more than a hundred million dollars."[39] Likewise, in Wolverhampton, England, contemporary collector Frank Cohen invites the public to see his cutting-edge contemporary art in two prefabricated sheds. Emblazoned with the donor's name or not, all such philanthropy ultimately serves a social purpose.

Not all bids for immortality survive the judgments of future generations. The aforementioned Albert Barnes, a patent-medicine mogul, collected many great paintings by Cézanne, Gauguin, Modigliani, Monet, Renoir, Seurat, van Gogh, and others; and in 1922 he built a small museum for his collection in a world-class arboretum next to his home in Merion, Pennsylvania. He left specific instructions that the museum should be used primarily as a school, that works should never be loaned out and be photographed only in black and white and that certain academics and professionals be barred from visiting. After much controversy both in favor of and against change the Barnes Foundation has moved to a more central location near the Philadelphia Museum of Art. Although in the new modern building, opened in 2012, the works are displayed more or less as they were before, access will be granted to all who pay the price of admission and, for better or for worse, the philosophy of the author of the institution, hailed by Matisse as "the only sane place"[40] in America to view art, will be extinct.

There is currently great sympathy for the notion that all works of art not privately owned should be made available in big-city museums presented to the public in well-lit galleries on tastefully colored walls with suitable explanatory labels. The appeal of this system is obvious:

it seems to be democratic; the work of art can be explained, and a wide audience reached. Most important, an argument that usually wins out is that only a big museum can afford the climate-control maintenance and conservation care that a great work of art surely needs to be preserved for posterity.

In bygone times individuals, sometimes including the artists themselves, gave works of art not to museums but to schools, universities, and even churches. In some recently celebrated cases the value of these works increased to the point that they have sorely tempted the overseers of certain institutions when they became strapped for cash. The scenario is a familiar one:

· The owner institution with great regret puts its treasure on the market, citing an inability to meet the rising costs, and says that the funds received will be well spent.

· A named or unnamed collector, out-of-area (Japan, Arkansas), declares interest, cash in hand.

· The ensuing furor sells newspapers as local pundits and the press loudly lament the loss to the neighborhood (town, city, state, country).

· An attempt is made to raise funds so that the great work or collection can be kept in the region.

What happens next is that either the private collector gets the work (cries of "Shame!"), or a museum raises the money to buy the work. If it is bought by a museum, local or out-of-state, the argument is made that it is available to a larger public than if it were bought privately or were to remain in the school or church to which it was given. Everyone wins: the school gets millions of dollars to spend on sports equipment, and the work of art gets to be seen by the public. Wait a minute. What about the intentions of the original donor?

Thomas Eakins's masterpiece *Portrait of Dr. Samuel D. Gross (The Gross Clinic)* (1875, fig. 25) was purchased for $200 by Jefferson Medical College in Philadelphia in 1878, and for 129 years could be seen by anyone interested enough to visit. The College had allowed Eakins to study anatomy and witness operations, and there is clear historical evidence of a strong relationship between Eakins and Dr. Gross. In 2007 the College announced that it would sell the painting to Alice Walton for her Arkansas museum for $68 million. A heroic effort by Philadelphians, led

Fig. 25
THOMAS EAKINS
Portrait of Dr. Samuel D. Gross
(The Gross Clinic), 1875
Oil on canvas
96 × 78 in. (243.8 × 198.1 cm)
Philadelphia Museum of Art.
Gift of the Alumni Association
to Jefferson Medical College
in 1878 and purchased by the
Pennsylvania Academy of the
Fine Arts and the Philadelphia
Museum of Art in 2007 with the
generous support of more than
3,600 donors, 2007

by the late Anne d'Harnoncourt, director of the Philadelphia Museum of Art, raised this amount so the work could remain in Philadelphia, albeit no longer at Jefferson Medical College but seven minutes' drive away at the Philadelphia Museum of Art.

In 1949 Georgia O'Keeffe bequeathed 101 paintings, including works by Picasso, Cézanne, Renoir, Charles Demuth, John Marin, Marsden Hartley, and herself, among many others, to Fisk University in Nashville, Tennessee, a small private college that promised O'Keeffe, who died in 1986, that it would keep the works in perpetuity. Struggling financially, in 2005 Fisk asked judicial permission to sell one of the works by O'Keeffe and one by Hartley, the pair valued at over $20 million. Immediately the O'Keeffe Museum in Santa Fe sued to stop the sale and then later

promised to drop the suit if it was permitted to buy the O'Keeffe for $7.5 million. Then Alice Walton's Crystal Bridges Museum proposed to give Fisk $30 million for possession of the entire collection six months of every year. That amount will be surely put to good use by Fisk, but the students lose the possibility of having great paintings quietly become part of their daily lives, a fiscally unquantifiable benefit to generation after generation. The argument is often made that works of art not in major museums are hidden away. The fact is that most of the works sold by schools and colleges in the last decade were available for viewing, at no cost at all, by members of the public.

Now and in the recent past individual works of art and occasionally entire collections are donated to museums, be they world-class institutions like the Los Angeles County Museum of Art or specialized college museums like the Rose Art Museum of Brandeis University. Possibly more than those in any other collecting nation, Americans are extremely generous in this respect, encouraged by the tax code and a workable system vetting the fair market value of gifts. The relatively small amount of tax relief that is given to the donors is vastly outweighed by value of the works that become, in effect, owned by the public. Responsible museums only accept works they need and want to exhibit and, in most cases, do not themselves have the funds to acquire. Every so often the system is buffeted by politicians who see it as favoring the wealthy. At the time of writing, the issue of fractional giving is being disputed. This device allows a collector to donate to a museum a specific percentage of the value of a work of art each year, while the work remains in the collector's home. One aspect of the Internal Revenue Code considered by most artists, collectors, dealers, and museum directors to be unfair is that when an artist donates a work of his or her own, the maximum tax deduction is the cost of materials, rather than the work's fair market value.

Depending, as many museums do, on continually upgrading their permanent collections by way of gifts, they can be aggressive in identifying prospective donors, declared or otherwise. Museum trustees are often chosen for the good they might do when they die, as much as for what they can contribute in acumen and fundraising while they live. Museum directors and curators invest a significant amount of their time courting collectors who might become donors, not only inviting them to private

lunches and dinners but in some cases advising them as they continue to collect. While this is obviously an advantage for the collector, there is often a very long-term advantage for the museum, which expects to receive in the future what the collector buys today. It is not uncommon for there to be a specific understanding between the curator and the collector that the collector will only buy, for him- or herself, what will one day be added as a needed work to the museum's collection.

IMMORTALITY IN AN AUCTION CATALOGUE

In fact, you do not even have to keep your works and found a museum to use art to burnish your social image in life or even after death. Auction houses lure collectors or their heirs to sell with the promise of a hard-cover catalogue extolling not only the works of art but the collector's depth of knowledge, wisdom, and perspicacity. More often than not these catalogues are posthumous, and the flattery is designed to mollify the greed of dry-eyed children and grandchildren looking forward to buying a second (or third) home with the proceeds of the sale. I am guilty of having penned more than my fair share of these paeans of eye-glazing flattery. But sometimes this unheralded prose form yields bracing honesty. As Alfred H. Barr Jr. wrote about the collector G. David Thompson in Parke-Bernet's catalogue for the sale of Thompson's collection in 1966:

> One would like to write of his insistent generosity and unpredictable naughtiness, his elaborate jokes, his shyness, his recalcitrance, his warm kindness toward his friends, and the cool anger and ingenuity of his assaults upon the grey ramparts of Philistia.[41]

One remarkable instance of using the auction catalogue as payback for a mother's perfectionism was the essay published by Sotheby's in May 2005 when it sold important paintings and sculptures by Matisse, Giacometti, Picasso, Miró, and others from the Estate of Mrs. John A. Cook. Her daughter Mariana Cook wrote:

> In the evening I would keep my mother company during "cocktail hour" while we waited for my father to come home from work. I wasn't allowed to touch the table surfaces in the living

room because I might leave fingerprints. And, in that world of a
certain degree of privilege, I wasn't allowed to sit on the couches
because the cushions were filled with down feathers and if the
maid were asked to "plump" them up too often, she might quit.
It seemed quite natural, then, to sit on the carpeted floor one
evening and train my cat to climb a sculpture. No plumping, no
fingerprints. . . . Dad joined us for dinner and there was often talk
of when a certain work of art would be arriving from Paris, Lon-
don, or 57th Street. It was intriguing how "messy" these works
of art were. . . . Paint was sometimes clumped on top of itself.
When any given piece was delivered at last, my mother would
vanish, leaving my father and me alone to place the new arrival
in the apartment, a disorganizing occasion which my mother
couldn't stand.[42]

ARTISTS, DEAD OR ALIVE?

Dead Artists and Social Value

The enduring nineteenth- and twentieth-century myth presents the
stereotypical young artist abandoning his bourgeois home and despairing
parents to paint furiously and share a bohemian slum with a doe-eyed con-
sumptive model and, after a few years of suffering and colorful wanton-
ness, die in dramatic fashion. Immediately his paintings are acclaimed for
their blazing novelty, and Hollywood buys the story (Gauguin, van Gogh,
Modigliani). The alternative ending, not as dramatic but possibly health-
ier for the artist, is that he marries his mistress, builds a dream house in
the country, and is lionized by society (Bonnard, Monet, Picasso).

Whether society shuns or embraces the artist in his or her lifetime, we
can be sure that if the artist's work enters the history books, he or she,
once dead, headlines exclusive invitations. From private dinner parties
designed to show off one recent acquisition to star-studded exhibition
openings at grand museums, works of art become excuses for social inter-
course that most of the participants would like to consider on a higher
cultural level than their block-association street party or Thanksgiving
with their relatives. In fact, as I can bear witness after having attended
legions of such events, the social intercourse itself is rarely on a par with

the quality of the works of art, nor does it usually have much to do with them beyond some general flattering comments. Few museums now allow drinks in the galleries, so the actual experience of looking at the show is usually rushed in favor of cocktails, smoked salmon on toast points, and a chance to switch the place cards at your dinner table. Conversation between dinner partners, whether friends or strangers, is likely to be more about gossip, children, or travel than profundities about art. Because openings are essentially social in nature, it is quite acceptable to say: "I didn't have time to see the paintings. I'm going to come back next week and really look."

Dinner is usually punctuated by speeches from the podium that vary in quality and length, usually commencing with the CEO of the sponsoring corporation, after which the museum's director asks for money. Occasionally there is a star turn. When the Museum of Modern Art mounted a retrospective of the Norwegian artist Edvard Munch in 2006, it was launched by Queen Sonja of Norway, whose informed and engaging ability to lecture about art will stand her in good stead in the event of a *coup d'état* in Norway.

Many big-time, black-tie art-world events are in fact enabled by the US government because it encourages tax-deductible contributions by wealthy patrons who pay handsomely to rub elbows with each other in what today passes for an upper crust. The opening of a new museum or a new wing of an old one in any community across the country will provoke a frenzy of gown-buying and cufflink-polishing by the local high rollers. A new museum in a major center will often require imported guests of distinction. When the San Francisco Museum of Modern Art's new building opened in 1995, trustees from major institutions across the country enjoyed a week of daylong and evening activities. The local collectors, justly honored for their well-sung contributions to the cost of the museum, opened their homes to the visitors in genial competition with each other, and Christie's sponsored the fleet of coaches that drove the visiting eminences from Rothkos and champagne to Warhols and caviar. The coach I was tour-guiding was briefly stuck at a hairpin bend in Napa Valley, and the driver was treated to gratuitous instructions shouted from the rear by a billionaire East Coast hedge-fund mogul whose soon-to-be ex-wife just as loudly contradicted him.

Not everyone, even among the wealthy, approves of anointing arts patronage with social elevation. Billionaire William H. Gross grumbled thus: "When millions of people are dying of AIDS and malaria in Africa, it is hard to justify the umpteenth society gala held for the benefit of a performing arts center or an art museum. A $30 million gift to a concert hall is not philanthropy, it is a Napoleonic coronation."[43] In the United States, however, there is no shortage of philanthropy for medical cures (with all the attendant gala awards ceremonies, of which I attend my fair share); and I believe art is an essential part of our society, one of the things worth saving lives for.

I am not sure who or what is able to measure the relative prestige of social gatherings but park conservancies, tropical diseases, and first nights at the opera rarely trump a gala museum opening for a high-ranking dead artist. Ever mindful not only of their elevated social standing as venues but also fishing for new patrons and maximizing the financial returns on their often awe-inspiring interior spaces, many major museums make themselves available for social events that have little or nothing to do with the arts. Corporate patrons of the Metropolitan Museum of Art may, for a healthy fee, hold events in the galleries. One highpoint of former President Bill Clinton's Global Initiative Conference in New York in September 2007 was an evening reception at the Museum of Modern Art. Past and present heads of state mingled with the richest individuals in the world. At that same opening of the new San Francisco Museum of Modern Art in 1995, I dined in the towering but empty rotunda designed by the noted Swiss architect Mario Botta and naively asked my dinner partner, a new trustee of the museum, why there were no works of art in the space: "Oh my dear," she said, gently fingering her 11-carat D flawless, "this space is for private parties, charity balls, and stockholder meetings, not art."

Fifteen years later, in January 2010, I witnessed the complete maturation of this process when I attended the opening of the curatorless Art Gallery of Alberta in Edmonton, Canada. The museum's staff listing designated one individual as both deputy director and chief curator, but the vast majority of staff titles were managerial, involved with technicalities of marketing and administration.[44] Outsourced (i.e., rented) exhibitions fill moderate spaces secondary to areas for eating, drinking, and shopping. At the gala opening "This Space Can Be Available for Your

Event" signs abounded, even in the boardroom and on the space-hogging sweeping central staircase—perfect for the bride to descend. I overheard a trustee boast, "Weddings are booked six months ahead."

The Social Life of Living Artists

The first time an artist, starving or otherwise, receives a visit from a prospective collector, the anxiety level is usually high on both sides. "Am I at work when they arrive?" says the artist to him- or herself. "Do I brush my hair? Should I clean the bathroom? Will they want coffee? What if they take one look and walk out? What if they ask prices?"

The collector, if new at the game, will be thinking: "This is a mistake. What can I say if I don't like anything? If I like something should I make an offer? What if I say something stupid? How long do I have to stay?"

Some artists, perhaps to their credit, never become social beings, even when successful. They prefer the company of their family or friends and rarely appear at public events; sometimes this includes their own openings. They cannot or will not sell themselves and often exist happily behind a reputation for being difficult. In the mid-1960s the British painter Bridget Riley was received rapturously in New York; her dazzling black-and-white paintings were tagged "Op Art," and their images were misappropriated for everything from paper napkins to couture dresses. Appalled and dismayed, she fled back to London and confided to me that rather than becoming a public entertainer, she would, quoting James Joyce, prefer "silence, exile, and cunning." Quite a few artists manage some form of this to the end of their lives. I can think of Cézanne, Munch, Clyfford Still, Joseph Cornell, and in our own time Johns, Freud, and Bruce Nauman. These, like others, have achieved a reputation for being reclusive simply because they make an effort to maintain a degree of privacy in their lives and don't accept every call for an interview or dinner party or because they choose to live and work far from the madding crowd.

Other artists, who once quaked before their first studio visit, eventually wind up in black tie, back against the wall, a glass of warming Chardonnay in their hand, staring at their hostess's sharp whitened teeth.

One artist not often seen at social events was nevertheless a veritable Dale Carnegie when it came to one-on-one sales opportunities. Un-

questionably a first-rate sculptor, Henry Moore made a fortune from Americans visiting his studio and home at Much Hadham, deep in the English countryside (fig. 26). I was duly impressed the first time a collecting couple with a huge Moore sculpture in their garden in Allentown, Pennsylvania, reverently displayed for my benefit snapshots of themselves visiting the artist in the 1960s. "He was so kind and down-to-earth," the wife told me. "We had a wonderful meal, very English, fresh farm food." They paused, thinking back to the magical day they had spent tramping across the fields with the great man inspecting his well-placed reclining figures scattered across the moors. "The most wonderful thing," said the husband, "was that he *allowed* us to buy one of his favorite pieces." (my emphasis). The fifth time I heard the same story and saw very similar snapshots, I came to realize that smart art dealers in London and New York should be taking sales lessons from that genial Yorkshireman living in Hertfordshire.

By and large, until late in the twentieth century, artists and collectors only mixed at carefully orchestrated events at which either the collector, the artist's gallery, or a museum was the host. Rarely did the collector socialize with the artist on equal terms. There were exceptions. Born to

Fig. 26
HENRY MOORE
Sheep Piece, 1971–72
Bronze
Height: 224½ in. (570 cm)
Henry Moore Foundation,
Perry Green, Hertfordshire,
Great Britain

Fig. 27
**DOUGLAS COOPER
DINNER PARTY**
At the Château de Castille,
c. 1965. From left to right:
Zette Leiris; unknown;
Lauretta Hope-Nicholson;
John Richardson; Douglas
Cooper; Pablo Picasso;
Francine Weisweiller;
Jean Cocteau; Michel Leiris;
unknown woman; Jean Hugo
Unknown photographer

wealth in England, Douglas Cooper (1911–1984) spent one-third of his inherited fortune before he was thirty purchasing Cubist masterpieces by Picasso, Braque, Gris, and Léger. By 1952 he had established himself and his paintings in an eighteenth-century château in the South of France with Léger as his first house guest. Picasso was a near neighbor and close friend. Flamboyant, intelligent, and irascible, Cooper had a wide circle of friends and acquaintances, ranging from these artists and others, including André Masson and Nicolas de Staël, to the Queen Mother and the eminent art historian and accused Soviet agent Sir Anthony Blunt (fig. 27).

In the 1960s in New York, by and large collectors and artists did not mix socially. The postopening party for an emerging artist at an uptown gallery was often held in Chinatown or a Greek restaurant, where a lot of people could be fed and become inebriated inexpensively. Most of the guests were friends of the artist, perhaps fellow artists, writers, family, and hangers-on who had contrived to stay at the opening long enough to find out the name of the restaurant. Tuesday evening was the night for these events, and dealers like myself sought to get clients in to our gallery that day so that perhaps one or two works would be already sold when the show opened. More collectors would come, some with their families, the following Saturday.

Now, fifty years later, the right to drop the first name of a fashionably successful artist is a passport to social acceptance by wealthy collectors of contemporary art. Conversely, artists who aspire to public careers rather than private vocations consider invitations to dinner parties in collectors' homes as intrinsic to their well-being as their summer studio in Sag Harbor.

Since 1945, artists gradually have become more interesting to the mainstream media, and their names are known beyond the art world. In May 1972, I gave a birthday party for David Hockney in my SoHo loft. He was thirty-five, and his transformation from bottle-blond *enfant terrible* to paid-up member of the art establishment was well under way. He was celebrating a sold-out solo exhibition at the André Emmerich Gallery. Because I had friends in the fashion world as well as the art world, the party occasioned a lengthy photo-story in *Women's Wear Daily,* then the journal of record for Manhattan's social whirl.[45]

In the 1980s the next generation of artists and dealers perfected a fusion of entertaining and marketing with glamour as the glue. The exploits of Julian Schnabel, Ross Bleckner, Eric Fischl, and their dealer Mary Boone made hot copy, and their parties were the place to see and be seen. As success came to these and other eighties artists, their studios were featured in "shelter" magazines, and they and their life partners, wives, husbands, and girl- and boyfriends posed for fashion photographers. Twenty years later the full circle is reached when the Tony Shafrazi Gallery in Chelsea landed a painting by Basquiat on the cover of the Sunday *New York Times.*[46] The actual painting is not identified because it is simply a backdrop for a model wearing fashion designer L'Wren Scott's "gold lace dress with a bustle back" at the unveiling, in the gallery, of her new couture collection as part of New York Fashion Week.

Throughout the twentieth century fashion courted art, famously when Elsa Schiaparelli enlisted Dalí in the design of the infamous "Lobster Dress" for Cecil Beaton's official prenuptial photo-portrait of the Duchess of Windsor in 1937, the flame-red crustacean placed strategically between her legs (fig. 28).

Many artists, like Riley, have vociferously spurned identification with the so-called rag trade. Barnett Newman angrily protested when a fashion magazine asked if it could reproduce a large red canvas in a feature

about the artist but instead used it as a backdrop for fashion models in matching red dresses. Other artists are profoundly flattered at the attentions of the fashion business. Takashi Murakami and Robert Wilson design for Louis Vuitton; Tracey Emin, for Longchamp. "Working with Louis Vuitton definitely challenged my aesthetics," neo-1960s artist Julie Verhoeven happily confessed; and Andrew Nairne, director of the Museum of Modern Art, Oxford, a respected small museum, likened Richard Prince designing handbags for Vuitton with "Picasso . . . when he began making and painting ceramics."[47] While presumably some people

Fig. 28
ELSA SCHIAPARELLI,
in collaboration with
SALVADOR DALÍ
Woman's Dress, February 1937
Silk organza, horsehair
Front length: 52 in. (132.1 cm),
waist: 22 in. (55.9 cm)
Philadelphia Museum of Art
Gift of Mme. Elsa Schiaparelli,
1969

collect fashion items designed by artists with an eye to greater future value (good luck!), and the artists themselves are well-rewarded financially, the marriage itself between art and fashion is celebrated socially with a constant round of semi-public promotional events and private dinner parties involving artists, fashion designers, and the attractive people who swim close to both. The wheels are oiled by über-collectors like Bernard Arnault, who owns Louis Vuitton and presumably is in a win-win-win situation when artists whose work he owns pair with fashion designers he owns and the result is a promotional party that *tout Paris* applauds.

Warhol deserves a great deal of the credit for transforming the public image of the rebellious American artist from that of unkempt social pariah (Pollock peeing into a marble fireplace at *Nation* critic Jean Connolly's party in January 1944) to that of society's darling.[48] Warhol was able to make himself the center of attention even as a fey young fashion illustrator cadging freelance work from the dragon ladies of Seventh Avenue.

When his first paintings of Campbell's soup cans made him a *succès de scandale,* he continued to shock with his filmmaking ambitions and eschewed the drawing rooms of the Upper East Side in favor of Max's Kansas City and the downtown clubs where his multigendered young superstars liked to frolic. His reputation then was that of a somewhat sinister Pied Piper. The phone rang in my office on June 3, 1968, during a gallery party; the call was from the artist Robert Indiana: "Michael, something terrible has happened," he said, "Andy has been shot; he may die." The aforementioned collector Robert Scull, owner of many Warhols, was standing next to me and must have seen the look on my face. "What's the matter?" he said. I repeated Indiana's words to him. His reaction was not immediate, and I could feel him processing the information to decide on his position. Finally he picked up his glass and sighed, "It's his own fault, running around with that drug crowd," and he moved on. Within a few years most of the drug crowd were gone from Warhol's life. Some died, others wore out, a few went more or less straight, and by the early 1980s, from Venice, Italy, to Venice, California, a seat next to Andy at dinner became the social brass ring.

Of course for both the artist and the collector there is a vested financial interest in establishing and maintaining a strong social bond. The artist would like to be assured of sales throughout a lifetime during which his or her popularity may wax and wane, and the collector who is deeply committed to the work of a particular artist would like to have a first-in-line position for new work. Between them stands the dealer, who is now often the orchestrator of such social connections, which he or she manipulates with events ranging from carefully seated multicourse black-tie dinners at home to more raucous but no less carefully invited summer beach clambakes, dogs and small children included.

SHOWING OFF AT HOME

A prominent collector once told me that when she visited other collectors for dinner, she always asked to use an upstairs bathroom because she wanted to see what art they had in their bedrooms. "People who are serious about art have what they really like where they will see it the most," she said. "If all the best art is in the living room, they are just in

it to show off." In my experience the show-off paintings are often in the dining room opposite the seated guests.

Not all great works of art are in gracious homes, by any means. Billy Wilder's modest Brentwood apartment had amazing paintings and drawings crammed cheek by jowl on every wall. More were stacked on the floor under the bed and even behind the bathtub—a lifetime of amazing buys, from Egon Schiele drawings acquired in Berlin just after World War II to recent works by Hockney.

Very different, but close by, the Beverly Hills home of Edith Mayer Goetz and producer husband William Goetz was in the 1950s and 1960s where Hollywood royalty gathered for martinis amid great paintings by Cézanne, Monet, Manet, Renoir, Bonnard, and Picasso (fig. 29). Greeting the guests in the foyer was the almost life-size bronze cast of Degas' *Petite danseuse de quatorze ans* (Little Dancer Aged Fourteen) wearing a real skirt and pink ribbon. Edith was the daughter of MGM founder Louis B.

Fig. 29
Interior of Mr. and Mrs. William Goetz residence showing works by Pablo Picasso, Édouard Manet, and Alfred Sisley, c. 1955 Unknown photographer

Mayer. The actor John Forsythe often dined at the Goetz home, and he told me that while powerful studio bosses, producers, and directors were frequent guests, the only actors and actresses invited to their dinner table were those successful enough to have their names *above* the movie title on the cinema posters and marquees.

Off Lakeshore Drive in Chicago legendary collectors Morton and Rose Neumann lived toward the end of their lives in a townhouse chocabloc with museum-quality works by virtually every great artist of the twentieth century from Picasso and Miró to Johns and Warhol. The furnishings were unremarkable, and a visitor might have to move a pile of newspapers and magazines to find a place to sit. It was not unusual to see a Giacometti bronze balancing on top of the television and a lifelike Duane Hanson sculpture propping open a door.

Regardless of the formality (or lack of it) in a true collector's home, the conversation often revolves around the circumstances of acquisition rather than feelings evoked by the objects. Couples reminisce about works that were gifts from one to the other, the travel that was involved, the idiosyncrasies of the gallery owner. The positive opinions of well-known curators and museum directors are quoted. If the work is easily recognized by most guests as being by Picasso, it becomes "very typical of his best." If it is unrecognizable, then "our Picasso is extremely rare, the only other one like it is in the Cleveland Museum" (probably in storage).

Not so very long ago it was generally considered taboo to discuss what things cost. A late van Gogh on the wall signaled that your hosts were extremely wealthy; numbers were not mentioned. The first time I visited Marion Cook, she said, almost as she opened the door, "I never discuss money and art at the same time." If that were still true, art-world dinner parties would be silent affairs. "Can you believe it: I only paid six million for that Warhol two years ago, and yesterday I turned down ten!" After a statement like that, it would seem churlish indeed to inquire, "What exactly do you like about it?" Issues of quality and critical judgments in general are trumped by Big Numbers.

Some of the most engaging experiences combining art and entertaining have happened to me in Asia. I was in Taipei, and good clients of mine with a major collection of Chinese art, as well as French Impressionist paintings, invited me to join them and their friends to celebrate

the arrival of a great seasonal delicacy, Shanghai hairy crab. As the honored foreign guest, I was served first: one large, cooked hard-shell hairy crab alone on a Sèvres plate and no silverware. All eyes were on me. "How do I eat it?" I whispered to my hostess. "Oh, with your hands of course!" she replied. I tapped it gingerly with my finger. No point of entry. Gales of laughter followed; then the silverware appeared. The actual point of the dinner was a competition to see who could consume the most. I threw in the towel after two, but the svelte lady to my left consumed eleven. An excellent wine was served. After dinner we gathered in the living room, and one of the guests unwrapped a small bottle-vase not more than nine inches high that had been fired in Hangzhou in the Southern Song period (1127–1279) (fig. 30). He had brought it from his home so that it could be admired and discussed. Everyone took turns looking at it closely, passing it delicately from hand to hand in animated conversation. I realized that I was actually at a meeting of a very informal collectors' club, and after a good meal an object that someone had brought or was owned by the host was looked at, discussed, and enjoyed. There seemed to be far less ego on parade than I would have imagined until one of the guests pulled me aside to let me know that it was unheard of to get hairy crab so early in the season and that my hosts must have spent a fortune to have it flown in from Shanghai. Thus, the cuisine trumped the art.

Fig. 30
KUAN YAO
OCTAGONAL BOTTLE
Southern Song Dynasty
(1127–1279)
Private Collection

When I started doing business in Japan in the 1980s, I met the legendary collector and dealer Sadao Ogawa. I was treated by him to the first of many wonderful meals in his home, which always culminated in the tea ceremony. In a traditional tea ceremony room there is an area called *tokonoma,* reserved for a Japanese scroll or a flower arrangement. Ogawa-san's *tokonoma* revealed a small still life by Cézanne of apples on a plate (fig. 31). Time slows down during a ritual

tea ceremony, and unforced conversation made it very easy for me to let the small painting work its magic in a manner that would have never happened if I had shuffled by it in the corridor of a Bel-Air mansion.

Fig. 31
PAUL CÉZANNE
Four Apples on a Plate,
c. 1882
Oil on canvas
4 × 6 in. (10 × 15.5 cm)
Nationalgalerie,
Museum Berggruen,
Staatliche Museen,
Berlin

YOU DON'T HAVE TO BE RICH

Some people who can afford to collect art enjoy seeing their names in the gossip columns, and much of their social lives, including marriage, friendships, and travel may be determined by their collecting and ownership activities. This is not restricted to the super-rich. Around 1965 I started noticing a young couple at virtually every gallery opening I attended. Their focus was most often on the exhibiting artist and any other artists in the vicinity. Dorothy and Herbert Vogel stood out from the crowd not only because of their relatively small stature (neither was more than five feet tall), but because they made no bones about their modest sources of income. Herbert, who had studied art, was a postal worker, and Dorothy was a librarian. Childless, they lived in a small apartment on Herbert's salary and devoted what Dorothy earned to collecting art. Many of the artists they first approached were unknown at the time, and some were

happy to let them pay for their purchases over time; others actually gave them works. Thirty years later the Vogels gave their collection (including works by Sol LeWitt, Donald Judd, Carl Andre, Richard Tuttle, and Chuck Close) to the National Gallery of Art in Washington, D.C. With interviews in major media, including a visit to their cramped apartment by Mike Wallace for *60 Minutes,* they became the poster couple for collecting on a dime (but with acumen and passion). After that, no gala art-world event was complete without the Vogels.

Other budget collectors I have known shunned publicity but enjoyed showing their collections quietly to private visitors. I invited myself and a friend to visit an elderly couple who had lived in the same small apartment in a certain Midwestern city for over fifty years. They had great treasures by Klee, Mondrian, Gris, and František Kupka that they had bought in the 1950s for relatively modest sums. They were not at all interested in what they were currently worth. It was a great pleasure to move slowly with them from one painting to another as they spoke gently about what the works meant to them. My companion wrinkled his nose as we left the apartment. "What on earth was that smell in every room?" "Pot," I replied, "possibly medicinal."

FREE ART FOR ALL

There are people strongly opposed to the private ownership of art who insist all art should be in museums and available for everyone to enjoy. Perhaps there lurks in our future a state-sponsored art utopia with hundreds of thousands of minimuseums in villages, towns, and cities. The entire output of artists selected by an impeccably credentialed committee of unbiased public servants would be purchased for the common good.

Until that time we do have, in the United States and indeed across the globe, museums that are open to the public, some even at no charge, filled with as many or more people than attend sporting events. Some museums advertised as free, however, require navigation past a suggested-donation counter, and others charge for entrance to special exhibitions within the museum (Tate Modern and Tate Britain, for instance). The politics and economics of "free" vary around the world. Edmund Capon, director of the Art Gallery of New South Wales in Sydney, told me with

glee that since he had stopped charging an entrance fee, the museum's income from concessions (restaurant, café, museum store) had soared with the increase in traffic. Great works of art can also be seen in relative comfort and genuinely free of charge in commercial galleries in most major cities.

Every visit to a work of art on public view is a social experience. Even if you go alone, you will encounter other people sharing the experience. Some may even be blocking the view of your favorite painting, chastising their children or trying to find a cell-phone signal. If photography is allowed, they may spend more time looking through their viewfinders than actually seeing the art on the walls. For someone as judgmental and irascible as me, this can be a dispiriting social experience. Visiting an exhibition of austerely quiet gray paintings by Johns at the Metropolitan Museum of Art, I could barely concentrate for the constant hive-like buzzing from a dozen audio guides. Adding insult to injury, one visitor's cell phone started ringing very loudly, but of course she couldn't hear it because she was glued to her audio guide.

Approached differently, the museum experience can genuinely elevate the social contact. This usually means visiting with people who share your general taste, if not specific preferences. De Kooning's brother-in-law Conrad Fried recalled visiting New York museums with him in the 1930s:

> The Met was almost empty in those days. It was free and open and it was great to go with other artists because they would pick only one or two pictures to look at. Bill [de Kooning] said, "If you go from picture to picture you get all mixed up. So you say to yourself 'what am I interested in?' and you go to that painting."[49]

One of the artists who haunted the Met with de Kooning was Kline. Another was Muriel Kallis (1914–2008), who purchased many great works by her fellow painters. "I really am not at heart a collector. I'm a failed artist—there's no other way to describe it," she said when years later she gave her collection to her favorite museum. "The artists I knew loved the Met, particularly Franz Kline, who used to go there and study Ingres by the hour."[50] Thanks to her generosity when we go to the Met, we can see wonderful works by de Kooning, Pollock, Kline, and many other of Muriel Kallis Steinberg Newman's friends.

ART, CLASS, SOCIETY

While I do believe that with practice we can improve our looking skills, I am not a great believer in attempts to teach art theory to otherwise reasonably well-educated adults. It is far more important and enjoyable to just get out and look at art. From a social point of view, however, there may be merit in attending lectures and panel discussions at your local museum, even perhaps joining a guided tour. If there is an annual art fair where you live, there will definitely be organized tours for the public and often ancillary educational efforts. You will be in the company of like-minded people. I don't entirely exclude the possibility of thus finding a life partner, but the odds for simply making friends are better than on a subway platform. All types of educational institutions offer opportunities to visit works of art with other people, whether recreationally or as part of a study course that can be audited by nondegree students of any age.

In cities with a number of art galleries it is usually easy to join a group that is either self-led or has someone with professional skills in charge. On a given day of the month the group weaves in and out of commercial galleries with or without commentary from a group leader or gallery staff.

ART PERFORMED

We have seen that art provides excellent reasons for many kinds of so-cial interaction. In the second half of the twentieth century art forms emerged that depended entirely on social intercourse. With roots in Dada activities in Europe in the 1920s and influenced by Pollock's action painting, Happenings were unscripted performances often requiring spectator participation and relying on unplanned developments. The first Happening was probably a mushroom hunt that took place in New Jersey inspired by Rutgers University artist-teachers Allan Kaprow and George Segal. Blurring the lines between artist, event, object, and on-looker, and in an often seemingly chaotic manner, Happenings influenced many artists, including Oldenburg, whose semipermanent installation *Store Days* in 1961 on the Lower East Side of Manhattan consisted of an actual street-level store where the artist made, displayed and sold his painted plaster-over-muslin simulations of consumer items, from skirts and shoes to hamburgers and pies.

On Sunday, March 23, 1969, I presented *Fire* by conceptual artist John van Saun, which consisted of various materials burning in different ways at different speeds on three floors of a loft building in SoHo (fig. 32). It lasted three hours, and about two hundred people came and went. Their presence was integral to the work.

One of the most subversive and elusive artists who engaged in social experiment was the enigmatic collagist Ray Johnson, who used the U.S. Postal Service as the principal medium for what he called the New York Correspondance (*sic*) School. Images and texts culled from very diverse sources were mailed to individuals with instructions to send them on to other specific individuals. Many were not initially known to each other. Johnson organized meetings of the School, the first at a Quaker meeting-house in Lower Manhattan. Many people attended, although there was no agenda and Johnson himself did not show up. He had announced the meeting as about "nothing." One by one people started to get up to say and do things, and in the end a lot did indeed "happen."

Performance artist Marina Abramović challenged social convention by placing nude men and women sitting, standing, and lying down on public view at her exhibition *The Artist Is Present* at the Museum of Modern Art in 2010, during which several visitors were removed from the galleries for inappropriate touching. According to the *New York Times,* "the museum's communications department stressed that untoward incidents have been few and far between . . . [but that the museum] is well aware of the challenges of having nude performers in the galleries."[51]

Perhaps not always in such an unorthodox manner, it is now quite common for visitors who attend art events to become participants, and such events have become almost commonplace. The Seventh Regiment Armory at Park Avenue and East 66th Street in New York was recently adapted to host such events, and a spokesperson told the press this was "to introduce people to a new use for the drill hall."[52] Untrue. In October 1966 *Experiments in Art and Technology* at the Sixty-Ninth Regiment Armory on East 26th Street brought together leading artists, composers, and dancers with Bell Telephone scientists for nine evenings of performances before a rapt audience. In Paris in 1961 Yves Klein pressed pigmented naked women onto canvas before an invited audience, and the paintings that resulted are highly prized.

Fig. 32
JOHN VAN SAUN
Fire performance at
Feigen Downtown Gallery,
March 23, 1969

"THE MEANING MUST COME FROM THE SEEING, NOT THE TALKING."[53]

———

BARNETT NEWMAN, 1905–1970

III | Aglaea

THE ESSENTIAL VALUE OF ART

By identifying the most elusive value of art as "essential," I am suggesting a range of responses that, depending upon our culture, education, and life experience we might file under "emotional," "spiritual," "psychological," or even perhaps "religious." Language is not a great help—at least not the English language, which favors the description of things over feelings. We can, however, be exhilarated, soothed, baffled, enlightened, uplifted, depressed, and much else—responses not always mutually exclusive and most likely not easily put into words. As Leonard w said about music, it "can name the unnamable and communicate the unknowable,"[54] or as Franz Kafka said about literature, "it should serve as the axe for the frozen sea within us."[55]

Imagine that on your way home one early evening you idly kick an empty Campbell's soup can into the gutter and the art genie appears:

"I will give you any work of art in the world," he says, adjusting his silver wig," but I have a few conditions."

"Thanks," you say breathlessly, imagining how much Bill Gates will pay for the *Mona Lisa*. "What are the conditions?"

"First, you can neither sell it nor profit from it in any way."

"S—t."

"Second, you can show it to no one, and you can discuss it with no one."

"Oh, I see," you say. "Art for art's sake; I think I've heard of that somewhere."

It does happen. At precisely 7 a.m. on Wednesday, April 26, 1967, I was sitting at the lunch counter of the Viand coffee shop on the northeast corner of Madison Avenue and 61st Street with a nervous young woman

I will call Sonia. She was wearing cowboy boots, jeans, and a brown suede jacket, her brown hair pulled into a shaggy ponytail. Behind us on the wall by the door was a pay phone, and we were waiting for it to ring. David Mann, a New York dealer, was in London with instructions from her to bid on *Maternity by the Sea* (1902, fig. 33), a stunning Blue Period Picasso that was the star of the sale at Sotheby's which had started at 11 a.m. London time, five hours ahead of New York.

She hadn't touched her coffee.

"Do you really think I stand a chance?" she said.

We had talked and talked about the painting, but I did not know what limit she had given Mann.

"It all depends," I replied, "on how badly you want it."

She had come to me for advice but was adamant that she was not a collector. The Picasso was a painting she had fallen in love with as a child when she saw it illustrated in a coffee-table book at home. Her grandfather had left her a great deal of money, but this was the only work of art she had ever been tempted to buy.

We were both getting agitated as another customer used the pay phone. I kept looking at my watch, calculating when the lot would come up for sale and how soon afterward Mann would be able to get back to his hotel and call us.

"Look," she said, "I really, really want it, but if I don't get it I wasn't supposed to have it."

"I think you'll get it," I said. "Don't worry." The customer moved away from the pay phone, and it rang almost immediately. I almost fell off my seat as I grabbed it.

"Michael?" It was Mann. "We got it! We got it!" he was whispering, but loudly. I nodded at Sonia and gave her a thumbs-up. Her eyes filled with tears.

"How much?" I asked.

"One hundred ninety thousand pounds, in dollars about five hundred thirty thousand."

Fig. 33 (opposite)
PABLO PICASSO
Maternity by the Sea, 1902
Oil on canvas
32 × 23¾ in. (81.5 × 60 cm)
Private Collection

"God almighty," I remarked, "that's plenty."

"I could have gone higher," he said, but I could barely hear him.

"Why are you whispering?" I asked. "Where are you?"

"I'm in someone's office at Sotheby's. There is a crowd of reporters

outside. I told them I had to call my client, and they let me use the phone because they are desperate to know who it is."

By then Sonia had dried her eyes, and I handed her the telephone. She listened. "Well done," she said. "That's great. Tell them the money will be sent today or tomorrow. In your name, as we discussed."

Drained and hungry, we ordered breakfast.

"So?" I said. "Are you happy?"

"I can't believe it's mine," she replied. "I can't wait to finally see it."

Sonia's heart lay far west of New York, and shortly afterward she married and bought a ranch in Montana. A few years later she came back to see her family, and I asked her about the Picasso.

"I look at it every day, and every day it's different," she said.

"What else do you have now?" I asked.

"Nothing much," she said. "Some Western art from a local gallery but no more Picassos." She laughed.

"What's so funny?" I asked.

"You haven't been to Montana, have you?" she said.

"No."

"We live pretty simply out there, which is why I like it."

"Simply, but with a Blue Period Picasso," I observed.

"I'll tell you a secret," she remarked. "Only my husband and I know it's real. Our neighbors assume it's some kind of reproduction. We don't even lock our doors."

There was no art genie in that story, and Sonia did, in time, sell the Picasso for considerably more than she paid, but basically she lived with it on her own terms and sought no social gratification from owning it. One could say that she was able to create and maintain an intimate relationship with a painting the image of which she had loved since she was a child. Presumably she shared the enjoyment of it with her husband, so there was a social component, and she also benefited from its increase in value.

Young as she was, she knew why she wanted to buy the painting and what she would do with it once she owned it. I know many instances of collectors who started buying works of art to store their money and increase their social reach and who subsequently ended up really looking at and loving what they had on their walls—what a bonus! After a hard half-day in the salt mines of Wall Street, tie loose, single-malt scotch in hand,

spouse in Aspen with the kids, cook's night off, you sink into your Jean-Michel Frank sofa and stare aimlessly into space. Gradually your eyes focus on your super-sized 1951 black-and-white painting by Franz Kline.

"No color, and I paid over eleven million," you muse to yourself, easing off your handmade Lobb loafers, "but they want it for the Philadelphia show and might put it on the cover. That should bump the value up. Bill told me that one coming up at Sotheby's is going to go for fifteen. Mine is bigger . . . what's that funny line in the corner? I never noticed that before. Oh, it's a shadow. These lights were never fixed properly. What does this damn thing look like anyway? A bolt of lightning? A messed-up Chinese character? I know I like it, but I have absolutely no idea why. Is that crazy or dumb or what? In fact, the more I look at it, the more I see and the better I like it. It looks . . . alive . . . full of energy . . . hope. Pretty amazing. It's what, fifty, sixty years old?" And so on. Eventually a real communication takes place, without words.

You don't have to own great works of art to have this type of experience. Just haul yourself to your local museum and stroll around without wasting time on the labels. Sooner or later something will grab your attention, so stare at it for a good long time, not just five minutes.

THEORIES ABOUT THE MEANING OF ART

If I look at a work of art and it leaves me cold, what can I hear or read about it that will profoundly change my attitude? If I look at a work of art and I am profoundly moved, what can I hear or read about it that matters more?

Because most of us lack confidence in our ability to simply look at and feel art, in the same way that we can listen to and feel music, there exists a vast business of interpretation. Postmodern critics, deconstructivist academics, gender-conscious curators, television nuns, and even, I dare say, loquacious art dealers pummel us with their theories about the meaning of what we can clearly see. But are they really theories? Not even. In science, empirical proof can result in a theory becoming valid or invalid. There is no possibility of empirical proof regarding the meaning of a work of art. Even the words of the artist, clear or opaque, glib or profound, are no more than afterthoughts, sometimes well pol-

ished and worthy of interest, but after all, the words of someone whose primary statement is visual.

Susan Sontag took up arms against the entire industry of art criticism:

> In most modern instances, interpretation amounts to the philistine refusal to leave the work of art alone. Real art has the capacity to make us nervous. By reducing the work of art to its content and then interpreting that, one tames the work of art. Interpretation makes art manageable, comfortable. . . .
>
> What is more important now is to recover our senses. We must learn to see more, to hear more, to feel more. . . .
>
> [T]he aim of all commentary on art now should be to make works of art—and, by analogy, our own experience—more, rather than less, real to us. The function of criticism should be to show what it is, even that it is what it is, rather than to show what it means.[56]

The same notion was presented more lyrically by the poet Wallace Stevens:

> You must become an ignorant man again
> And see the sun again with an ignorant eye
> And see it clearly in the idea of it.[57]

Many claims are made about the nature of individual responses to experiencing works of art. Aristotle believed in the therapeutic value of art. It is useful, he believed, because it arouses and purges dangerous emotions. In other words, two thousand years before Sigmund Freud's talking cure, a Greek philosopher proposed a "seeing cure." I particularly like the suggestion made by Russian Formalist critic Viktor Shklovsky in 1917: "Art exists that one may recover the sensation of life, it exists to make one feel things, to make the stone *stony*."[58]

Earlier in these pages I mentioned Robert Scull, a pioneer collector of contemporary American art in the 1960s and 1970s with an inflated ego balanced by an extraordinary eye for acquiring major works by unknown artists long before their names headed chapters in art-history books—Johns, Warhol, Rosenquist, and many others. In his desk diary for the year 1968 he entered the following revealing quotation from an

essay on Renaissance churches by the scholar Bernard Berenson: "Spontaneous feeling for art is *a gift possessed by few.* Most of us enjoy works of art *indirectly,* by association, by preparation, and above all, by finding in them what our education and general reading have led to us to expect" (my emphasis).[59]

Education and general reading deal with information rather than emotion. The emphasis is on describing (or assuming or inventing) contexts either to facilitate the understanding of others, to promote the author's opinions, or both. There is nothing wrong with the study of information and opinion *about* art, but it should always be absorbed in equal measure with *direct* familiarity with what is being discussed, and facts about a work of art should not be confused with what it might mean to you.

The most popular contexts are historical, biographical, and comparative.

Historical

Can we understand a seventeenth-century Dutch still life without knowing the visual symbolism of the culture? Can we derive meaning from a German polychrome wood Madonna unless we know what happened at the Diet of Worms in 1571? I think so. Studying the culture of the times in which a particular work was made is fascinating and can be very rewarding, but only the work itself will stir our passion. Whatever religious, cultural, or political message that the artist may have intended, a great work of art has the power to communicate beyond time and place. Treating a work of art, particularly that of the past, as a mere puzzle with the answers to be found in studying the life and times of the artist is in my opinion to leech it of its essence.

We might take a lesson from the way in which artists of one era grapple with and seek to know and beg, borrow, or steal from their predecessors. Picasso tangled with the best, from Rembrandt to Velázquez to Manet. He explained them to himself and us, uniquely, by dissection, repetition, rearrangement, and parody. The mother of two of his children, Françoise Gilot, recounts that in the mid-1950s, when Picasso embarked on a series of his own versions of Eugène Delacroix's *Femmes d'Alger* (Women of Algiers), he would take her on average once a month to the Louvre to study the original. "I asked him how he felt about the Delacroix,"

she relates. "His eyes narrowed and he said, 'That bastard. He's really good.'"[60] Picasso's versions upend and eviscerate Delacroix's triumph, but in homage and feeling so that we return to the earlier painting with greater understanding of both men's genius.

Likewise, Johns approaches the magnificent Isenheim Altarpiece of c. 1516 by Matthias Grünewald less savagely but with just as much passion. He feels his way through the work with great sensitivity and deliberation and by appropriation invents a new language from the old—one just as poetic. What gives a work of art meaning is a sufficiency of observation on our part, and not necessarily with a book in one hand or an audio guide in the other.

Biographical

In 1996 the Museum of Modern Art presented a wonderful exhibition of Picasso portraits. At the opening I followed the crowd from room to room to room until I saw, just ahead of me, a small gallery packed with people who were all staring at a wall that was invisible from where I was standing. Their attention was rapt, some jaws even slack. I could not wait to enter the gallery and turn the corner. What I saw astonished me. They were looking not at any paintings (those were, in fact, on the walls behind them) but at a display of enlarged black-and-white photographs and large-print text detailing the sordid but apparently delicious drama of the artist's life of adultery and betrayal. The crowd was happy to turn its back on the actual paintings to indulge in salacious biography. Had they spent as much time looking at Picasso's paintings of his wives and mistresses as they did reading the wall panels, they might have entered a more ambitious and ambiguous world than that presented, tabloid-style in these texts. What an artist wants us to know about his or her life is in the work. All too often the information flows in the opposite direction, and absurd claims are made about works of art based on an often-exaggerated personal myth, the more filled with violence, madness, and self-destruction the better. In a Christie's catalogue note for the sale of a painting by Basquiat, an anonymous specialist speculated that the artist was:

> painfully aware . . . of becoming a mascot for the genteel and predominantly white world of art. It was this fear which would

lead to his insecurity, in part coming to fuel his dependency on drugs in the coming years, and that would also result in the raw, expressive and expressionistic energy that makes his paintings appear so electrically direct, so filled with passion, with an anger that once again seems linked to the graffiti of his early years.[61]

White folks. Fear. Drugs. Raw energy. Passion. Anger. Graffiti. Genius reduced to the level of a B-movie script.

Anyone who can visit the works of van Gogh, Gauguin, Modigliani, and even Warhol and Basquiat ignorant of their various complicated lives is to be envied.

Comparative

An ability to make comparisons between works of art is a vital component of connoisseurship. If you have never eaten an apple, you might enjoy a bruised Granny Smith until you taste a fresh, juicy Fuji. Despite the fact that all taste is subjective and, given that as one era succeeds another, entire forms and vocabularies of art can fall from favor, there does emerge a consensus among curators, collectors, and dealers, either shared with or driven by the public, that certain artists of a particular era are better than others and that certain works or types of works by those artists are the best that they have made. Over the past two hundred years it would seem that these opinions often emerge within the artists' lifetime (if they have enjoyed a long life, as Monet and Picasso did) or fairly soon after their death (if they die relatively young, as did van Gogh and Modigliani). Later works by long-lived artists are sometimes little appreciated at the time (Monets of the 1920s, Picassos of the late 1960s), but within a few decades become heralded. Forming your own taste in the face of received opinion and the combined orthodoxy of academia, museums, and the art market can only be achieved by a great deal of looking at and comparing actual objects.

LOVE AT FIRST (AND SECOND) SIGHT

In mid-June 1890 van Gogh painted three portraits of Adeline Ravoux, the daughter of the keeper of the inn where he was staying in Auvers-sur-Oise. Vincent wrote to his brother Theo, "I did a portrait of a girl of

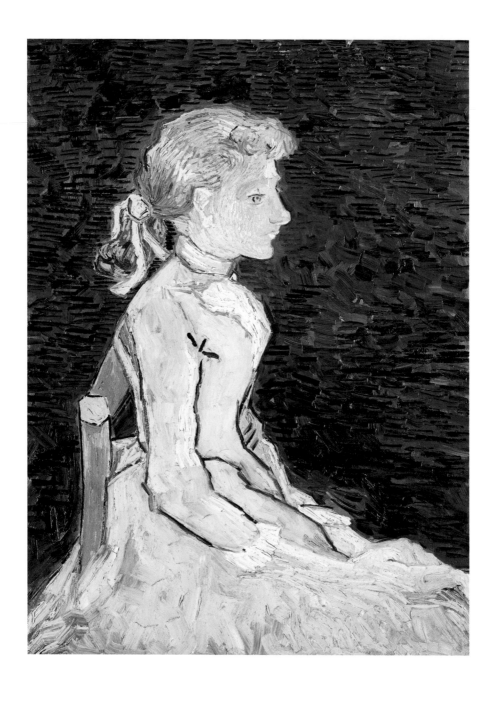

about sixteen . . . the daughter of the people with whom I am staying." In fact, Adeline was twelve at the time. She died in 1965 at the age of eighty-eight, certainly the longest-living person to have known the artist, who fatally shot himself a few weeks after she posed for him. Unlike most of us, her memory improved as time passed, and by the time she was in her eighties she was able to recall minute details about his personal habits, dress, behavior, and indeed entire conversations between them as well, such as a graphic description of his final hours and last words.

One of the first owners of *Adeline Ravoux* (1890, fig. 34) was blissfully unaware of both the subject and the artist when he saw it in the window of the Durand-Ruel Gallery when he and his wife were strolling along 57th Street: "We bought it in ten minutes, for about $11,000. I wasn't thinking about investment. We were both struck by its cheerful quality and thought this was the type of picture that would always give us a lift."

Later he remarked, about this and two other works he also bought by the same artist: "At the time I bought the van Goghs, some people thought I was rather queer. In those days van Gogh wasn't too well known here."

The collector was the Reverend Theodore Pitcairn, a Swedenborgian minister who had been a missionary in Basutoland. He was also the son of the founder of the Pittsburgh Plate Glass Company, which allowed him to do more than window shop.[62]

Millions of words have been written about van Gogh and his work from all perspectives, modern, postmodern, financial, and medical, ad nauseam. The vast majority of them have been penned by people who neither bought, nor lived with his work on a daily basis. Reverend Pitcairn's simple words of praise—"cheerful quality" and "always give us a lift"—coming from someone who made his own commitment to the artist at a time when he was still relatively unknown resonate as truer and wiser. Because he was speaking long after he had made the purchase, we can assume that the painting did, in fact, continue to do its job and give him a lift. This is no mean feat.

A similar chance encounter occurred a generation later when Victor Ganz chanced upon an exhibition of work by Picasso in the Paul Rosenberg Gallery, not far from where Reverend Pitcairn saw his van Goghs. With very few preconceptions about the artist or his work, Victor was

Fig. 34 (opposite)
VINCENT VAN GOGH
Adeline Ravoux, 1890
Oil on canvas
29 × 21½ in. (73.7 × 54.7 cm)
Private Collection

transfixed by *The Dream* (*Le rêve,* 1932, fig. 35), then owned by the American sculptor Meric Callery, who had loaned it to the show. The lovestruck Victor brooked no obstacles and, finding Callery in the New York telephone directory, eventually succeeded in purchasing the work for $7,000, a large amount at the time and considerably more than he could afford. He enjoyed it every day of his life, and it remained in his family collection until his wife Sally passed away in 1997, when it was sold at auction for $48.4 million.[63]

Collectors who live with works of art have the possibility of engaging with them deeply and constantly. I have enjoyed visiting many private collections, listening to the owners talk about their favorite works. Some retell hunting stories recounting how and why they bought, and sometimes they boast about how little they spent. For them, the object represents both a successful investment and is a pleasant memento of a particular place or time in their life. Other collectors talk about the impact of first seeing a work, how they felt then, why they had to have it, and how the meaning of it, for them, has developed from years of constant casual contact. Occasionally I have had the experience of showing a painting to clients and seeing them experience an immediate, powerful, positive response that renders moot discussion about anything except the price: they have fallen in love. At other times clients will return again and again to view a painting, not necessarily because they lack the ability to be decisive but because of a need to process what they have seen, perhaps to look again at what they have at home or visit similar works in a museum.

The more we look, the greater our confidence in the validity of our first impression, our gut response, and the likelihood that it will be confirmed or increased by continued engagement with the work of art. Serious looking at all types of art hones our visceral response mechanism for all other types of art but in particular looking again and again at works by the artists who most appeal to us increases our ability to access what is truly intrinsic to a particular painting, sculpture, drawing, or print.

PERCEPTION TRUMPS INFORMATION

Forty years ago the Impressionist galleries at the Metropolitan Museum of Art were a warren of divided spaces, many with just one or two paint-

Fig. 35 (opposite)
PABLO PICASSO
The Dream (Le rêve)
Boisgeloup, January 24, 1932,
1932
Oil on canvas
51¼ × 38½ in. (130 × 98 cm)
Private Collection

ings and a bench. On many a weekday at noon I sat on a bench in front of Monet's majestic *Four Poplars* (1891), which Mrs. Havemeyer gave to the museum in 1929. I ate my tuna on rye as the guard turned a blind eye, and often I was the only visitor. A problem with most American museums is there aren't enough chairs, benches, or nice soft sofas. Perhaps I am lazy, but you can see a painting just as well sitting down as standing up. Try looking at a painting for one hour and see what happens. Why not? How long did it take for the artist to make it? Movies are two hours. You might read a novel for an hour. A lot of us spend no more time looking at a painting than we spend staring from our moving car at a traffic cop giving out a speeding ticket. You really cannot take in any details at all, and what you think you saw is corrupted by what you expected to see. If you force yourself to look at one thing for an hour, I guarantee that after ten minutes you will be bored stiff but after twenty minutes things start to happen, and what you thought you knew about the work will start to be replaced by what you are actually seeing. After forty minutes you might become so absorbed you forget to look at your watch. In the catalogue for his magnificent Poussin exhibition in 2008, the former director of the Louvre, Pierre Rosenberg, wrote:

> Since the triumph of Impressionism we have lost the habit of taking time to study paintings. We look at them in the same way we leaf through a book, which is to say, distractedly. It is important then, to learn to stand before Poussin's work for a long time—the time to which Poussin paid so much attention. . . . He wanted the time one might spend reading and absorbing a text and in understanding its significance or its message to be spent contemplating his paintings, with the same complete attention the same concentration, the same emotional engagement.[64]

The bad old days of sandwich munching in quiet alcoves are long gone. Now there is a growing tendency on the part of museums to create specific traffic patterns. Some degree of crowd control may be necessary when so-called blockbuster exhibitions attract long lines, but mostly the need is to make sure you visit the gift shop and restaurant. Installations, both permanent and temporary, are organized sequentially, and in most cases labels (and a mellifluous voice in our ear) conduct us in an orderly

manner around the galleries. We allow ourselves to be led because we are more comfortable with language than imagery and the mission of many exhibitions is to tell a story with the works of art as illustrations. If you stand or can actually find a place to sit in the center of any fairly busy gallery, you will see most people enter and peer at the first label they encounter. They will look up at the work on the wall, briefly, and then move on and read the next label. This process is repeated until they have circumnavigated the room at a distance of four to six feet from the walls. With nary a backward glance they move on to repeat the process in the next gallery. After an hour their legs are tired and they need to find a cash register (tea, coffee, cake, three-course gourmet meal) and sit down.

An alternative approach was suggested to a friend of mine by his eight-year-old daughter, whom he took to an exhibition of dazzling early Fauve paintings by Matisse, Braque, Maurice de Vlaminck, and André Derain: "I don't know how you want to do this, Daddy, but I'm going to just stand in the middle of the room and let the colors come to me."

Living or dead, if the artist or his or her ghost were standing at your side, do you think they would want you to read the artist's name, the title of the work, the date it was done, its size, what it is made of, and what the curator thinks it means *before* you look at it? How about standing in the middle of the room and looking for one work that hooks your visual attention, then contemplating that for a good two minutes? Easier said than done in the era of the blockbuster exhibition with timed ticketing.

I mentioned in a previous chapter that I like to go through big, crowded exhibitions backward. The crowd is thickest in the first couple of rooms, where one often finds more reading material on the walls and possibly blown-up photographs of the artist's girlfriends. The crowd thins considerably toward the middle and end as people get bored and quicken their step.

My advice for getting the most value out of visiting public exhibitions is to go with at most two friends. Each of you might consider wandering aimlessly, choosing one work you like, spending at least five minutes looking at it, and then sharing your thoughts with the others. Sit down as much as possible.

Did I have lofty thoughts as I stared at Monet's poplars and swallowed my lunch? Not really. I do recall these moments as being intensely

pleasurable, times when I almost felt I could enter the picture plane and inhabit the work—a guided meditation, with my eyes open. In the four decades since then I have heard many lectures about Monet, read numerous books and exhibition catalogues, and even produced some verbiage myself, but only the act of actually looking at that painting again and again, and at many others by Monet, has given me real personal pleasure.

Classical, pop, jazz, rock, or rap—many of us feel very comfortable enjoying music without being steeped in either its history or the technicalities of its performance, and we do not really need to be told what it means by an expert. Why then, when it comes to art, do most of us feel the need for someone else's words in order to have a fulfilling experience?

Living with and really looking at works of art beat all book-learning and indeed all conversation about art. Sometimes I visit a collector and find myself able to provide some fact about a work of art that the collector did not know, such as:

"Your Picasso used to be owned by the artist's son Claude."

"Toulouse-Lautrec made this circus drawing from memory while he was hospitalized for alcoholism."

"There are thirteen other portraits of Liz Taylor by Warhol done in 1964, but yours is the only one in purple."

What I can never do, however, is to really know and feel the work as well as someone with the opportunity to put his feet up, turn the music down, and look at it for as long as he or she wants. In his excellent book *Pictures and Tears: A History of People Who Have Cried in Front of Paintings*, James Elkins writes: "Paintings repay the attention they are given . . . the more you look, the more you feel."[65]

Conversely, he relates that in thirty-five years of subsequent visits, he has never matched the intense feelings he had on seeing Giovanni Bellini's *Ecstasy of St. Francis* at the Frick Collection on a visit with his father as a very young child. As the years passed he came to know more about the painting, as a scholar, than possibly anyone else, yet he never felt it as strongly as at that original moment:

> When I looked, it was as if words had been swept out of my head and replaced by brushstrokes and colors. The word "magical" doesn't do justice to what I felt, but then again I can hardly re-

member what I felt: I was attached to the painting in a strange fashion that I have nearly lost the ability to recall.[66]

When we look at a work of art our neurological perception is based only 20 percent on "bottom-up" information transmitted from the retina. By contrast, 80 and sometimes 90 percent comes "top-down" from regions of the brain governing functions like memory. We make sense of what we are seeing with complex neurological functions. This is why, for instance, some forms of brain damage can make individuals unable to distinguish between people's faces even though they can "see" everything else perfectly well. Looking at a painting, whether new to us or very familiar, we fill in much from our brain; the information from our retinas alone is not enough. Of course, most of us are unable to filter what the brain delivers, which is why art, a primarily visual medium, can be so explosively subjective. Different people look at the same work of art and can have very different reactions.

It is very difficult to use language to describe the intensity of a visceral experience looking at a work of art. Art is itself a language with an infinite number of dialects. Synesthesia is a brain function that results in the perception of musical notes as colors, and in adults it is rare and considered abnormal. It is possible that we are born synesthetic not only in terms of seeing music as colors but with an ability to experience visual sensations viscerally, as music is experienced, without verbal or written language as an interpreter. A speculative theory of disinhibition suggests that as the brain develops, it creates a balance between excitatory and inhibitory forces. The left brain functions of rational and linguistic structures inhibit, and the holistic, intuitive right brain functions excite.

When it comes to engaging with a work of art, the analytical, logical, and semantic left brain processes information about commercial and social value, while it is the intuitive, emotional, and visual right brain that processes the object itself. To experience the essential value of art, it makes sense for us to disinhibit our response by muting the left-brain impulses. It is possible that certain drugs, particularly so-called hallucinogenic drugs, perform this function. I am not advocating drug use, but I do suggest that to access the essential value of a work of art, and indeed, to test whether it merits consideration as art, it is important to turn the

volume way down on facts about it (what can be adequately or accurately expressed with words) and just sit with it for at least as much time as it takes to read your newspaper or favorite blog. Reverse the well-known adage, "What you see is what you get," and ask yourself, "Do I get what I see?" With modern and contemporary art, "getting it" is often not about solving a puzzle so much as feeling the nature of the questions.

Contemporary Western culture promotes belief in what can be proven scientifically or demonstrated empirically and is not comfortable assigning value, other than commercial or social, to creative endeavors. Not all cultures are unwilling to assign intangible values, and thankfully there are still artists today who believe in them. In a recent interview British painter Bridget Riley (fig. 36) recalled seeing Chinese scroll paintings at an exhibition in the British Museum in the 1970s:

> After seeing the exhibition I bought a book about the criteria by which these works were assessed. The Chinese had very, very exacting standards. They developed a way of judging based on the spirit, mood and feelings conveyed by the paintings. Shih, as I seem to remember, has to do with "alive-ness." The informality of the little brush marks means they require great discernment. No matter how facile and vivid the brush marks might be, unless they were imbued with a basic truth, li, the scroll painting was worthless. I liked the way in which the criteria were to do with states of being, and that the paintings conveyed frames of mind.[67]

Most of us understand what Riley is getting at, but only through the medium of current English usage, which is vastly inferior to Mandarin when it comes to describing nuanced feelings. Besides, it helps little to understand what she is saying: ideally, we should *feel* it, and the only way to begin to even open the door to the possibility of doing that is to experience the object itself. When Riley uses the word "worthless" to describe a scroll lacking "li," I do not imagine she is talking about commercial value (or social value), but is instead suggesting that, very simply, the work is not worth looking at because it does not function on the high level deemed necessary to convey "spirit, mood and feelings."

Fig. 36 (opposite)
BRIDGET RILEY
Chant 2, 1967
Emulsion on linen
91 × 90 in. (231 × 228.6 cm)
Private Collection

DECORATION

It would seem that the first thing that *Homo sapiens* did once food and shelter were taken care of was to cover the walls of his caves with striking images of animals using carefully prepared materials and amazing techniques of modeling and perspective. "They've invented everything," Picasso reportedly exclaimed when visiting the Lascaux caves. Throughout history mankind has appropriated walls as surfaces for imagery. The *Playboy* centerfold in the auto-shop grease pit and Picasso's *The Dream* in Victor and Sally Ganz's living room are to one extent serving the same purpose: something nicer to look at than a bare wall.

The pictures we have the most intimate and personal connections with are those in our homes. These usually include photographs of friends and family; works by children, grandchildren, nieces, and nephews; posters of events we attended or wished we had; and also paintings and drawings by artists with varying degrees of commercial value and critical acclaim. Etched indelibly in my memory is a small still life of a white snowdrop floating on a black ground in a hideous scalloped white frame that hung over the fireplace in my childhood home. We had other equally unremarkable minor works, but that one I recall the most vividly, I have no idea why.

We choose what to put on our walls for a wide variety of reasons, including nostalgia, sentimentality, remembrance of loved ones and heroes secular and religious, but when the opportunity arises to choose a work of art, regardless of the budget, most people opt for what they think "will always give us a lift" and, of course, match the sofa. It has long been fashionable in the art world to deride those collectors and their decorators who are looking for a work of art that will fill a specific space in the home. After all, "real" collectors buy what speaks to them and to hell with where it will go (in some cases to the maid's room, eventually). In the same way that "decorative" is often used as a pejorative, particularly as applied to contemporary art, the implication being that an object that is decorative cannot also be intense, witty, shocking, evocative, didactic, trenchant, compelling, mysterious, and drop-dead beautiful. It is useful, particularly in the current climate of collecting as a blood sport, to remember that the Latin root *decos* referred to a trophy won on the

field of battle, as with the law-degree diploma, a stuffed marlin, and a red painting of Chairman Mao by Warhol.

In English *decoration* is usually defined as an add-on or a covering rather than an essential. We decorate a wedding cake with icing and ornaments. A face is decorated with makeup. In French *décoratif* is understood more profoundly as an intrinsic, eye-pleasing quality that neither negates nor contradicts other qualities. Matisse proved this conclusively by creating throughout his life extremely decorative works in all media that are not only at times explosively innovative but passionate, poignant, and lyrical.

The most serious collectors lavish a great deal of attention on how their works of art decorate their homes. Objects may not be chosen because they fit a predetermined design but, once chosen, need to be successfully integrated into the room. Seeking to create a daily dialogue with a new purchase, a collector might hang it where it will be seen often, rather than ceremoniously above the fireplace. I know collectors who look forward to shifting works of art around in their homes regularly. Not only does this help them see again the merits of a work that, occupying the same spot for years has become visual furniture, but the juxtaposition of diverse works creates a dialogue between them (sometimes an argument, in which case they must be permanently separated) that may have little logic from a curatorial perspective.

"Today the market is master of the artists and of their work."[68]

FAUSTO MELOTTI in 1963

———

"Artists today know more. They are aware of the market more than they once were. There seems to be something in the air that art is commerce itself."[69]

JASPER JOHNS in 2008

IV | Marley's Ghost

The capacity of art to affect the individual on a personal and private level receives increasingly less attention in public discourse than its commercial and social value. Consider the following statements by artists born between 1866 and 1965:

> The soul is emerging, refined by struggle and suffering. Cruder emotions like fear, joy and grief, which belonged to this time of trial, will no longer attract the artist. He will attempt to arouse more refined emotions, as yet unnamed. Just as he will live a complicated and subtle life, so his work will give to those observers capable of feeling them emotions subtle beyond words.[70]
> —WASSILY KANDINSKY, BORN 1866

> I was asked what my painting really means in terms of society, in terms of the world . . . And my answer then was that if my work were properly understood, it would be the end of state capitalism and totalitarianism. Because to the extent that my painting was not an arrangement of objects, not an arrangement of spaces, not an arrangement of graphic elements, was [instead] an open painting . . . to that extent I thought, and still believe, that my work in terms of its social impact does denote the possibility of an open society.[71] —BARNETT NEWMAN, BORN 1905

The result of my research aims to comprehend the human as a
spiritual being. A human must learn to elevate himself above his
reality: he must create a spiritual vehicle for himself with which
he can reach a totally different site in the cosmos.[72]

—JOSEPH BEUYS, BORN 1921

I always feel that the art's there and I just see it, so it's not really
a lot of work.[73] —DAMIEN HIRST, BORN 1965

Hirst is often described, admiringly, as a brilliant businessman, a far
cry from the myth of tortured genius alienated from society. While some
of us might have a misplaced attachment to the narrative of the artist
as hopelessly uninterested in money, an artist overwhelmingly ruled by
the market surely requires a Herculean effort to resist the temptation
to produce what the market demonstrably wants and will pay for rather
than what he, as an artist, needs to express.

Successful artists from Rodin and Picasso to de Kooning and Lichten-
stein also enjoyed making money and were keenly aware of their markets,
but their business acumen was largely exercised in private. Not so today.
In fact, the artist's skill in creating, maintaining, and increasing his or
her market is often front and center, and for many of the artist's admir-
ers a definite plus.

The unease with which artists used to approach the appearance of
their work at public auction has been replaced in Hirst's case with an
unprecedented coziness. Sotheby's auctioneer Tobias Meyer announces
a Hirst painting as by "Damien," no last name necessary. Ever-prescient
in business, Hirst performed an end-run around his dealers in September
2008 by successfully using a public auction as a primary market vehicle,
thus obviating the process of critical review that would attend the debut
of new work in the gallery system.

The sale at Sotheby's in London, on the very day that the rock-solid
investment banking firm of Lehman Brothers filed for bankruptcy, ap-
peared to be a great success. Sadly for Damien, the worm quickly turned,
and just a few weeks later, when more of his works were offered by So-
theby's in New York, very few found buyers. The New York Times saw fit
to describe him as "yesterday's news,"[74] thus dashing any ambition he

might have had to emulate David Bowie and sell public shares in himself, lock, stock, and stuffed shark.[75]

FINGS AIN'T WOT THEY USED T'BE

Legendary curator Henry Geldzahler referred to the generation of abstract painters that came of age in the 1940s and 1950s as "a generation of rabbis" because he felt that Newman, Rothko, Still, Kline, Reinhardt, and their peers "wanted to project the immanence of God, of divinity, in their work, without specificity. . . . They wanted to lift you and keep you at that elevation."[76] In a very different art world from the current one, it took a long time for most of them to achieve even a modest amount of financial stability, and those blessed with longevity were *éminences grises* when finally visited by some degree of fame in the late 1950s. But by then they were about to be supplanted by the so-called Pop generation, hard-edged figurative and abstract artists who were identified, labeled, and made art-world stars while still in their early thirties—artists like Johns, Rauschenberg, Warhol, Lichtenstein, Rosenquist, Wesselmann, Stella, Kelly, and others. These new young artists were inspired by comic strips, billboard advertising, American flags, and dollar bills, and many admirers of Pollock and de Kooning refused to accept what they were making as art. That argument seems quaint today, when the same person who buys a 1950 Rothko at auction for $73 million bids $72 million the next day for a 1963 Warhol, presumably to hang in the same living room.

One enduring narrative of the past 150 years is the eventual success of pioneer artists whose controversial works were initially deemed "not art" by critics and the public. To name just a few, Marcel Duchamp, Pollock, Warhol, and Beuys fit this category, and their work will probably be hung in museums and be discussed, bought, and sold throughout the twenty-first century. Fifty or so years ago (longer in the case of Duchamp) they produced their major work, they are enduringly influential and astonishingly prophetic, and the argument about whether what they made is or is not art is still fertile.

Today's art world seems to me very different from forty or fifty years ago. Will today's art stars make it into the history books as complete chapters, small footnotes, or at all? Some went quickly from rags to

riches, and while they seem to be both feeding and well fed by the current art market, even their best work may be reflecting, rather than creating, the intellect of our times. While the nature of art must evolve from age to age, its measure is surely the effect it has on the common culture and subsequent generations. In fifty year's time will a shark preserved in formaldehyde look dated or profound?

ART AND THE INFLUENCE OF LANGUAGE

The type of language used for public and critical discussion of works of art reflects the current culture as much as the nature of the work discussed. For the first half of the twentieth century much writing about art might today be considered excessively lyrical. With typical Gallic overstatement Octave Mirbeau opined about Renoir in 1913:

> Perhaps Renoir is the only great painter who has not created a sad work. To him, joy is a matter of intent rather than chance. His artistry is awakened by joy as naturally as light embraces and reveals what we see. When Renoir's eyes contemplate objects he sees their immersion in light and the play of light changes his perception of the object. This gives birth to a dual serenity in him: the joy that he feels in the contemplation and the certainty that he can paint the image just as he perceives it. He knows the world is there and he is there to paint it.[77]

A decade later the distinguished British critic Roger Fry tackled Cézanne's nudes with words perhaps, to our ears, only slightly less florid:

> Thus there exists a number of small compositions which have an extraordinary freshness and delicacy of feeling, a flowing suavity of rhythm and a daintiness of colour. . . . It is the expression of a mood that surprises one by its almost playful elegance in a temperament that for the most part was so grave, so austere, and so little attracted by the factitious.[78]

Whether agreeing with this particular sentiment or not, the interested public, as well as the artists, collectors, and dealers of the time, accepted and understood this approach and type of language. The mid-century

American critics Clement Greenberg and Harold Rosenberg ruled the art world with theories of modern art unadulterated by references to commercial value. As modern art became more popular, however, this changed.

After World War II, in America contemporary art became a fit subject for mass circulation weekly magazines like *Life* and *Time,* and a few contemporary artists subsequently became household names. The writers often knew the artists well and generally speaking supported their innovations but the *Time/Life* house style demanded an ambiguous presentation that would alienate neither the eggheads nor the know-nothings.

"Is He the Greatest Living Painter in the United States?" screamed the title of the article about Pollock in the August 8, 1949, issue of *Life.*[79] And at the time of his early and dramatic death in 1956 *Time* dubbed Pollock "Jack the Dripper," which proved so enduring that it headlined a 2008 story in the fashion pages of the *Herald Tribune* subtitled, "His Influence Splatters across the Runways."

"Is He the Worst Artist in the U.S.?" queried *Life* in a January 31, 1964, story about Roy Lichtenstein. While leaving room for a positive answer, the article nevertheless quoted nameless "critics, museum officials and collectors" as finding Lichtenstein's work "fascinating," "forceful," and "starkly beautiful."

Throughout the 1960s, when these magazines had huge readerships, writers for them like Rosalind Constable and David Bourdon, now largely forgotten, unabashedly promoted avant-garde artists in articles heavy on illustrations and light on verbiage. Christo in particular benefited from this exposure because his projects enveloping landscape and architecture lent themselves to stunning photography. These writers were by no means following popular art-world opinion: Bourdon championed the vast earthworks of Michael Heizer and Robert Smithson in a 1969 *Life* story about "dirt art" when this radical genre was in its infancy. Tellingly, there was not a great deal in those articles about commercial value.[80]

In the 1970s the language of contemporary art discourse became more existential and, gradually, more abstruse. It lent gravitas to work by Minimalist painters and sculptors and Conceptual artists, but it left many of us struggling with our dictionaries. Noted German critic, dealer, and curator Heiner Bastian wrote as follows about the work of American

artist Cy Twombly: "The primary fascination of these paintings is the experience they convey of a direct mutual infiltration of an inherent formalism through the prismatic dissection of multiple states of form."[81]

Gradually such language became largely confined to academia, and popular journalism appropriated financial-market terminology. Hitherto, a work of art would only make the front page of the *New York Times* if it was stolen, but by the mid-1980s the increasing market savvy of the auction houses and the public's appetite for tales of greed led to repeated front-page appearances by works of art deemed suddenly newsworthy solely because of the price paid for them at auction. When a magnificent example of van Gogh's *Sunflowers* was sold at Christie's in London for $39.9 million (tripling the previous auction record for a work of art), the story broke as headlines around the world. The buyer kept its identity secret for a week while curiosity mounted and speculation ran rampant. Then the Yasuda Fire and Marine Insurance Company of Japan announced that it had purchased the work to commemorate the founding of the company in 1887, perhaps not so coincidentally the same year van Gogh embarked on the sunflower series. The company told curious readers worldwide that it would join works by Picasso, Gauguin, Renoir, and Grandma Moses in its corporate museum and that it symbolically replaced the *Sunflowers* destroyed by the Allied bombing of Nagasaki in 1945. Thus, the second-largest insurance company in Japan garnered vastly favorable worldwide editorial coverage that no advertising budget could have delivered. Yasuda made most of the headlines, but these headlines were made only because of the then-astonishing price, not the exemplary work of art.

Over the ensuing twenty years the auction houses increased their marketing skills and budgets, financial news dominated the headlines, and many of the people with newly created wealth spoke "trading" as a first language. While other idioms were used to write doctoral dissertations and review exhibitions in art journals, much of the art world fell in line behind the language of commerce, and most working journalists followed suit. In the nineteenth and early twentieth centuries, art dealers engaged in international trade usually spoke more than one language fluently. When the center of the art trade shifted to London and New York after World War II, English began to predominate. But now in the early twenty-first century, as Asians, Middle Easterners, Russians, and others

have entered the fray as collectors, dealers, curators, and artists, the lingua franca of the international art world appears to becoming "Globish," defined by a French former IBM executive as a minimal utilitarian vocabulary of English words suited to commerce, devoid of nuance or subtle description.[82] While most art-world dialogues rely on trade talk, the language of spiritual values has migrated to consumer product advertising. PepsiCo CEO Indra Nooyi relies on words like "aspirations" and "higher values" to define the salty, high-calorie, corn-syrup allure of her company's products.[83]

One of the great patrons of postwar American art was Count Giuseppe Panza di Biumo, a wealthy Italian who was an enthusiastic early buyer, like Robert Scull and Emily Tremaine, of works by Rothko, Kline, and Guston and then Rauschenberg, Rosenquist, and Lichtenstein, as well as Donald Judd, Flavin, Serra, and many others who have now entered the canon of historical importance. A philanthropist, he gave away many of his works of art, some to American museums; he sold others to turn his home into a museum, which is now run by the Italian National Trust. When he died in April 2010, the *New York Times* ran a substantial obituary:

> Count Panza waved away talk of dollars and cents. "To understand the new art was of primary importance to me," he told *Vogue* in 2007. "It was like discovering a new theory in physics, or a new celestial body. It was born of this same desire, to know the unknown.

The obituary concludes with a 2008 quotation: "I collect art because I love beauty, not to make money." Despite this unequivocal statement the author of the obituary comments: "He *invested* in Minimalism early, *snatching up* works by Judd, Flavin, Carl Andre" (my emphasis).[84]

As historian Tony Judt noted, "we have made a virtue out of the pursuit of material self-interest: indeed, this very pursuit now constitutes whatever remains of our sense of collective purpose. We know what things cost but have no idea what they are worth."[85]

Not long ago I participated in a panel discussion organized by the Appraisers Association of America, Inc., which I assumed would be about the criteria used for determining defensible values for insurance and tax purposes. The subject, much broader, was in fact, "Is Art an Asset Class?"

None of the participants, myself included, were in any way embarrassed to discuss art as just so much "product."

Art-movement nomenclature may be inexact, but it is frequently used as shorthand by virtually everyone except the artists thus described. As the twentieth century progressed, "ism" followed more "isms" (Impressionism, Fauvism, Cubism, Post-Impressionism, Surrealism, Abstract Expressionism, Pop, Minimalism), until either fatigue or diversity overtook the art world of the 1980s. *Artforum* attempted to launch what writer Ronny H. Cohen called "Energism" in the September 1980 issue, but it was stillborn.[86] Twenty-eight years later, just a few months shy of a global economic meltdown, the same venerable magazine had much better luck with an issue devoted to "Art and Its Markets" (April 2008). I am disappointed, however, that the editors failed to identify the soon-to-be-eclipsed dominant art movement of the early twenty-first century as "Commercial-ism."

To debate the art market *Artforum* convened a roundtable discussion of distinguished critics, curators, historians, an auction-house specialist, and even, amazingly, an artist but in a strange omission given the subject, not one art dealer. One of the moderators, scholar James Meyer, opened the discussion by stating that "[t]he extraordinary boom of the contemporary market in recent years, along with the globalization of art's production and display . . . are among *the most pressing subjects* in any discussion of current practice" (my emphasis).[87]

MUSEUMS AND MAMMON

The degree to which money rules the art world is evident from the way in which museums schedule events either to take advantage of commercial activities or to avoid conflict with them. In Switzerland Art Basel in June attracts the art-world elite (painter Chuck Close compared an artist at an art fair to a lamb visiting an abattoir), and one of the best small museums in the world, the Beyeler Foundation, just outside Basel, always presents a very important exhibition to take advantage of the heavy traffic. Announcing the date of the opening of the New Museum's new building in New York in the fall of 2007 the director Lisa Phillips said, "It also falls nicely between the auctions and Art Basel Miami."[88]

Acknowledging the power that money wields in the world of art the Metropolitan Museum of Art in 2007 chose to curate *The Age of Rembrandt: Dutch Paintings in the Metropolitan Museum of Art* by grouping the paintings by their illustrious former owners (and donors). Included were works acquired directly by the museum. I was not surprised, then, when reading the extensive wall label for their star picture, *Aristotle with a Bust of Homer* (1653, fig. 37) to see as a headline: "The Museum purchased the painting for a record price." The price itself, however, was not named, perhaps out of modesty. It was in fact, $2.3 million, paid at auction in 1961. Adjusted for inflation that would be $15 million today, a sum that causes nary a murmur in the auction rooms, let alone applause.

Fig. 37
REMBRANDT HARMENSZOON VAN RIJN
Aristotle with a Bust of Homer,
1653
Oil on canvas
56½ × 53¾ in.
(143.5 × 136.5 cm)
The Metropolitan Museum of Art, New York. Purchase, special contributions and funds given or bequeathed by friends of the Museum, 1961

The style and substance of the language that the Metropolitan Museum of Art chooses to use when speculating on the meaning of this work has changed dramatically since it was acquired, a change very much in keeping with today's emphasis on art as a vehicle for careers and commerce. In 1962 the museum's renowned scholar and curator Theodore Rousseau speculated that, upon contemplating the bust of Homer, Aristotle's thoughts are "drawn . . . into a distant world of dreams and melancholy."[89] Visitors to the museum's show in 2007, their ears glued to the ubiquitous audio guide, heard instead that Aristotle was most likely thinking, "Will I be remembered in five hundred years like Homer?" thus ascribing to the Greek ancient described by Dante as "the master of those who know" the sentiments of a talent-show contestant.

The boundaries that used to exist between culture and commerce have largely disappeared from the public eye. Museum retrospectives of living artists are sponsored by the galleries and auction houses that sell their work. "Dealers' Money Nudges Museums" headlined a story in the *New York Times* that revealed opposition to this trend within the museum community and a certain defensiveness on the part of some participants.[90]

Museums advertise their blockbuster exhibitions with full-page color advertisements in newspaper entertainment sections and actively promote local tourism with hotel packages that include timed tickets. This is big business. Museum shops have evolved from a few racks of postcards to high-revenue stand-alone franchises selling everything from replicas of the Sphinx Hatshepshut to one-handed pepper mills. Many museum directors now have at their shoulder a business manager with a mandate to increase revenue any way possible, including private-function viewings, publishing, and ticket sales. Maximizing income is not always compatible with a program of curatorial innovation and excellence. Exhibition proposals deemed from a commercial perspective to be obscure or controversial can lose out to proven crowd-pleasers. Most money-making exhibitions are expensive to curate and market, and since the economic downturn of 2008 belt-tightening has forced many museums to be come up with less expensive shows. The results are mixed. A typical successful ploy is for the museum to curate novel theme exhibitions with works from their permanent collections. Most major museums have significant repositories of works formally exhibited rarely if at all. In

2010 New Yorkers were treated to three hundred paintings, drawings, sculpture, ceramics, and prints in *Picasso in the Metropolitan Museum of Art,* all owned by the museum. This show presumably cost much less than the cost of borrowing a single work by the same artist from another museum or private collector, which would have incurred the significant additional expenses of shipping, insurance, travel, and administration.

Saving money, however, can also lead to a museum to compromise standards of expertise. The April 2010 issue of *Art News* reported that many art professionals familiar with the work of Edgar Degas, including not only curators but dealers and auction-house specialists, did not accept as bona fide bronze sculptures newly cast from "recently discovered" plasters allegedly made during the artist's lifetime.[91] Nevertheless, the sponsors of these "new" works by an artist who died in 1917 organized an exhibition with a lavish catalogue in three languages, which began at a little-known private museum in Greece. After stops at museums in Sofia, Bulgaria, and Tel Aviv, the show was destined to open at the New Orleans Museum of Art in November 2011, but Susan M. Taylor, the newly appointed director, postponed the show indefinitely. Such a packaged, precurated exhibition delivers a big-name artist to the box office, but are visitors looking at original works or reproductions?

AUCTIONS AS NEWS AND ENTERTAINMENT

Very sophisticated marketing and promotion now accompany auctions of Impressionist, modern, and contemporary art in New York and London.[92] Prior to the auction in New York of works by Picasso, Matisse, Bonnard, and Giacometti from the collection of Mrs. Sidney F. Brody in May 2010, Christie's showed the works by appointment in private galleries redesigned to simulate the décor of her Los Angeles residence, including the black-and-white tile floor. On Friday April 30, 2010, readers of the *New York Times* were treated to a two-page, full-color advertisement for the sale of Mrs. Brody's collection juxtaposing her major Picasso with a painting by Johns from the collection of author Michael Crichton.[93] The catchy but ambiguous caption, "Two Great Moments in Art," implies a relationship between the two paintings, although for Christie's the two great moments were when the heirs of the recently

deceased but otherwise unconnected collectors both chose that auction house over Sotheby's. The Picasso and the Johns did not share the same space because an art historian or museum curator suggested a relationship but because their respective owners were recently deceased.

Two days later the Sunday readership of the *New York Times* was treated to a second large color image of Mrs. Brody's Picasso on the front page of the Arts and Leisure section illustrating an article about how disappointing it would be if the painting sold for less than $100 million.[94] While the colors and date of the work are alluded to, briefly, its market value is the subject of the article, which nevertheless was not published in the newspaper's business section. Whom did the story serve? The circulation of the Sunday *New York Times* is in the area of 1.4 million, but there are only five private owners, worldwide, of paintings similar enough to the Brody Picasso to have a vested interest in its value and, it turned out, only five actual bidders for the painting. Notwithstanding this, the *New York Times* devoted three more articles to this event. Not only did their regular auction columnist Carol Vogel file her obligatory morning-after story, but writers Roberta Smith and Holland Cotter, who mostly review exhibitions, were pressed into service and produced "The Coy Art of the Mystery Bidder"[95] and "Another Auction, Another Trophy,"[96] respectively.

While this coverage is not uncritical, it is a very far cry from the more limited scrutiny given to the museum and gallery shows, as well as books, plays, and films, in the same arts pages. And while there is clearly a rigorous selection process defining which current museum and gallery exhibitions might even be worthy of one or two paragraphs (and the reviewers are critics, not reporters), each new auction season is accorded greater attention than many serious and popular events at major New York museums. The attendees and buyers, named or not, are the same year in and year out. The works offered are discussed only for their merits as merchandise, and the results are offered, like sporting events, with self-serving comments from the auction houses themselves and volunteer pundits. "The market is all about global liquidity," the *New York Times* quoted Sotheby's Tobias Meyer after he presided over a perfectly respectable but hardly market-shifting auction on May 5, 2010.[97] Every few years there is indeed an auction season that signals a shift in the art

market but that hardly justifies the extensive and intense coverage of these purely commercial events in the arts pages.

THE COMMODITIZATION OF CONTEMPORARY ART

According to Karl Marx, commoditization occurs when commercial value is assigned to things (objects, activities, people, even ideas) that are not generally considered in economic terms. Thus, slavery involves the commoditization of people and prostitution the commoditization of sex. In our society candidates for high office are required to raise and spend many millions of dollars: the commoditization of politics. Accused of a crime, the person who can afford a successful and experienced lawyer has a much better chance of liberty than an indigent defendant: the commoditization of justice. Education is commoditized. A British government report in October 2010 stated that "the cost of courses will be indexed to the likelihood of financial rewards down the line. A course's 'key selling point' will be that it provides improved employability."[98] Knowledge for money's sake. Disasters are commoditized. Three days after the tragic earthquake near Sendai in northern Japan in March 2011, Reuters reported the estimated cost to the nation as $180 billion, a sum to most of us so staggering as to be virtually incomprehensible.[99] Helpfully the writer compares this event to the 1995 earthquake in Kobe, but does this in any way increase our understanding of what happened? Buried at the bottom of the story was the death toll: 10,000.

Essential to the process of commoditization in art is the lack or loss of uniqueness—that which distinguishes one work of art from another. Economists define goods as "commoditized" when they are interchangeable with other goods in that category offered by another producer. In his excellent essay "Historical Returns," in the aforementioned April 2008 issue of *Artforum,* Thomas Crow aptly quotes *Forbes*'s "Investopedia": "When a product becomes indistinguishable from others like it and consumers buy on price alone, it becomes a commodity."[100]

Large, mechanically produced spin paintings signed and presumably inspected by Damien Hirst come, like Starbucks coffee, in three sizes. Galleries and auction houses have a difficult time arguing that one deserves to cost more than another because they are more or less inter-

changeable and sold as branded items ("I found a spin painting for you," I will call and tell my client, not even needing to name the artist), rather than as unique works of art.

History

One of the first American collectors I met was the legendary Emily Tremaine, who bought *The Black Rose* (1927) by Georges Braque not long after it was painted and before she was thirty. She owned one of the first truly abstract paintings, Robert Delaunay's *Disque simultané (premier)* (Simultaneous Disk [First], 1913, fig. 38), and went on to support de Kooning and his generation, then Rosenquist, Warhol, Lichtenstein, and Wesselmann when they were virtually unknown. At the time of her death she was championing the next generation of as yet little-known progressive artists, including Robert Irwin and Walter De Maria. Along the way she also acquired major works by Mondrian, Ernst, Pollock, Kline, Johns, and Rauschenberg. This book was in part inspired by her words quoted in the introduction.

She and her husband Burton were indefatigable gallery-goers, rarely missing a debut exhibition by any new artist. A former aviatrix, she was tall and statuesque and would stand stock-still staring at a work long before she voiced an opinion. While Emily was not shy about enjoying both the commercial and social success of her dazzling collection, she exhibited a passion for art that informed her choices and toward the end of her life (she died in 1987) bemoaned the degree to which money ruled the art world.

In her biography of Tremaine Kathleen Housley suggests that it was the early acceptance of Pop Art and its relatively meteoric rise in value that "destabilized the art world. . . . The collectors were investors, not patrons, primarily acquiring precisely because the values were rising so rapidly."[101] She also recalls the 1973 auction of fifty works from the Scull Collection, mostly by artists in the middle of their careers, which the art critic Irving Sandler suggested "kicked off the art market that we know today."[102]

Six years later, in 1979, Citibank set up its art advisory service with Jeffrey Deitch as one of its principal specialists. Deitch later became a gallery owner showcasing new artists and brokering secondary-market

sales. In step with a somewhat chastened art market, in 2010 he entered his third art-world incarnation as director of the Museum of Contemporary Art in Los Angeles. Although he believes the greening of the art world started later than the 1960s (we all like to think things began when we did), he describes it very accurately:

> When I arrived, in the seventies . . . it was still the older model. Collectors were psychiatrists or lawyers—intellectual people, not the social or business élite. . . . The art world used to be a community, but now it's . . . not just a market—it's a visual-culture industry, like the film industry, or the fashion industry and it merges with both of them. . . . We live in an increasingly culture-based economy, and the value of art is in synch with other tangible assets now, like real estate.[103]

It is no coincidence that in the late 1980s and 1990s, when Christie's and Sotheby's started to invest heavily in promotion and marketing, they

Fig. 38
ROBERT DELAUNAY
Disque simultané (premier),
1913
Oil on canvas
Diameter: 52¾ in. (134 cm)
Collection Esther Grether,
Basel

both added real estate to the roster of "collectibles" that they brokered. At about the same time the term "lifestyle" entered the lexicon, redolent of second homes, spa resorts, wine tastings, and original works of art. This ambience of luxury, good taste, and ease that the auction houses projected in the late twentieth century has given way to a more palpably red-blooded opportunistic approach in a contemporary art market where the $100,000 boy or girl wonder becomes tomorrow's $6 million (per canvas) man or woman.

In fact, there were plenty of collectors in the 1960s who were part of the social and business elite, but while their social lives involved art, their business lives did not, and few openly treated their collecting as investment. Somewhat like philanthropy, collecting Old or Modern Masters signaled the achievement of a certain dignified and respectable level of success—the ability, taste, and intelligence to enjoy fine art rather than just adding another category to one's personal investment portfolio. More adventurous collectors scouted for the new geniuses of the avant-garde and enjoyed the possibility of being pioneers by supporting artists who were either as yet unknown or derided by the establishment. If in later years it was evident they had "picked a winner," their satisfaction was much more than financial. One of the earliest collectors of postwar American art was Richard Brown Baker. In 1995 he gave his entire collection to Yale, his alma mater. It included masterpieces by Pollock, Hans Hofmann, Robert Motherwell, Rosenquist, Lichtenstein, de Kooning, and Twombly, some bought at the time for less than $1,000. In half a century of collecting (1941–95), the highest price he paid was $52,000 (in 1986 for a George Segal sculpture). As he once stated, "I've never sold anything. . . . I pride myself on not making a profit on art. I buy at the bottom of the market, and I collect works by contemporary artists who are not very well established."[104]

Interestingly, Baker only ever bought from galleries, not at auction. While he got to know a few of the artists whose work he collected, their presence in his extremely low-key social life was not his motivation for buying their work any more than profit, and in those days artists were not particularly ambitious to know their patrons.

How It Works

This was all a far cry from today's complex business and social relation-ships between artists and patrons. The dawn of the new millennium wit-nessed the apotheosis of the collector-speculator. These are individuals who began collecting in the conventional way, buying works they like with discretionary income. Motivated either by high offers for works recently bought or a simple desire to test their judgment, they resold into a rising market. What fun! What profit! Thus emboldened they ventured into the auction and the gallery markets to buy as much as they could of this or that rising star's work in the very process creating greater buzz about the work. In some cases, in collaboration with the artist him- or herself and the artist's primary dealer, they purchased large groups of work directly from the studio, to hold for a month or a year. Word leaked out that "Joe is heavily invested in New Artist X" and because Joe was known to have made a killing by buying a number of almost-immediately iconic neo-Pop nurse paintings by Richard Prince at $100,000 each and selling them at $7 million, lesser mortals were inspired to get on the New Artist X bandwagon.

When it comes to the very high prices that were paid for the work of artists yet to graze the footnotes of art history, I like a phrase coined by venture capitalist Eric Janszen: "asset-price hyperinflation," which he describes as "the huge spike in asset prices that results from a perverse self-reinforcing belief system."[105] This asset-price hyperinflation was rampant in the art world when money was *the* qualifier. In days of yore dealers used to price the work of new artists as reasonably as possible in order to encourage the widest possible interest from their clients. Since the turn of the century until the reckoning of 2008 (when the self-reinforcing belief system met the implacable reality of the worst economic crisis since the Great Depression), dealers priced new work as high as they dared to get it noticed. Accepting the premise that quality is expensive, collectors and their advisors were lured by art that, because it was expensive, presumably must be good, or else other people would not be paying so much for it. Often this reasoning replaced meaningful scrutiny of the object.

Branding

When the Museum of Contemporary Art in Los Angeles collaborated with French luxury-goods company LVMH, owned by collector Bernard Arnault, to install in the museum a store selling Louis Vuitton handbags designed by Murakami and American fashion icon Marc Jacobs, a perfect trinity of art, fashion, and business was created. Hundreds of people enjoyed the thrill of being latest-fashion art patrons without having to spend a million dollars plus for a major painting by Murakami. This powerful *ménage à trois* even seeks to embrace long-dead art and artists with no sense of irony or absurdity. A previously mentioned story titled "Jack the Dripper," published in the *International Herald Tribune "Style" Magazine* in March 2008, identified a host of well-known fashion designers inspired by Pollock's paintings. One, Adam Kimmel, was obviously seduced by the artist's sparse wardrobe: "He was at the forefront of existential masculinity."[106]

Branding has always been important in art; we might say that both "Leonardo" and "Warhol" are brands. Successful branding obviates the critical approach: the work of art *must* be good (i.e., worth its considerable price) because the artist's name is currently fashionable. Where we once might have looked for a discussion of meaning or interpretation, now we merely find evidence that reinforces the brand identity. In the catalogue note for Murakami's *My Lonesome Cowboy* (a sculpture in an edition of five of a naked youth wielding a stream of ejaculate as a lasso), which sold at a Sotheby's auction in May 2008 for $15.2 million, an anonymous specialist writes: "Murakami is often billed as the next Andy Warhol."[107] "Billing" used to be advertising jargon confined to the entertainment industry, but in this art world "billing" is paramount because it is the name of the artist that propels consideration of the work, not vice versa. And the linking of Murakami to the well-established Warhol brand provides rub-off luster.

I learned a good lesson in generic art branding in Indonesia in 1995. I was taken by a client to see her collection in a suburb of Jakarta. Making polite conversation in the car, I asked her what she collected. "All famous names," she answered. I pressed her for specifics. "You know," she said, "Sotheby's and Christie's, those names." When I examined the paintings, I could see what she meant. Not all were first-rate, but each one proudly

sported the ubiquitous sticker on the front or side of the frame with the printed name of the auction house and a handwritten lot number (today they are bar-coded).

From Readymade to Factory-Made

In 1914 Marcel Duchamp upended the definition of fine art by declaring "found" objects (such as a galvanized iron bottle-dryer) worthy of being exhibited and accepted as bona-fide sculpture (fig. 39). Duchamp rationalized that the act of choosing a readymade allowed him to "reduce the idea of aesthetic consideration to the choice of the mind, not to the ability or cleverness of the hand which I objected to in many paintings of my generation."[108] As a profoundly radical position, this was clever, challenging, and witty. It was certainly not profitable for Duchamp. In fact, he lost the first bottle rack he had "found."

In the 1960s Warhol called his studio the Factory and promoted the idea that by working in series, as artists have done throughout history, he had created an assembly-line approach to making art. In fact, while he did employ studio assistants, as do many painters, his glib pronouncements concealed hands-on control. His paintings are to manufactured goods as his experimental films are to Hollywood movies: handmade, rough, demanding, and original.

Duchamp and Warhol are frequently invoked today to justify the teams of skilled professionals, including computer programmers, who actually produce the highly finished works of art designed by the person ("artist") whose brand name sells the work.

Like Damien Hirst, American art star Jeff Koons unabashedly designs paintings and sculptures that are largely manufactured by assistants and subcontractors. "I'm basically the idea person," boasts Koons. "I'm not physically involved in the production. I don't have the necessary abilities so I go to the top people."[109] In November 2008 the British newspaper the *Guardian* reported that Hirst would not be renewing the contracts for some of the "workers" who manufactured his products, presumably because of diminishing sales, prompting the speculation that one day he might actually have to make his paintings and sculptures *himself.*

Duchamp was true to the iconoclastic spirit of Dada, which registered the chaos and disillusionment of Europe between the two world wars;

and Warhol's breathless "gee-whiz" attitude in the 1960s was loaded with irony. Two decades after Warhol's death, great wealth was created by the manufacture of visually appealing objects by artist/entrepreneurs in the form of commoditized paintings and sculptures consumed by some collectors and museums as well as many speculators. To me, there is some wit in this cynical process but none in the work itself. Sculptor Richard

Serra defined the commodity-oriented misunderstanding of Warhol very well when interviewed by Kynaston McShine for his 2007 retrospective at the Museum of Modern Art:

Warhol challenged and critiqued the media, spoofed it and mocked it by saying "We're all stars." But that also had the effect of attracting the media, and the generations that have come after Warhol took that at face value—they misread his subversiveness. He was able to manipulate the media and turn it back on itself as a critique; that's been lost. Later generations have understood his marketeering and his ideas about art as business, but they have not understood the radicality with which he mocked the media— how he inverted it and made the culture understand that the media served everything up the same, whether it was a car crash or a soup can. I think the younger generation sees what Warhol did as a way to make the market respond, but that's not all he was up to. His criticality and subversiveness have been lost.[110]

By the turn of the century the language of money had become the lingua franca of the art world and the entry point for many new collectors. Serious critical discourse was drowned out by the noise of the marketplace. In such an atmosphere, why should one "original" painting or object have to be different from another, and why should they have to be handmade by a particular individual?

My old-fashioned belief is that art appeals to a higher part of my nature other than that which decides which television show to watch. But clearly there has emerged a highly influential generation of makers and consumers of art for whom art fit seamlessly into an exciting life of fashion and finance. The furious debate caused by the critically panned exhibition *High and Low: Modern Art and Popular Culture* at the Museum of Modern Art in 1990 now seems quaint and irrelevant. In the first decade of the twenty-first century contemporary art and popular culture have been married, with commerce holding the shotgun and the photos sold to the *New York Times Magazine*.

What Are the Consequences?

A small museum not far from New York raised funds recently by selling large posters from long-ago solo exhibitions of now dead-and-famous artists. I happened to visit a local frame shop filled with excited couples who had bought the posters and were eager to hang them in their homes.

I could not avoid seeing that, while impressively large, the posters were poorly printed, featured colors not true to the artists' work, and bore penciled signatures that looked suspiciously clear and well formed. I was surprised to hear the customers boast that they had paid "only" $750 for each poster, half the advertised price. In my opinion one-tenth that amount would still have been too much. Expensive frames were being ordered, and there was a great deal of semi-informed discussion back and forth across the counter about sunlight, special glass, and acid-free mounts. It was clear that these poorly printed posters with suspect signatures were, to their new owners, distinguished works of art by famous artists and that they were paying a small fortune to have them handsomely framed. Sadly, what they were spending would have purchased bona-fide lithographs, etchings, or silkscreen prints, actually made, signed, and numbered by established living artists.

The greatest consequence of the commoditization of art is the loss of integrity of the object because it is with the integrity of the object that all lasting, true value lies. In his later years Giorgio de Chirico painted replicas of the early Surrealist works upon which, justifiably, his reputation rested. These repeats of his youthful inventions appear more skillfully executed, and the colors are brighter, yet as paintings they are shallow and lifeless.

Posh Lust

Many works of art by some of the recently top-billed art stars combine a fetish for finish with a deadpan dumbness and lack of originality for which there is no expression in English, but the untranslatable Russian word *пошлость* (pronounced "poshlost") seems apt. Vladimir Nabokov defined it (and punned "posh+lust") as "not only the obviously trashy but also the falsely important, the falsely beautiful, the falsely clever, the falsely attractive." Svetlana Boym elaborates: "Poshlost . . . encompasses triviality, vulgarity, sexual promiscuity, and lack of spirituality."[111] These attributes have been fodder for contemporary artists for half a century but have recently been elevated and worshipped with no sense of irony.

We pride ourselves on an extremely diverse culture and respect for everyone's opinion, including that of the uninformed and inexperienced. This contributes to the syndrome, recently prevalent in contemporary-art circles, of the Emperor's New Clothes. In some critical quarters

qualitative judgments are considered to be old hat, and in this topsy-turvy world bad art is good. Connoisseurship is condemned in favor of philosophical gamesmanship. Furthermore, when the art market was booming, the commercial success of an artist immunized him or her from any front-row critical evaluation. Voices crying from the back of the crowd that the reigning art emperors are bare-assed naked went unheard by the speculators and their fellow travelers who took charge when the auction houses started to serve Dom Perignon champagne and Beluga caviar at their preview parties.

THE ART OUR CULTURE DESERVES

> If politicians were painters, with FDR as Titian and Churchill as Rubens . . . Bill Clinton might aspire to the heights of Salvador Dalí (and believe himself complimented by the comparison), Tony Blair to the standing—and cupidity—of Damien Hirst.[112]
>
> —TONY JUDT

Every aspect of our culture suffers from the conflation of quality and price. Political candidates are judged by the sums of money they raise. Movies are good if they take in $50 million the first weekend. We say of our neighbors, "They live in a $2 million house," and many of us are convinced the more expensive wine must be better. Publishers give multi-million dollar advances for ghostwritten books authored by celebrities while they pulp literary works that fail to meet their modest advance. In our voracious consumer society an act of purchase is not a means to an end: it is the end itself, and the higher the price, the more justified the purchase.

One of the signs of a decaying culture is a reverence for form over content. Much contemporary art commanding high prices is extremely polished—a good reason for the artist to employ professional fabricators. Expensive cars and yachts are well crafted from expensive materials that fit together perfectly. Why should art be any different? Most wealthy people used to purchasing the best in homes and vehicles have a quick eye to discern between shoddy, slapdash workmanship and top craftsmanship. This is just as well because, they, like many of us, are unable to find the time to do more than snack on art, distracted as we are

by the constant flow of information and communication that we receive in every minute of every day. Increasingly we exist in a culture where being self-interrupted by connections (laptop, BlackBerry, iPad, iPod, iPhone) replaces living. For fine art to compete for our highly diffused attention, it has to be big, expensive, well made, and fun to buy. Auction-house owner Simon de Pury keeps his finger on the pulse of the art world, and in April 2008 (just six months before the global credit implosion) he packaged a sale of work by contemporary Japanese artists under the rubric "Kyōbai," which he explained thus in his foreword to the catalogue: "Kyōbai stands in Japanese for Go, Run & Get it! This is our motto at Phillips de Pury & Company and will hopefully be the motto for collectors and art lovers around the world."[113]

Today many of us are ruled by technical innovation to such a degree that we are not even aware that staring at a two-inch screen in the palm of our hand can become an addictive distraction from life. Sustained attention to anything at all, let alone a work of art, violates our need to be constantly connected and informed. We allow ourselves to be bombarded with information, most of which we absorb unedited and unanalyzed. In the previous chapter I placed great emphasis on the need to look well and long at a work of art in order to absorb its essential value. Powerful works of art, of any era, grow with careful, patient scrutiny—the longer you look, the more you get. Lesser works of art reveal their deficiencies when looked at repeatedly over time. Some of the most expensive art made and sold since 2000 is neither designed for nor receives meditative examination. Not unlike certain forms of literature, film, and music it accommodates short attention spans. McArt. Go, run, and get it.

So inured is the art world to this approach that it became headline news when Takashi Murakami decided to *actually make his own paintings*. In the September 2010 issue of the *Art Newspaper,* he announced, "I am now nearly 50 years old, I have created my company, and created my world. . . . The works you see behind you are the production of a team of assistants. Now that the situation permits, it is the moment to do my own work by my own hand." According to his dealer, hitherto "Murakami works from computer graphics using teams of assistants . . . working from computer files, *there is no element of subjectivity*" (my emphasis).[114]

IS OURS A GOLDEN AGE?

Contemporary art used to mean work by artists very much alive—that is, "new" compared to art of the previous generation. Now the term applies to almost anything created since 1945. So-called classical contemporary art (old new art?) might be defined as the Warhol you wished your parents or grandparents had bought in 1962 for $750. As soon as we decide on a catchphrase for new art, such as "avant-garde" or "cutting edge," it quickly becomes hackneyed and not quite tough or sassy enough to adequately package *today's* new art. For a while we seem to have settled on "postmodern," which has an academic definition wide enough to include almost anything except a building by Mies van der Rohe. For the rest of us "modern" simply means up-to-date, so anything postmodern must be, like the latest from Procter and Gamble, newer than new.

In order to justify high prices for today's new art, it has to be presented as intrinsically more important than the art of yesterday or a hundred years ago, as if we are in a golden age of creativity. Sadly, golden ages are not a dime a dozen, and if we look back we see but a handful of glowing spots in the history of Western art, each one followed by many decades of indifferent or inferior works of art, most of which are imitations and elaborations of or degenerations from golden-age masterpieces.

In the last two hundred years or so of Western culture there have been a number of milestones of vastly accelerated innovation, sometimes lasting just weeks or months, usually followed by decades of digestion and elaboration. William Wordsworth and Samuel Taylor Coleridge spent less than a month together in 1796, as very young men, collaborating on *Lyrical Ballads* and yet changed the course of English literature. In 1907 Picasso and Braque together created Cubism, and in 1953 Rauschenberg and Johns met and started the synthesis of common objects and uncommon ideas that later became known as Pop Art.

I am convinced that in modern times the most exciting and innovative art occurs in concert with events (invention, war, migration) that mark tectonic shifts in human behavior and thought. The role of the artist has often been to anticipate, record, or express visually the colossal effect of these shifts. It is then unsurprising that the twentieth century, a period of unparalleled developments in science and philosophy, as well as "an

age of brutality and mass suffering perhaps unequaled in the historical record,"[115] had more than its fair share (as examined today, still in close-up) of fine-art revolutions.

While at the time they often appeared to be making clean breaks with the art of the past, the giants of the twentieth century were in fact in perpetual dialogue with the history of art, endlessly studying their aesthetic ancestors to borrow and steal, parody and pay homage. They respected the weight of the history that they were following but were not confined or intimidated by it. The new was perpetually informed by the old even as it sought to replace it.

A hundred years ago the emergence of Cubism created palpable excitement among artists, dealers, writers, and collectors. There was a real sense that a new aesthetic was dawning. The English critic Clive Bell described it, as it was happening, in 1913:

> Art is as good an index to the spiritual state of this age as of another; and in the effort of artists to free painting from the clinging conventions of the near past, and to use it as a means only to the most sublime emotions, we may read signs of an age possessed of a new sense of values and eager to turn that possession to account. It is impossible to visit a good modern exhibition without feeling we are back in a world not altogether unworthy to be compared with that which produced primitive art.[116]

Bell was both keenly aware that the new art was not only a manifestation of radical change but also linked historically to a much earlier age of forceful expression. For some of today's headliner artists, the history of art appears to be weightless. The past only has meaning for them if it can be made to reference the present. Ideas and images that were potent constructions in the hands of modern masters like Picasso and Matisse, Rauschenberg and Warhol, became so much Play-Doh for object designers liberated from the world of the intellect.

At the dawn of the twenty-first century science fiction has become a reality, cell phones and laptop computers are as commonplace as wristwatches. 9/11 is the symbol of the new nature of war as stateless terrorists challenge the so-called superpowers and science seems to give credence

to our own end of days with the acceleration of global warming. I may be looking in the wrong places, but so far I don't see many artists reacting, expressing, or prophesying because of these game-changing events. A hundred years ago great innovators such as Picasso, Braque, Kasimir Malevich, Léger, and Delaunay upended the very nature of art as science and war similarly changed the world, suddenly and radically. Nevertheless, I am convinced that the twenty-first century will produce its own truly great artists (some perhaps as yet unborn) to express the impact of current history on the human condition.

THE RECKONING

In late 1999 I had lunch with a veteran collector who began buying Impressionist, modern, and contemporary art in the mid-1980s and had seen the value of many works in his collection rise dramatically, particularly those by postwar artists like Warhol and Basquiat. We both agreed that the contemporary-art market had to peak in 2000, as it had in 1990. We were off by almost a decade. It took another eight years and a financial tsunami of global proportions to settle the contemporary-art market back on its heels. During those first eight years of this new century, many new artists, gallery owners, auction-house specialists, speculators, and pundits who had never experienced a downturn were sucked into a vortex of rising prices.

From 1987 to 1990 the Japanese bought approximately one-third of all the nineteenth-century, Impressionist, and modern art in the market, as well as a substantial number of Old Master paintings. Fueled by loans against inflated real-estate values, they bought the good, the bad, and the indifferent with little or no negotiation and, with help from fellow travelers across the globe, values for certain kinds of work doubled annually. When the Japanese economy crashed in 1991, the art buyers dropped out overnight. There were no more golf-course owners in Fukuoka to inhale every Renoir in sight. For a couple of years the phones in galleries and auction houses rang only intermittently. By 1995 a recovery had started, and the vacuum left by the Japanese began to be filled by new collectors in places like Taiwan, Singapore, and Hong Kong, as well as newly rich buyers from the burgeoning dotcom industry in the United States.

From 1945 until 1995 the art market moved in cycles of anywhere from seven to nine years, so the stretch between 1987 and 1995—when it rose quickly, peaked, dropped back somewhat, and began, more slowly, to rise again—was typical. By 2005, however, there had been ten years of growth and seemingly no signs of any slowdown. A whole new generation of contemporary artists had a whole new generation of buyers prepared to put million-dollar deposits on as-yet-unmade work. There is no wonder that enthusiastic promoters preached that the cyclical-market model should be retired and that with the fusion of art, entertainment, fashion, and lifestyle a brave new order had been established, aimed forever skyward. This new order was celebrated in a chatty book by an economics professor published just before the October 2008 financial collapse. In Don Thompson's *The $12 Million Stuffed Shark: The Curious Economics of Contemporary Art and Auction Houses* works of art are measured by price in the same way that in tales of Hollywood glamour movies are measured by box-office receipts, and the emphasis is on the flashy lives and foibles of the stars (artists), moguls (collectors), and agents (art dealers). Toward the end of the book Thompson opines, in retrospect wistfully, "There is further hope that a crash will be avoided."[117]

What Happened, and When?

Nobel Prize–winning economists, bankers, and politicians will long debate the causes of the roiling fiscal debacle that hit the headlines in the fall of 2008. Suffice it to say that the art market, which rarely reacts to the general economy in any conveniently predictable way, was immediately rocked by the same waves that toppled investment banks and businesses large and small.

In December 2008, the US government announced that the economy had been in recession for a year, hardly news to the recently unemployed and the many whose homes were worth less than their mortgage debt. It was slower in coming to the art world. The annual Art Basel fair in June 2008 was the best in memory for many of the participating galleries, and it may have marked the high point of the market for dealers. Still, dealers noted a growing tendency for collectors to take longer to make up their minds and to negotiate harder; and, over the course of the summer, some commitments were canceled.

The lack of activity in August, traditionally the slowest month of the year in the art business, was not worrying, but on September 4, Sotheby's filed a lawsuit against well-known collector Halsey Minor, claiming he had failed to pay $13 million for paintings bought in May, a drastic action, the news of which contributed to the general anxiety. On September 15 Lehman Brothers filed for bankruptcy protection, and the New York stock market plummeted. In London, five hours ahead, Sotheby's auctioneer Oliver Barker started to wield the gavel for an unprecedented two-day sale of almost three hundred new works fresh from the studios of Damien Hirst. It was an astounding success, totaling over $200 million. Presciently symbolic and marking the teetering zenith of the first bull art market of the millennium was the star lot *The Golden Calf,* a white bullock preserved in formaldehyde with hoof, horns, and halo of 18-carat gold. It sold for $18.6 million. This becomes *Cash Cow* by "Liam Hogg" in Sebastian Faulks's novel *A Week in December,* which partly chronicles the shenanigans in the financial worlds of London and New York. Proving fiction to be less strange than truth, the novel predated the auction by a good ten months, thus situating it well before the debacle. Many of his leading characters gather at the glamorous preview party: "'I've yet to meet a single person not in finance,' grumbled Lance Topping. 'Half the bloody hedge-fund industry seems to have pottered over from Mayfair after work.'"[118]

Why was Hirst's sale such a success when the global economy was spinning out of control? Optimists cited art as a target for capital fleeing from the uncertainty of the stock markets. Pessimists chalked it up as the last gasp of superhype. Both Sotheby's and Hirst had relentlessly promoted the auction with lavish advertising and VIP gala events worldwide. They had also, it was rumored, extended unprecedented credit terms to entice bidders.

Frieze Art Fair: Conflicting Reports

Any sense of bullets dodged engendered by the Hirst sale evaporated when the Deutsche Bank–sponsored sixth annual Frieze Art Fair of contemporary art opened in London one month later on October 16. A reporter for *New York* magazine filed a particularly pessimistic story from the fair's front lines—"talk of financial doom filled the air"—but while

participant dealers and their clients both admitted that the frothy buzz of yesteryear was absent, many boasted that significant sales had been made and business had not even remotely ground to a halt.[119] However, "Art Sales What They Used to Be a Couple of Years Ago" is not a headline that will sell newspapers, and with predictable *schadenfreude* the press looked to the art world for evidence of the mighty brought low, as if fired blue- and white-collar workers alike might derive solace from knowing that the company's CEO had to sell one of his Picassos. More genuine concern was voiced that with Lehman Brothers and other investment banks seriously disabled or out for the count, corporate support for museums and art fairs would dwindle. But very quickly other sponsors like UBS and AXA Insurance pledged to continue their programs and pick up some of the slack. At least one top museum official looked on the bright side: "Maybe we'll finally be able to afford to buy things," commented Michael Govan, director of the Los Angeles County Museum of Art.[120]

An Idea Whose Time Suddenly Went

Days following the Frieze Art Fair, New York's Central Park hosted an ill-timed celebration of the apotheosis of the commoditization of art— possibly the last of its kind for the decade. Fashionable architect Zaha Hadid's portable minimuseum, her ode to Chanel's quilted chain-strap handbag, arrived near Fifth Avenue and 69th Street fresh from appearances in such brand-hungry hotspots as Tokyo and Hong Kong. Free to the public and with none of the Chanel bag–inspired art that was installed inside for sale, this Oldenburgian nightmare of conspicuous consumption prompted Nicolai Ouroussoff of the *New York Times* to muse that while Central Park's co-designer Frederick Law Olmsted had planned the space "as a great democratic experiment, an immense social mixing place as well as an instrument of psychological healing for the weary. The Chanel project reminds us how far we have traveled from those ideals by dismantling the boundary between the civic realm and corporate interests."[121] We needed no reminder from Ouroussoff that the boundary between art and fashion was also long since dismantled (although hopefully in storage somewhere).

The Fall 2008 Auctions

Two weeks of New York auction sales started on November 3 at Sotheby's in an atmosphere at best subdued. The strong results of the sales in May and June and fierce competition between the houses had inspired high estimates agreed well before the signs of financial turmoil. Many top-value paintings were guaranteed at equally high levels. This meant that the auction houses were committed to paying sellers specific amounts regardless of where the bidding ended or indeed, if there was any bidding at all. As the sale dates approached, many auction-house specialists made it clear to prospective buyers that the estimates could be ignored and that even very low bids might be successful. This meant that not only had they persuaded some consignors without guarantees to sell well below the estimate range but that guaranteed works could be sold also below the estimate range, indicating that the auction houses were prepared to lose money on the guarantees. Which they did. The biggest casualty was a Rothko bought in 1988 for $1.5 million and estimated by Christie's for a whopping $20–30 million. It failed to attract any bids.

Although the works sold in these Impressionist and modern sales were of varying quality, they were by artists with decades (or over a century) of solid market sales by established galleries, artists well represented in the major museums of the world. Almost all enjoyed rising values during the boom years, but the majority were bought by serious collectors, not speculators. The same is not necessarily true for all of the works offered by Sotheby's, Christie's, and Phillips during the following week of contemporary sales. The results indicated that many of the speculators who had supported very high prices for currently fashionable artists were sitting on their paddles. One exception was Los Angeles collector Eli Broad, who spent freely at Sotheby's and then told the *New York Times* that it was a "half-price sale."[122]

Silver Linings

In late October 2008 both Christie's and Sotheby's held auctions of twentieth-century Italian art by artists such as Lucio Fontana, Giorgio Morandi, and Marino Marini. Their market is international but dominated by Italian collectors, whose national artistic heritage weighs heavily in favor of art, coming a close third after food and shelter as a life

necessity. Sotheby's sold over 88 percent of the sale, establishing records for five artists, and Christie's did almost as well. Obviously, the bidders believed in the longevity of the artists' reputations and the quality of the individual works offered.

Six weeks later, with no end of economic turmoil in sight and stock markets gyrating wildly, the annual auctions of Old Master paintings were held in London with both houses doing well. Christie's sold 80 percent, with top prices of over $4 million for a painting by Giovanni Battista Tiepolo (fig. 40) and almost $6 million for one by Antonio Canaletto. As an example of inflation, at that time still evident in the contemporary-art market, compare these prices to the $5.5 million paid at Sotheby's three weeks prior for *Nice 'n Easy* (1999, fig. 41), a painting by the young American John Currin. Heralded in recent years for his erotic images of amply endowed females, Currin is a few centuries short of Tiepolo in the art-history stakes. *Nice 'n Easy* was supported in Sotheby's catalogue by a small (wise decision) image of Lucas Cranach the Elder's *The Three Graces,* proving that not even the global credit squeeze had halted the momentum of hype.

As the visible tip of the art market, auctions are a useful thermometer of the market's health only for people who can remember the average temperature, not just yesterday's heat wave. In a bull market caught short, comparisons are made with the most recent high points, rather than with business as usual. Thus a five-day auction at Christie's in Hong Kong in December 2008 of Asian works of art, including many recently minted contemporary artists, totaled an astounding $146 million, but was reported as a failure because only 70 percent was sold and the total was half that of the previous sale in May. In fact, the result of those sales, as well as the Italian and Old Master sales in London, showed the amazing resilience of the commercial value of art in a time of global economic crisis.

What Happens When the Art Market Slows Down?

While an overheated art market attracts speculators, most of whom disappear when things slow down, there are always a few who caught the bug so badly that they become "real" collectors and continue to look for things to buy. They are joined by inveterate collectors, some of whom

Fig. 40
**GIOVANNI BATTISTA
(GIAMBATTISTA) TIEPOLO**
Portrait of a Lady as Flora,
c. 1760
Oil on canvas
34¾ × 27½ in. (88.3 × 69.9 cm)
Private Collection

were sidelined by escalating prices and now return, cautiously. With less money around, the art market shrinks and sheds what has most recently been added, such as:

Preposterous prices for "hot" young artists.
Preposterous prices for overhyped midcareer artists.
Auction catalogues weighing over ten pounds.
Champagne openings and caviar preview parties.
Assistants for gallerists' assistants.

Fig. 41
JOHN CURRIN
Nice 'n Easy, 1999
Oil on canvas
44 × 34 in. (111.8 × 86.4 cm)
Private Collection

Art fairs in totalitarian countries.

"I don't need to see it; just tell me the price" mentalities.

Once this happens the business of exhibiting, looking at, buying, and selling art becomes infinitely more interesting and personal. The buyers take charge of the market, and sellers, including artists, adjust their expectations. This started to happen in 2009, a year that many in the art trade look back upon as their most recent *annus horribilis*. Sotheby's

and Christie's auction catalogues took on a leaner, hungrier look, and a few galleries closed or downsized. Following the resignation of longtime director Ann Freedman, Knoedler and Company, established in 1846, put its distinguished Upper East Side Manhattan townhouse on the market.

Some primary-market galleries representing boom-time artists faced the dilemma of either lowering the prices for their artists' new work to make sales or maintain the fiction that the old values still held, and sell nothing. Art fairs reported sales relatively modest in both quantity and price, but some business was done. Late 2009 saw a marked improvement as collectors got bored doing nothing and, perhaps more important, turned to fine art as a low-risk tangible asset.

AN ART MARKET IN RECOVERY

Cheers were heard at Sotheby's London sale in February 2010 when one of ten bronze casts of Alberto Giacometti's *L'homme qui marche I* (Walking Man I, 1960, fig. 42) sold for $104.3 million,[123] and again two months later in May when Christie's in New York sold the previously mentioned Mrs. Brody's 1932 Picasso for $106.5 million. Proving that there is now no distance at all between high art and popular culture, a *New York Post* headline screamed "Picasso Green Period."[124] Furthermore, barely three months after Giacometti's "world record," the work appeared on the wide screen in comic-book hero Tony Stark's mansion in the hit movie *Iron Man 2*. Both final bids just topped the previous highest price paid at auction six years earlier, also for a Picasso. In November 2009 fierce bidding at Sotheby's shot Warhol's *200 One Dollar Bills* from an estimate of $8–12 million to a final bid of $43,762,500, and a few days following the triumph for Mrs. Brody's heirs, those of Michael Crichton celebrated the $28.6 million paid for the author's painting by Johns of the American flag. The press loves to hear from the auction houses that world records have been broken and then to concoct different categories, rather like the *Guinness Book of Records*: "American Living Artists," "Contemporary Chinese Painting," and so on. Few of these so-called records would hold up against prices that have been paid in private transactions because many sellers and buyers of truly great works of art prefer to have their business conducted privately, away from the circus atmosphere.[125]

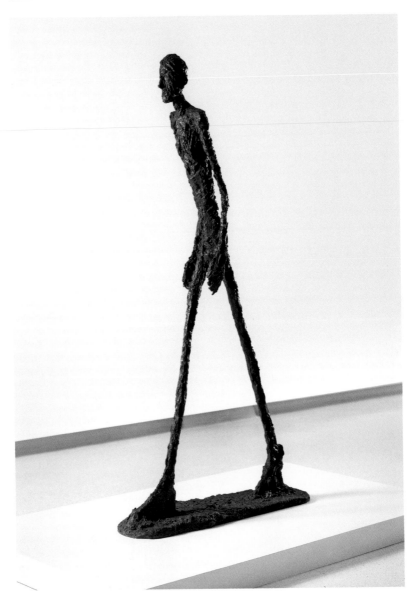

Fig. 42
ALBERTO GIACOMETTI
L'homme qui marche I,
edition 1/6, 1960
Bronze
71¾ × 38 × 10½ in.
(182 × 97 × 27 cm)
Carnegie Museum of Art,
Pittsburgh. Patrons Art Fund

Rather than relate prices paid at auction in May 2010 to the quality of the works on offer, which would have been a struggle for most commentators, surprise was expressed that the sales did so well given that the international money markets were teetering once again, with the Dow average sinking to the news of credit downgrades for Greece, Spain,

and Portugal.[126] In fact, as was the case in the private-sales market, an increasing number of extremely wealthy individuals from the Americas, Europe, Russia, and Asia were shopping for top-quality works of Western art. Why? Perhaps some of them actually like art and enjoy collecting! These persons are immune to money-market fluctuations or perhaps are actually increasing their wealth by betting against growth.[127]

While the demand for top-quality Impressionist, modern, and post-war fine art in 2010 was as strong as before the recession, indicating a widespread taste for blue-chip paintings and drawings, major modern sculpture became particularly popular. A short-term collector bought a bronze cast of Rodin's trademark *Thinker* in a Paris auction in June 2009 for $3,577,322, and less than a year later sold it at Sotheby's in New York for $11,842,500.[128] Also, the value of important works by Warhol surged in late 2009 and 2010: *Airmail Stamps* (1962), a small painting that had been sold in 2005 for $1,024,000 and again in 2007 for $1,364,500, fetched $3,890,500 in May 2010.[129]

In September 2010 Sotheby's auctioned the Lehman Brothers Corporate Art Collection almost two years to the day after the venerable firm collapsed. The star lot, with a four-page catalogue entry, was Damien Hirst's perhaps now ironically titled *We've Got Style (The Vessel Collection—Blue/Green)*, a sculpture of shelves of ceramic objects. It was estimated at $800,000 to $1.2 million, but there were no bids.[130] Works by Richard Prince and John Currin sold for half their estimates. More modestly priced works fared better.[131]

Auction houses and galleries do not always serve the same clients. I found that by 2010 new collectors were both asking dealers to find them specific treasures and also browsing in galleries with serious intent to get a feel for the market and the prices of available works. Collectors who only buy at auction think this old-fashioned and time-consuming, but those who do it believe they are educating themselves, spending their money wisely, and having fun, all at the same time.

Barring another global financial meltdown, the art-market recovery will continue but probably without spikes in the near future. The New York auction sales in May 2011 started slowly with Sotheby's Impressionist and modern auction failing to sell 25 percent of its fifty-seven lots. Moreover, many that did sell received only one bid. The following night

Christie's sold more works of art with much bidding but made less money. Each sale had one or two stellar lots, but overall the quality was mixed. The contemporary sales started off well, with Sotheby's sale of works from the estate of a highly respected New York dealer, Alan Stone. He represented Wayne Thiebaud, and a group of early Thiebaud paintings went for record prices. After that it was downhill with bids few and far between. The Koons *Pink Panther* cover lot, estimated at $20–$30 million, sold to a lone bidder for under $17 million. The sale totaled $128 million—slightly over the low estimate—but the following night Christie's took in almost $302 million with very determined bidding. Christie's offered better-quality works, particularly by artists whose reputations transcend fashion, such as Alexander Calder, Joan Mitchell, Guston, Francis Bacon, Rothko, and yes, Warhol, whose early 1963–64 four-part self-portrait sold for almost $40 million against an estimate of $20–30 million. As usual, these auctions were parsed minutely by the art press, the *New York Times* going so far as to identify one high-end bidder as a "young, unidentified blue-jeans clad man,"[132] as if he were a police suspect.

The contemporary auctions in London in June 2011 demonstrated more competition for good works by artists with historical strength than for work by today's aging young turks. As in New York a few weeks prior, Basquiat and Warhol fared very well, as did Freud, whose small *Woman Smiling* (1958–59, fig. 43) fetched $7,599,695.

Top honors went to Bacon's *Study for a Portrait* (1953), which sold for almost $29 million. Whether or not my reading of these auctions is fair (some works may not sell for reasons having little to do with their quality), the micro-analysis that much of the art press engages in exaggerates what may be a fluke into a trend. Missed in the mix is the breadth and depth of year-round selling and buying in the galleries, which is steadily increasing. Even when the auctions are boasting record results, the total amount of business transacted by the trade is far greater. The primary market is robust so long as the prices for work by emerging and midcareer artists are kept reasonable and not speculative, and in the secondary market sellers often prefer the greater control they have when working with a dealer to gambling with their work at auction.

Crowing about record prices is a timeworn auction-house tradition, although well-founded rumor suggests that the highest prices for art are

Fig. 43
LUCIAN FREUD
Woman Smiling, 1958–59
Oil on canvas
28 × 23 in. (71 × 55.8 cm)
Private Collection

in fact negotiated by dealers. For example, at least three works (by Pollock, de Kooning, and Gustav Klimt) sold in 2006 in private transactions for more than the $106.5 million paid for the aforementioned Brody Picasso in May 2010.[133] The Pollock, *Number 5* (1948), was tagged at $140 million, but this price was well eclipsed by the murmured $250 million ("or more," according to Georgina Adams of the *Financial Times*) paid in the spring of 2011 for Cézanne's *The Card Players* from the collection of the late George Embiricos.[134]

Contemporary auction catalogues for the fall 2012 season in New York were fatter than ever with close to a billion dollars changing hands. Significantly, 85 percent of the works sold for over $10 million were by deceased twentieth century artists with strong secondary markets, not the smoothly marketed "superstars" of the previous decade. This season also witnessed widely discussed public defections by two art writers of very different stripes. The distinguished curator, educator, and critic Dave Hickey announced his retirement in a lengthy interview[135] excoriating the mores of an art world utterly changed from the one he (and I) entered in the 1960s, and art market journalist and cultural sociologist Sarah Thornton wrote an article about the art market titled, paradoxically, "Top 10 reasons NOT to write about the art market."[136]

AD 2020

Relative to the lasting values of art, the second decade of the twenty-first century is likely to be a lot more exciting than the first, particularly in the field of contemporary art. With money no longer the sole power of the equation, quality judgments may be less clouded. Just as no work of art is made great for having cost a fortune, neither is great art made less great for being sold at a reasonable price. In a stable art market there is more parity between the commercial, social, and intrinsic values of art. To quote Michael Govan again: "Art doesn't lose its emotional or artistic value. . . . That doesn't change no matter what the economy."[137]

Not all artists are obsessed with high prices—even ones that command them. Some achieve both financial success and critical acclaim, steer clear of commercialism and careerism, and are to a large extent immune from the vagaries of both bull and bear art markets. Decades ago the California dealer Irving Blum approached Johns to sell his masterpiece *White Flag* (1955, fig. 44) for the then-astonishing sum of $2 million, well above what had been paid for any work by the artist. The proposal came during an expensive lunch. Johns avoided the subject as Blum became more and more persistent. Finally, Johns said he would not sell. "Irving, it's not worth it," he told the dealer, with a smile as he left the restaurant.[138]

Rosenquist, who, like Johns, still paints by hand, said the following words to students at the venerable Rhode Island School of Design, who

were in danger of being beguiled by wealth and fame at the height of the boom in 2007 (fig. 45):

> Fine art is not a career. You may be very good and no one looks at your work until you are dead. Most artists don't cut it. I have had thirty-five assistants in the course of my fifty years as a painter and not one of them achieved any success as an artist. What you need is luck. Nothing is guaranteed or automatic.

When asked about the process of making art, he has said, "It is working like hell towards something you know nothing about."[139]

Fig. 44
JASPER JOHNS
White Flag, 1955
Encaustic, oil, newsprint, and
charcoal on canvas
78⁵⁄₁₆ × 120¼ in.
(198.9 × 306.7 cm)
The Metropolitan Museum
of Art, New York

Only one thing is guaranteed, and that is change. Cutthroat cultures have flourished in the past, died, and been succeeded by periods of genuine innovation. Art that excites me today by artists both celebrated and emerging is that which is unusual, challenging, intelligent, profound, and, above all, visually stimulating. Such work transcends appropriation, attitude, and fashion, hallmarks of yesterday's hollow high-priced art objects.

I have said I cannot discern the impact of 9/11 on American art of the last ten years (it might well be there; I just don't see it) but artists from other parts of the globe, particularly Asia, appear to be more finely tuned

Fig. 45
JAMES ROSENQUIST
*The Richest Man Gazing
at the Universe*, 2011
Oil on canvas
108 × 240 in.
(274.3 × 609.6 cm)
Private Collection

to the temper of their times. The following passage appears in *Beijing Coma,* Ma Jian's masterful novel about pro-democracy activists in China in the late 1980s:

> The drifter hadn't shaved for months. His beard had grown so long that security guards had arrested him twice recently, sus-pecting him of being a dissident artist. It was during the week when a band of avant-garde artists put on a show at the Beijing Art Gallery which involved shooting guns into the air.[140]

The very real incident referred to occurred in February 1989, five months before the massacre in Tiananmen Square (a self-inflicted 9/11), when Xiao Lu, a woman artist, fired two shots into her own mirrored sculpture in the first government-sponsored exhibition of experimental art at the National Gallery of Art. After that, progressive art in China went underground. Some artists moved overseas, and in the mid-1990s a loose-knit gang of artists denied official status (and thus access to paint

and canvas) came together, calling themselves the East Village Community. Using performance, installation, and photography, they created eloquent works expressing profound dimensions of change, from the personal to the political to the environmental. Interestingly, one of these artists, Zhang Huan, who achieved considerable success in the West, both critical and financial, now has a 75,000-square-foot complex of six buildings in Shanghai, where a commune of one hundred craftspeople and helpers collaborate on his paintings, sculptures, and prints (fig. 46).

It is possible that the most compelling global narrative of the end of the twentieth century is the social, cultural, and economic synergy between the Occident and the Orient. Authority is shifting, and in the art world Asia is emerging as both a vital consumer and producer. This has not happened overnight. The Japanese taste for Western art contributed to three buying peaks between 1960 and 1990, and overseas Chinese in Hong Kong, Singapore, and Taiwan have been active buyers of Impressionist and modern Western art for thirty years. Koreans have long been ardent collectors of contemporary American art and now recognize video-art pioneer Nam June Paik, who lived most of his life in New York, as a national hero. Western artists from van Gogh to Kline have claimed influence from Asian art.

Fig. 46
ZHANG HUAN
To Raise the Water Level in a Fishpond, 1997
Color coupler print mounted on board
Performance, Beijing,
Courtesy of Zhang Huan Studio

In the early twenty-first century Chinese artists are producing ener-
getic and innovative work. Not surprisingly, this is also happening in
other regions that are undergoing profound change such as India and
Russia. American and European collectors have wasted no time in col-
lecting contemporary Asian art, and galleries in New York and London
are variously devoted to emerging Chinese, Korean, Indian, and Russian
artists, just as there were galleries in Paris, Cologne, and Tokyo devoted
to showing contemporary American art when it was radical and innova-
tive in the 1960s. Some of these artists imitate established tropes, oth-
ers fuse styles, and a few are genuinely innovative. Kashmiri art student
Raqib Shaw graduated from St. Martin's College of Art in London in
2002 at the age of twenty-eight. Five years later, after shows in top gal-
leries and museums in London and New York, a painting of his sold at
Sotheby's in London for over $5.5 million. His painting strongly refer-
ences Indian tradition, and it is unlikely his success would have been as
meteoric without a huge surge of interest in contemporary art by a rising
generation of wealthy Indians.

Artists have always traveled, most often for inspiration, but today the
nationality of an artist may give no clue to where they are living. Korean
artists work in Paris, Indian artists in London, Chinese artists in New
York. Irish-born painter Sean Scully has studios in Spain, Germany, Ire-
land, and New York. This mobility is very positive for both the creativity
of the artist and global access to the work.

At the dawn of the second millennium art was a necessary anchor in
the lives of individuals and societies. By the end of the second millen-
nium it had become a luxury stimulant for the rich. In the third millen-
nium it is likely that the purpose of art and the role of artist will evolve
beyond the unique object contained in the traditional boxes of home,
gallery, and museum. New technology is creating highly sophisticated
visual-delivery systems that reach millions. David Hockney, after a dis-
tinguished four-decade career of producing paintings, drawings, and
prints with conventional materials, now draws with his iPhone appli-
cation Brushes, using only the pad of his thumb, and sends sequen-
tial studies of what he sees, in real time, to friends all over the world
(fig. 47):

You look out at the world and you're called to make gestures in response. And that's a primordial calling: goes all the way back to the cave painters. May even have preceded language. People are always asking me about my ancestors, and I say, Well there must have been a cave painter back there somewhere. Him scratching away on his cave wall, me dragging my thumb over this iPhone's screen. All part of the same passion.[141]

High above Times Square the 891-square-foot NBC Astrovision screen is used by New York–based nonprofit arts organization Creative Time to bombard throngs of tourists and natives alike with experimental video art. The archetypal role of the artist is to focus our attention, and the means by which this can be done started undergoing radical change in the middle of the twentieth century and is slowly gathering momentum. While the commercial art world is still dominated, and will be for decades to come, by the unique movable object (painting, drawing, sculpture, print) the vanguard of contemporary art tends toward work that is temporal, collaborative, and essentially uncollectible in the traditional manner. The roots of this tendency are found in the Fluxus movement of the 1960s, which generated intermedia events incorporating objects, sounds, images, and texts. For the following twenty years German artist Joseph Beuys was the leading proponent of art performances and installations that were inclusive, communal, and emphasized social activism over commercial opportunism. In 2008 Qiu Zhijie, a professor at the prestigious Beijing Academy of Art, presented an organically evolving and constantly changing multifaceted exhibition/event called *A Suicidology of the Nanjing Yangzi River Bridge,* which traveled to several places and incorporated a "think tank," archival material, and a suicide-prevention clinic. Contemporary Chinese artists have staked wide territory from the didactic and

Fig. 47
DAVID HOCKNEY
Untitled, 7 July 2009, No. 5.
iPhone drawing

deceptively traditional installations, paintings, and texts of Xu Bing to the polemical, authority-baiting, my-life-is-art antics of Ai Weiwei, who met John Cage, Laurie Anderson, and Allen Ginsberg when he lived in New York, an impoverished and unknown artist, in the early 1990s.

New methods of funding will be created that may depend more on numbers of small contributions (in the form of entrance fees, publication sales, and royalty and copyright payments) than the purchase by a particular collector of one particular object by one particular artist. As this new system evolves, there will be new leaders. In 1975 Tom Wolfe's polemical book *The Painted Word* pilloried the enormous power of Clement Greenberg, Harold Rosenberg, Leo Steinberg, and the social sycophancy of a world of modern art that was in thrall to these critics. Within a few years their celebrity had waned, and by the 1980s it seemed that dealers were the art stars. Today the art world seems to be led by extremely wealthy collectors who not only buy art in quantity for their private museums but also own auction houses and art magazines. The art-world leaders of the future might be the artists, reaching massive audiences with delivery systems as yet undreamed.

I am strongly convinced that, while there will always be commercially successful artists surfing trend waves, a very positive by-product of the recent boom years in contemporary art has been the championing by dealers of artists trafficking in all conceivable subject matter from the deceptively traditional to the outrageously transgressive. The battles of the last century (abstract v. figurative; new realism v. Pop) have given way to a multiplicity of styles and media, each with its own promoters accommodating a wide variety of tastes from the ethereal to the didactic.

What fascinates me is art that exposes issues of identity and transformation. This can be personal, geopolitical, or cross-cultural, such as the videos of the Danish artist Jesper Just, the videos and photographs of Iranian-born Shirin Neshat (fig. 48), the beautiful porcelain sculpture of Sydney-based Chinese artist Ah Xian, the haunting silhouettes of African-American Kara Walker (fig. 49), or the provocatively casual portraits by New Yorker Billy Sullivan. Unlike Paris, London, and New York in the twentieth century, there is no longer a geographical center as a crucible for emerging artists. Not atypical is the trajectory of the

Fig. 48
SHIRIN NESHAT
I Am Its Secret, 1993
RC print and ink
49½ × 33¾ in.
(125.7 × 85.7 cm)
Gladstone Gallery,
New York and Brussels

talented Fiona Tan, who was born in Indonesia, grew up in Australia, and now lives and works in Amsterdam.

One of the benefits of a diverse market, particularly when a shrinking economy chastens the big brand names, is freedom from fashion and

Fig. 49
KARA WALKER
Darkytown Rebellion, 2001
Cut paper and wall projection
187 × 450 in. (475 × 1143 cm)
Collection Mudam Luxembourg,
Musée d'Art Moderne
Grand-Duc Jean
Acquisition 2004

orthodoxy. From Williamsburg in Brooklyn to Brunnenstrasse in Berlin, there are shoe-string galleries run by men and women passionate about showing artists as yet undiscovered working in a vast variety of styles.

WHAT VALUES OF ART ARE PERMANENT?

The Commercial Value of Art Is Subject to Prevailing Taste

Demand for any specific work of art, albeit by a well-known and coveted artist, may change, and its value may decrease over a period as short as two decades, just as within that same period artists fallen from favor can enjoy Lazarus-like resurrections. Short-term speculators who buy works only for resale can come to grief. A living artist may seem destined for a place in history one day and either because her later work fails to please or her style is replaced by a new movement, she is dropped from the "must-have" lists. Such artists can vanish into the mists of history, even though some are brought back to the market decades or even centuries

later. In the 1960s a young sculptor, Lee Bontecou, enjoyed a few years of critical success and sales to major collectors and museums (fig. 50). She then left the prestigious Leo Castelli Gallery in 1972 to teach and raise a family: "I needed a rest. I wanted to explore and expand. I just didn't want to have to make things, and finish things, and show them every two years."[142]

In those days her action was not quite considered the career-killer it would be now. I cannot imagine those words coming from one of today's high-rolling artists. It takes a lot of courage for an artist to remove herself from the center of the marketplace to work according to her own time-table. Bontecou never stopped making art, but by the late 1980s, when the whole art market was booming, major early works by Bontecou were selling at auction for barely more than $20,000. By 1993 the highest price paid for a large construction was $46,000 and this "record" remained

Fig. 50
LEE BONTECOU
Untitled, 1962
Welded metals and canvas
67¾ × 71¾ × 30 in.
(172 × 182 × 76.2 cm)
Museum of Fine Arts, Houston.
Gift of D. and J. de Menil

until 2003, when she was discovered or rediscovered by a new generation of collectors, and a small work sold for just under $300,000. A year later a Bontecou sculpture sold for $850,000.

Similarly, Hungarian-born French abstract artist Simon Hantaï (1923–2008) went underground in the late 1960s when his work started to become fashionable. "I felt the art world was going wrong," he said. "I was starting to receive commissions. . . . Society seemed to be preparing to paint my work for me. The prospect did not coincide with my desire."[143] He basically remained a recluse the rest of his life, surfacing once to show his work in the late 1990s. In such ways artists of acknowledged achievement may exercise a need for seclusion that confounds both conventional wisdom and the art market speculators but not the serious collectors.

The purpose of art is not to make money for its owner. The capacity of a work of art to hold, lose, or increase commercial value is incidental to its meaning. This is not always easy for an investment-addled culture to understand. Comparing the investment value of works of art to that of nontangible financial instruments is not particularly helpful, although it is frequently done. A work of art, unlike a financial instrument, has an independent existence as an object. It may be saleable at any given time (or not), for more than was paid (or less). As a tangible asset, it can re-enter the market in one, twenty, or one hundred years time with the attendant possibility of a substantial increase in commercial value.

There is a widespread notion that the death of an artist automatically causes that artist's prices to go up. What actually happens is that anywhere from one to ten years following the death of any moderately well-known artist there is a gradual review of his or her reputation with results that can be positive or negative for commercial value. The exact extent of the artist's output becomes known more widely than during his or her lifetime, and this impacts supply, which affects value. The artist's collection of his or her own work might be extensive and threaten to flood the market, or it might be meager and establish rarity. Some artists sustain great popularity in their lifetime by dint of their personality and salesmanship, without which their reputations dim. Art of the past, like art of the present, requires the enthusiasm of collectors and dealers, as well as public exchange, to sustain commercial value. In every generation

there are good artists who express their times successfully for their peers but somehow do not suit the taste of the next generation. A great artist makes work that speaks to generations yet unborn, often generations willing to pay good money.

Virtually all works of art that achieved some degree of merit when they were made retain marketability, although there may be periods of time when their commercial value is low. Certain collectors, out of penury or a spirit of adventure, search for overlooked and undervalued works of art and sometimes this leads to a re-examination of artists and art movements relegated to the minor leagues of art history. I am often asked by new buyers what it was that guided legendary collectors like Emily Tremaine to make the choices they did. Translated, this often means, "How can I buy for one dollar today what I can sell tomorrow for one hundred?" I tell these individuals that true collectors do not make their choices by trying to second-guess history and the art market. They buy from reliable sources, spend what they can afford, and consider these amounts spent, not invested. By constantly looking they develop a degree of personal connoisseurship in their area of interest and are in frequent touch with other collectors, as well as dealers and curators who share their enthusiasms.

The Social Value of Art Is Constant

Five hundred years ago art was vital to all levels of society, from the princes who commissioned it to the peasants in whom it inspired piety and a sense of community. In the short and brutal lives of most people it was their only visual stimulation besides the living landscape.

Now art competes with manifold images, still and moving, that bombard us day and night in all aspects of our lives, social and otherwise—at work, at home, and in the street, even in our cars. What unique social value does art have that elevates it above this constant stream of visual stimulation?

A significant contribution to this special social value is the dedication of specific places for the installation and enjoyment of art—museums, galleries, and the walls of our homes and institutions, perhaps even our place of business. In fact, we have come to rely on where it is (a museum) to figure out what it is (art), particularly when it might be something (like Duchamp's iron bottle dryer) that could be mistaken for a less exalted

object. With dedicated spaces firmly entrenched in our culture, the social value of art is the necessary result of the gathering of two or more individuals for the general purpose of experiencing it.

I complain about the degrees to which some museums go to make themselves user-friendly, but I have to confess that if the net result is more people learning to take genuine interest and pleasure in works of art, then I am reluctantly on board with the paraphernalia and the hoopla, but please, more chairs and benches. For a few dollars most museums sell memberships that provide access to special events, private openings, and lectures that provide company of the like-minded. After looking at art with a friend or your family, talk about what you have seen that you like and what you do not like, and why.

The Personal Value of Art Is Paramount

How does a painting affect you? What happens when you look at it once quickly or twice slowly or return to it after a year or live with it day after day?

There are so many ways in which a work of art can act on our sensibilities from the primly intellectual to the wildly emotional. We can be grounded, or we can be elevated. We can be transported to the lowest depths of sorrow or taken to a high spiritual plane. We can be delighted, we can be baffled, we can be appalled, we can be refreshed, we can be moved to tears or spend the rest of the day smiling.

Whether it is an object you own or one you are inspired to return to in a museum, a work of art you can engage with on a purely personal level is a life-enhancing treasure. In fact, the noncollector has the easier road to enjoying art for art's own sake because considerations of commercial value are irrelevant. Despite this, many of us are seduced by our commodity-driven culture into confusing the dollar value of a work of art with quality, and thus we are drawn toward works we have been told are expensive at the risk of overlooking those whose commercial value is insignificant or, better still, unknown to us.

A docent at the Toledo Museum of Art in Ohio chastised me for being part of the machinery that established and promoted "art as money." She was in charge of their children's programs and said that when she started, in the 1960s, the children chose their favorites based on what they saw

and what they felt, but now they just want to see the van Gogh because the one thing they had learned at school or at the dinner table was that it must be worth millions of dollars. Innocence lost.

I have described the possibility that a collector can eventually engage personally with a work that he or she originally purchased as an investment or to impress or fill a particular space—just as a person can choose a mate for practical reasons and, after rubbing along together for a while, acquire some genuine affection. The intrinsic, essential value of a work of art does not always manifest itself at first glance. Collectors are often driven toward particular objects because of peer pressure and investment promise; they are happy to find "a good example" by the artist everyone else is trying to buy. At first they do not enter into the spirit of the particular work. This could take weeks, months, or even years of ownership. Sometimes it is sparked by the perceptive remark of a visitor who sees something we have missed.

Again, just as with a spouse, our understanding, appreciation, and sheer enjoyment of a work of art can grow, ebb, or simply change in nature as we develop a relationship with it. It is difficult to avoid being slaves to our culture and the opinion of others, but one advantage of spending serious time with a work of art is the ability to let go of external associations. The more celebrated a work, the harder it is to rid it of associations.

Approach Leonardo da Vinci's *Mona Lisa* (1503–05, fig. 51). That may be literally impossible because of the constant crush of camera-wielding tourists. Conceptually, it is even harder because the image has been so savagely bowdlerized that it is impossible to separate our experience of seeing the actual painting from the plethora of abuse it has suffered.

The essential nature of this undeniable masterpiece has been interpreted inconsistently throughout the ages. Commentators have reflected on La Gioconda's enigmatic smile in very different ways. The artist and writer Giorgio Vasari (1511–1574) was the first Barnum of the work. In his immensely influential *Lives of the Painters, Sculptors, and Architects*, Vasari declared himself enraptured by the face and particularly the pit of her throat, which was rendered so naturally that the viewer "cannot but believe he sees the beating of the pulses." In the seventeenth and eighteenth centuries the *Mona Lisa* languished unsung, but in the late nine-

teenth century it was rapturously elevated to its current status "to what is now inelegantly called 'iconicity'" by the writers Théophile Gautier in France and Walter Pater in England. Imitating nature was no longer the hook; they were moved to rapture by their own imaginings, which they expressed in purple prose. Pater found her "irresistible and intoxicating" with an "unfathomable smile, always with a touch of something sinister in it." Oscar Wilde declared Pater's words to be "criticism of the highest kind."

Such opinion reigned until a daring reappraisal by Bernard Berenson in 1916. He tried to appreciate the formal, stylistic qualities of the work but ended up declaring La Gioconda "a foreigner with a look I could not fathom." Three years later Duchamp made a coarse Dada joke at her expense and launched her century-long career as a kidnap victim, easy pickings not only for serious artists such as Warhol but also for computer mouse pads and an intrauterine device (Mona Lisa-Cu375). Millions have seen her image, yet who can truly experience her in the same way as the first visitor to Leonardo's studio when she was completed? The genius of the work is that there is still a power left after all the pillaging.

RELAX AND ENJOY

Information about a work of art, whether external (authorship, commercial value, popularity) or internal (structure, symbolism), can inspire my interest but is unlikely to contribute to that "aha" moment when I feel, rather than understand, its intrinsic meaning for *me*.

When it comes to fully experiencing a work of art, language can be as much a boundary as a bridge. Art criticism, no matter how eloquent and erudite, attempts to use one language to describe another, very different language but with no dictionary to assist the translation. Painting, sculpture, drawing, and other visual media on the highest level represents the creation of a language that is not read or spoken. It is comprehended with the eyes, the mind, and what we might call the heart, our internal capacity to be deeply moved. This can render us speechless, when we find it difficult to put our responses into words. And why not, since we are dealing with a wordless language, like music? We can speak, hear,

Fig. 51
LEONARDO DA VINCI
Mona Lisa, 1503–5
Oil on wood
30¼ × 21 in. (77 × 53 cm)
Louvre, Paris

and read words, but we cannot see or feel art with words, only with our eyes and minds. As discussed earlier, when it comes to music, most of us tend to have confidence in our taste even though we may totally lack knowledge regarding historical development or compositional theory. I frequently hear, "I don't know anything about art" but hardly ever, "I don't know anything about music." Instead, most of us are confident with saying, "I like classical music," or "I prefer rhythm and blues to rap."

Fig. 52
HENRI MATISSE
The Moroccans,
Issy-les-Moulineaux,
late 1915 and fall 1916
Oil on canvas
71⅜ × 110 in. (181.3 × 279.4 cm)
The Museum of Modern Art,
New York. Gift of Mr. and Mrs.
Samuel A. Marx

When it comes to art, we harbor a belief that the simple experience of just looking is useless without information.

I have found that in exhibitions it is more effective to relax and use my eyes patiently on works of art themselves than to read the writing on the walls at the same time. If I jog through a museum cruising the labels and snacking on famous names, I am unlikely to have an "aha" moment. A painting that may have taken months of toil to complete deserves more than twenty seconds of our attention (of which ten is spent reading the label). I try to take the time to let my eyes and mind adjust to what I am seeing and provide it with a reasonable degree of undivided

attention. Sometimes my response is immediate and powerful, as on two visits to the Rothko Chapel in Houston, thirty years apart. It took a new installation of the permanent collection at the Museum of Modern Art, however, for me to finally connect with Henri Matisse's *The Moroccans* (1915–16, fig. 52), a painting I had looked at many times before but had never really "got."

Our interest in a work of art can be sparked by information and opinion from others, but total appreciation and enjoyment of it can only come when we concentrate on it in a relaxed but fundamentally attentive manner, surrender our prejudices, and trust our eyes.

Fig. 53
PETER PAUL RUBENS
The Last Judgment of Paris,
1632–35
Oil on oak
57 × 76¼ in. (144.8 × 193.7 cm)
National Gallery, London.
Bought 1844

Afterword

THE JUDGMENT OF PARIS

I started this book with the Three Graces, and I am ending it with another trinity of female pulchritude, rivals in the first recorded beauty contest. When Achilles' parents were married, so the Greek myth goes, Zeus threw a huge party that was gate-crashed by Eris, goddess of discord, who lobbed a golden apple inscribed "for the fairest one" into the crowd. Goddesses-in-training Hera, Athena, and Aphrodite each clamored for this prize, which Zeus decided should be awarded by a mortal, Paris. Laxer rules prevailed in those days, and each candidate was allowed to offer incentives to the judge.

Affording the opportunity for the representation of three attractive and unclad women being ogled by a handsome youth, the Judgment of Paris has appeared in art from Roman times, on sarcophagi, to the Middle Ages, in illuminated manuscripts, to the masterpiece by Peter Paul Rubens in London's National Gallery (fig. 54), as well as works by Renoir and Dalí in the twentieth century.

Hera offered to make Paris king of Europe and Asia, Athena's bribe was wisdom and skill in war, and Aphrodite tempted Paris with the love of the world's most beautiful woman, Helen, wife of the Greek King Menelaus.

The bribes of Hera and Athena were worldly, as we might consider the commercial and social promise of value in art to be worldly. Aphrodite offered beauty itself, in the form of Helen. Paris chose Aphrodite's gift, so Zeus gave Aphrodite the golden apple, Paris took Helen to Troy as his reward, and the Greeks fought the Trojan Wars to retrieve her.

While "beauty" may be a currently outmoded word to describe the essential value of art, particularly contemporary art, I would argue that

when it comes to choosing what you like, let alone what you might want to buy, take a cue from Paris and go for what appeals to your senses, not your rational mind.

There is a basic symbiosis between the commercial value of art and the social value of art in our lives. After all, people like to talk about how much things cost. Owning big-price-tag art compels the interest of others in ourselves. The essential value of art, on the other hand, is best absorbed privately and personally, and for us to access it we have to put aside the commercial (how much it is worth in dollars) and the social (the fame of the artist, be he Leonardo or Rothko) and learn to concentrate, quietly, on just what we see.

NOTES

1 "Emily Tremaine: Her Own Thoughts" in Wadsworth Atheneum, *The Tremaine Collection: 20th-Century Masters: The Spirit of Modernism* (Hartford, CT: Wadsworth Atheneum, 1984) 25.

2 Théophile Gautier, *The Works of Théophile Gautier,* vol. 24, trans. and ed. F. C. de Sumichrast (Cambridge, MA: Harvard University Press, 1903), 24.

3 Susan Sontag, "Against Interpretation," in *Against Interpretation and Other Essays* (New York: Farrar, Straus and Giroux, 1966), 3.

4 Judith Thurman, "Letters from Southern France: First Impressions; What Does the World's Oldest Art Say about Us?" *New Yorker,* June 23, 2008, 58–67.

5 *The Collection of Helena Rubenstein [Princess Gourielli]: Modern Paintings and Sculpture,* two parts, Parke-Bernet Galleries, New York, April 20 and 29, 1966, sales 2428 and 2431. The de Kooning was cat. no. 72 of the first sale.

6 *A Selection of Fifty Works from the Collection of Robert C. Scull [Post-war and Contemporary Paintings and Sculpture from the Collection of Robert C. Scull],* Sotheby Parke Bernet, New York, October 18, 1973, sale 3558.

7 Judith Goldman, *Robert and Ethel Scull: Portrait of a Collection* (New York: Acquavella Galleries, 2010), 14.

8 William Acquavella, in conversation with the author, June 2009.

9 Georg Frei and Neil Printz, eds., *The Andy Warhol Catalogue Raisonné,* vol. 2, *Paintings and Sculptures, 1964–1969* (London: Phaidon, 2003).

10 Christian Zervos, *Pablo Picasso: 1895–1973,* 33 vols. (Paris: Éditions Cahier d'art, 1932–78).

11 François Daulte, *Auguste Renoir: Catalogue raisonné de l'oeuvre peint,* vol. 1, *Figures, 1860–1890* (Lausanne: Éditions Durand-Ruel, 1971).

12 Arthur Pfannstiel, *Modigliani et son oeuvre: Étude critique et catalogue raisonné* (Paris: Bibliothèque des Arts, 1956); Joseph Lanthemann, *Modigliani, 1884–1920: Catalogue raisonné; Sa vie, son oeuvre complet, son art* (Florence: Ed. Vallecchi, 1970); Amboglio Ceroni and Françoise Cachin, *Tout l'oeuvre peint de Modigliani* (Paris: Flammarion, 1972); Christian Parisot, *Modigliani: Catalogue raisonné, peintures, dessins, acquarelles,* (Livorno: Ed. Graphis Arte, 1990); Osvaldo Patani, *Amedeo Modigliani: Catalogo generale* (Milan: Leonardo, 1991).

13 American Association of Museums, "Code of Ethics for Museums," http://www.aam-us.org/ museumresources/ethics/coe/cfm (accessed August 8, 2008).

14 Ai Weiwei, in Ai Weiwei et al., "Art and Its Markets: A Roundtable Discussion," *Artforum* 46, no. 8 (April 2008): 295.

15 Merrill Lynch Wealth Management and Capgemini, *World Wealth Report* (New York: Merrill Lynch, Pierce, Fenner & Smith Inc. and Capgemini, 2009): 2, 5–7. See Table 7.1 in Clare McAndrew, *The International Art Market: A Survey of Europe in a Global Context* (Helvoirt, The Netherlands: European Fine Art Foundation, 2008).

16 Bettina Wassener, "Asian Art Auction Sets Records for Artists," *New York Times,* April 6, 2010,

http://www.nytimes.com/2010/04/07/business/global/07auction.html (accessed October 30, 2011).

17 Peter Schjeldahl, "Golden Girl: The Neue Galerie's New Klimt," *New Yorker,* July 24, 2006, 76–77;
 Michael Kimmelman, "The Face That Set the Market Buzzing," *New York Times,* July 14, 2006, E27.

18 Ray Falk, "French Art in Tokyo," *New York Times,* June 21, 1959, sec. 2, pt. 1, 12.

19 R. H. van Gulik, *Chinese Pictorial Art As Viewed by the Connoisseur* (Rome: Istituto Italiano per
 il Medio ed Estremo Oriente, 1958), 410–15.

20 JPMorgan Chase & Co, *The JPMorgan Chase Art Collection,* http://www.jpmorganchase.com/
 corporate/About-JPMC/jpmorgan-art-collection.htm (accessed October 4, 2011).

21 Citi Private Bank, *Art Advisory and Finance,* https://www.privatebank.citibank.com/our_services/
 individuals_families/wealth_advisory/art.htm (accessed October 4, 2011).

22 Fine Art Capital, *About Us,* http://www.fineartcapital.com/hp_v5_aboutus1.html (accessed
 December 14, 2007).

23 McAndrew, *The International Art Market,* 83.

24 Toddi Gutner and Kerry Capell, "Funds to Please the Eye," *Business Week,* February 14, 2005,
 http://www.businessweek.com/magazine/content/05_07/b3920109_mz070.htm (accessed
 October 4, 2011).

25 Max Rutten, "Art Is Not a Prudent Investment," *Art Newspaper,* no. 182 (January 2007): 29.

26 The Distressed Debt Alert, *The Distressed Debt Alert for the Week of January 19, 2009,*
 http:// distresseddebt.dealflowmedia.com/wires/011909.cfm (accessed January 27, 2009).

27 Gutner and Capell, "Funds to Please the Eye," n.p.

28 McAndrew, *The International Art Market,* chap. 2.

29 William J. Baumol, "Unnatural Value: or, Art Investment as a Floating Crap Game," *American
 Economic Review: Papers and Proceedings of the Ninety-Eighth Annual Meeting of the American Economic
 Association* 76, no. 2 (May 1986): 10–14.

30 Godfrey Barker, "Give 'Em Shelter," *Forbes,* December 24, 2001, 82.

31 Skate's, *Skate's Art Investment Handbook,* http://www.skatepress.com (accessed November 7, 2006).

32 Sarah Douglas, "Sizing Up the Indexes," *Art and Auction* 30, no. 12 (August 2007): 28–29.

33 Donald Kuspit, "Maurizio Cattelan, La Nona Ora (The Ninth Hour)," *Art Economist* 1, no. 3
 (March 2011): 4–5.

34 Rob Walker, "Just Priceless—Assessing the Value of an Art Object That Sells Itself," *New York Times
 Magazine,* May 9, 2010, 22.

35 Félix Pyat, quoted in Peter Schjeldahl, "Painting by Numbers: Gustave Courbet and the Making
 of a Master," *New Yorker,* July 30, 2007, 81.

36 Randy Kennedy, "The Met's Plans for Virtual Expansion," *New York Times,* February 11, 2011, C1.

37 Sidney Janis, interview with Harry Arouh, in *Art for Whose Sake?* directed by Gordon Hyatt (1964;
 Lanham, MD: National Film Network), DVD.

38 J. Paul Getty, quoted in Robina Lund, *Getty: The Stately Gnome* (London: Hobbs/Michael Joseph,
 1977), 12.

39 Rebecca Mead, "Alice's Wonderland: A Walmart Heiress Builds a Museum in the Ozarks,"
 New Yorker, June 27, 2011, 32.

40 Jack Flam, *Matisse: The Dance* (Washington, D.C.: National Gallery of Art, 1993), 19.

41 Alfred H. Barr Jr., "Foreword," in *The Collection of Twentieth Century Paintings and Sculptures
 Formed by the Late G. David Thompson of Pittsburgh, Pennsylvania,* Parke-Bernet Galleries, New York,
 March 23–24, 1966, sale 2420, n.p.

42 Mariana Cook, "Property from the Collection of Dr. and Mrs. John A. Cook," in *Impressionist
 and Modern Art, Part One,* Sotheby's, New York, May 3, 2005, sale 8089, 36.

43 William H. Gross, quoted in Stephanie Strom, "Big Gifts, Tax Breaks, and a Debate on Charity,"
 New York Times, September 6, 2007, A22.

44 Art Gallery of Alberta, *Staff Listing*, January 19, 2010, http://www.youraga.ca/about-aga/our-mission/
 staff-listing (accessed October 4, 2011).

45 Rosemary Kent, "The Lofty People," *Women's Wear Daily*, May 18, 1972, 18–19.

46 Cover, *New York Times Magazine*, October 2, 2008.

47 Fiona McKenzie Johnston, "Artists Vying for a Spot on the Fashion Runway," *Art Newspaper*,
 no. 188 (February 2008): 28.

48 For an account of the infamous Jackson Pollock incident, see Steven Naifeh and Gregory White
 Smith, *Jackson Pollock: An American Saga* (New York: Clarkson N. Potter, 1989), 469.

49 Mark Stevens and Annalyn Swan, *De Kooning: An American Master* (New York: Knopf, 2004).

50 Muriel Kallis Steinberg Newman, quoted in Dennis Hevesi, "Muriel Kallis Steinberg Newman, 94,
 Donor of Abstract Expressionist Works to the Met," *New York Times*, September 5, 2008, B6.

51 Claudia La Rocco, "At MoMA Show, Some Forget You Should Not Touch the Art," *New York Times*,
 April 16, 2010, A24.

52 Rebecca Robertson, quoted in Carol Vogel, "Inside Art," *New York Times*, July 20, 2007, E28.

53 Barnett Newman, in "'Frontiers of Space' Interview with Dorothy Gees Seckler" (1962), in
 Barnett Newman, *Barnett Newman: Selected Writings and Interviews*, ed. John P. O'Neill (New York:
 Alfred A. Knopf, 1990), 251.

54 Leonard Bernstein, *The Unanswered Question: Six Talks at Harvard* (Cambridge, Mass.: Harvard
 University Press, 1976), 140.

55 Franz Kafka, quoted in Philip Rahv, "Introduction," in Franz Kafka, *Selected Short Stories of Franz
 Kafka*, trans. Willa and Edwin Muir (New York: Modern Library, 1952), xx.

56 Sontag, "Against Interpretation," in *Against Interpretation*, 8, 14.

57 Wallace Stevens, "Notes Toward a Supreme Fiction" (1942), in Wallace Stevens, *The Collected Poems
 of Wallace Stevens* (New York: Knopf, 1954), 380.

58 Viktor Shklovsky, quoted in Trevor Pateman, "English Formalism and Russian Formalism:
 Clive Bell and Viktor Shklovsky," November 8, 2002, http://www.selectedworks.co.uk/formalism
 .html (accessed October 4, 2011).

59 Bernard Berenson, "A Word for Renaissance Churches," in *The Study and Criticism of Italian Art*,
 2nd ser. (London: George Bell and Sons, 1902), 62.

60 Françoise Gilot and Carlton Lake, *Life with Picasso* (New York: Anchor Books, 1989), 203.

61 *Post-War and Contemporary Art Evening Sale*, Christie's, London, October 14, 2001.

62 Milton Esterow, "A Monet May Bring $1.2 Million at Charity Sale," *New York Times*, November 7,
 1967, 40.

63 Tony Ganz, in conversation with the author, August 15, 2011.

64 Pierre Rosenberg et al., *Poussin and Nature: Arcadian Visions* (New York: Metropolitan Museum of
 Art, 2008), 8.

65 James Elkins, *Pictures and Tears: A History of People Who Have Cried in Front of Paintings* (New York:
 Routledge, 2001), 6.

66 *Ibid.,* 58.

67 Pace Wildenstein, *Bridget Riley: Recent Paintings and Gouaches* (New York: Pace Wildenstein, 2007), 22.

68 Fausto Melotti, quoted in Karen Rosenberg, "Italian Sculptor Attuned to the Harmonic
 Occupation of Space," *New York Times*, May 8, 2008, E5.

69 Carol Vogel, "The Gray Areas of Jasper Johns," *New York Times*, February 3, 2008, Arts and
 Leisure sec., 32.

70 Wassily Kandinsky, *Concerning the Spiritual in Art and Painting in Particular, 1912,* trans. Francis
 Golffing, Michael Harrison, and Ferdinand Ostertag (New York: Wittenborn Schultz, 1947), 24.

71 Barnett Newman, in Melissa Ho, "Chronology," in Ann Temkin, ed., *Barnett Newman* (Philadelphia:
 Philadelphia Museum of Art, 2002), 334.

72 Joseph Beuys, Rosemarie Schulz, and Stefan Graupner, *Joseph Beuys: A Private Collection* (Munich: A11 Artforum, 1990), 31.

73 Blake Butler, "Damien Hirst on Writing," *HTMLGIANT,* May 25, 2011, http://htmlgiant.com/craft-notes/damien-hirst-on-writing (accessed October 4, 2011).

74 Carol Vogel, "In Faltering Economy, Auction Houses Crash Back to Earth," *New York Times,* November 17, 2008, C9.

75 Carol Vogel, "Damien Hirst's Next Sensation: Thinking Outside the Dealer," *New York Times,* September 15, 2008, E1, E5.

76 Henry Geldzahler, quoted in Kathleen L. Housley, *Emily Hall Tremaine: Collector on the Cusp* (Meriden, Conn.: Emily Hall Tremaine Foundation, 2001), 137.

77 Octave Mirbeau, "Préface," in *Renoir* (Paris: Bernheim-Jeune, 1913), n.p. Translated for the author by Christian Bonvin.

78 Roger Fry, *Cézanne: A Study of His Development* (Chicago: University of Chicago Press, 1989), 82.

79 Dorothy Seiberling, "Is He the Worst Artist in the U.S.?" *Life,* January 31, 1964, 79–83 (quotations on 79). The *Life* article on Pollock is "Jackson Pollock: Is He the Greatest Living Painter in the United States?" *Life,* August 8, 1949, 42–45.

80 David Bourdon, "What on Earth!" *Life,* April 25, 1969, 80–86.

81 Heiner Bastian, ed., *Cy Twombly: Catalogue Raisonné of the Paintings,* vol. 3, *1966–1971* (Munich: Schirmer/Mosel, 1994), 27.

82 Isaac Chotiner, "Globish for Beginners," review of *Globish,* by Robert McCrum, *New Yorker,* May 31, 2010, 76.

83 John Seabrook, "Snacks for a Fat Planet," *New Yorker,* May 16, 2011, 54.

84 William Grimes, "Giuseppe Panza, 87, Collector of Postwar American Art," *New York Times,* May 2, 2010, A32.

85 Tony Judt, "Ill Fares the Land," *New York Review of Books,* April 29, 2010, 17–19.

86 Ronny H. Cohen, "Energism: An Attitude," *Artforum* 19, no. 1 (September 1980): 16–23.

87 James Meyer, in Ai Weiwei et al., "Art and Its Markets," 293.

88 Carol Vogel, "The New Museum Sets the Date," Inside Art, *New York Times,* July 27, 2007, E28.

89 Theodore Rousseau, "Aristotle Contemplating the Bust of Homer," *Metropolitan Museum of Art Bulletin,* n.s. 20.5 (New York: Metropolitan Museum of Art, January 1962), 149.

90 Jori Finkel, "Dealers' Money Nudges Museums," *New York Times,* November 18, 2007, Arts and Leisure sec., 1.

91 William D. Cohan, "A Controversy over Degas," *Art News* 109, no. 4 (April 2010): 86–97.

92 See Christie's press release, "Christie's to Sell the Collection of Mrs. Sidney F. Brody," March 9, 2010, http://www.christies.com/about/press-center/releases/pressrelease.aspx?pressreleaseid=3948 (accessed October 4, 2011).

93 Christie's advertisement, "Two Great Moments in Art," *New York Times,* April 30, 2010, C30–31.

94 Carol Vogel, "The Blue-Chip Period," *New York Times,* May 2, 2010, Arts and Leisure sec., 1.

95 Roberta Smith, "The Coy Art of the Mystery Bidder," *New York Times,* May 9, 2010, WK4.

96 Holland Cotter, "Another Auction, Another Trophy," *New York Times,* May 6, 2010, C1, C6.

97 Carol Vogel, "A More Sober Follow-Up to a Record Auction Night," *New York Times,* May 6, 2010, A28.

98 Stanley Fish, "The Value of Higher Education Made Literal," The Opinionator, *New York Times,* December 13, 2010, http://opinionator.blogs.nytimes.com/2010/12/13/the-value-of-higher-education-made-literal/ (accessed October 4, 2011).

99 Natsuko Waki, "Analysis: Japan Disaster Costs Seen at Least $180 Billion," *Reuters,* March 14, 2011, http://www.reuters.com/article/2011/03/14/us-japan-economy-costs-idUSTRE72D60V20110314 (accessed October 4, 2011).

100 "Investopedia," *Forbes,* quoted in Thomas Crow, "Historical Returns," *Artforum* 46, no. 8 (April 2008): 287.

101 Housley, *Emily Hall Tremaine,* 175.

102 Fred Kaplan, "Showing a Couple's Eye for Art (and Money)," *New York Times,* April 10, 2010, C5.

103 Jeffrey Deitch, quoted in Calvin Tomkins, "A Fool for Art: Jeffrey Deitch and the Exuberance of the Art Market," *New Yorker,* November 12, 2007, 72.

104 Bruce Fellman, "Collecting from the Heart," *Yale Alumni Magazine,* October 1995, http://www .yalealumnimagazine.com/issues/95_10?baker.html (accessed October 4, 2011).

105 Eric Janszen, "The Next Bubble: Priming the Markets for Tomorrow's Big Crash," *Harper's Magazine,* February 2008, http://harpers.org/archive/2008/02/0081908 (accessed October 4, 2011).

106 Armand Limnander, "Jack the Dripper: His Influence Splatters across the Runways," *Herald Tribune "Style" Magazine,* March 15, 2008, 16.

107 *Contemporary Art Evening Auction,* Sotheby's, New York, May 14, 2008, sale NO8441, 36, no. 9 (illus.).

108 Marcel Duchamp, quoted in Anne D'Harnoncourt and Kynaston McShine, eds., *Marcel Duchamp* (New York: Museum of Modern Art and Philadelphia: Philadelphia Museum of Art, 1973), 275, cat. no. 106.

109 Arthur C. Danto, "Banality and Celebration: The Art of Jeff Koons," in *Jeff Koons: Retrospective* (Oslo: Astrup Fearnley Museet for Moderne Kunst, 2004).

110 Richard Serra, in Kynaston McShine, "A Conversation about Work with Richard Serra," in Kynaston McShine and Lynne Cooke, *Richard Serra Sculpture: Forty Years* (New York: Museum of Modern Art, 2007), 35.

111 Svetlana Boym, *Common Places: Mythologies of Everyday Life in Russia* (Cambridge, Mass.: Harvard University Press, 1994), 41. For the Nabokov quote, see Vladimir Nabokov, *Nikolai Gogol* (Norfolk, Conn.: New Directions, 1944), 70. For more on *poshlust,* see Vladimir Nabokov, "The Art of Fiction XL: An Interview," *Paris Review* 11, no. 41 (Summer–Fall 1967), 103.

112 Tony Judt, "On Being Austere and Being Jewish," *New York Review of Books,* May 13, 2010, 21.

113 Simon de Pury, in *Kyōbai,* Phillips de Pury & Co., London, April 3, 2008, sale UK000208. Total sold (including premium): $6,560,476.

114 C.B.C., "Murakami's Change of Direction," *Art Newspaper,* no. 216 (September 2010): 8.

115 Tony Judt, "What Have We Learned, If Anything?" *New York Review of Books,* May 1, 2008, 16.

116 Clive Bell, *Art* (New York: Frederick A. Stokes, 1913), 239–40.

117 Don Thompson, *The $12 Million Stuffed Shark: The Curious Economics of Contemporary Art and Auction Houses* (London: Aurum Press, 2008), 251.

118 Sebastian Faulks, *A Week in December* (New York: Doubleday, 2009), 210.

119 Jerry Saltz, "Frieze after the Freeze," *New York Magazine,* October 24, 2008, http://nymag.com/ arts/art/features/51525/ (accessed October 4, 2011).

120 Carol Vogel, "Museums Fear Lean Days Ahead," *New York Times,* October 20, 2008, C7.

121 Nicolai Ouroussoff, "Art and Commerce Canoodling in Central Park," *New York Times,* October 21, 2008, C5.

122 Carol Vogel, "In Faltering Economy, Auction Houses Crash Back to Earth," C9.

123 Carol Vogel, "At London Sale, a Giacometti Sets a Record," *New York Times,* February 4, 2010, C1.

124 Andy Soltis and Amanda Longo Bucco, "Picasso 'Green' Period," *New York Post,* May 5, 2010, 31.

125 Carol Vogel, "At Christie's, a $28.6 Million Bid Sets a Record for Johns," *New York Times,* May 12, 2010, A20.

126 Rita Nazareth, "U.S. Stocks Tumble Most Since February on Europe Debt Concern," *Business Week,* May 4, 2010, http://www.businessweek.com/ news/2010-05-04/u-s-stocks-tumble-most-since -february-on-europe-debt-concern.html (accessed May 5, 2010).

127 Lindsay Pollock and Philip Boroff, "Picasso Nude Fetches Record $106.5 Million in N.Y.,"
 Bloomberg, May 5, 2010, http://www.bloomberg.com/news/2010-05-05/picasso-s-nu-au-plateau
 -sells-for-106-5-million-record-for-work-of-art.html (accessed October 4, 2011).

128 *Impressionist and Modern Art Evening Sale,* Sotheby's, New York, May 5, 2010, sale NO8633, no. 8
 (illus.). Estimate: $4–6 million; sold (including premium): $11,842,500.

129 *Contemporary Art Evening Auction,* Sotheby's, New York, May 12, 2010, sale NO8636, no. 26 (illus.).
 Estimate: $2.8–3.5 million; sold (including premium): $3,890,500.

130 *Selected Works from the Neuberger Berman and Lehman Brothers Corporate Art Collections,* Sotheby's,
 New York, September 25, 2010, sale NO8704, no. 31 (illus.). Estimate: $800,000–1.2 million;
 bought in (no bids at $200,000).

131 Lindsay Pollock, "Lehman $12.3 Million Art Sale Picks 'Long Way Home' Over Hirst," *Bloomberg,*
 September 27, 2010, http://www.bloomberg.com/news/2010-09-26/lehman-art-sale-raises-12-3
 -million-for-creditors-at-sotheby-s-new-york.html (accessed October 4, 2011).

132 Carol Vogel, "44 Works Sell for $170 Million at Sotheby's Auction," *New York Times,* May 4, 2011,
 A22.

133 Gabriel Fernández, "The Most Expensive Paintings Ever Sold," *theartwolf.com,* http://www
 .theartwolf.com/10_expensive.htm (accessed October 4, 2011).

134 Georgina Adam, "The Art Market: Bad Apples and Big Bucks," *Financial Times,* April 22, 2011,
 http://www.ft.com/intl/cms/s/2/6e000e46-6b9f-11e0-93f8-00144feab49a.html#axzz1TVRadV00
 (accessed October 4, 2011).

135 Sarah Douglas, "Dave Hickey Is Retiring (Sort Of)," *New York Observer,* October 24, 2012, http://
 galleristny.com/2012/10/dave-hickey-retiring-sort-of-interview/ (accessed September 19, 2013).

136 Sarah Thornton, "Top 10 reasons NOT to write about the art market," *TAR,* no. 8 (Fall 2012): 82–83.

137 In Vogel, "Museums Fear Lean Days Ahead," C7.

138 Calvin Tomkins, "The Mind's Eye: The Merciless Originality of Jasper Johns," *New Yorker,*
 December 11, 2006, 81.

139 James Rosenquist, in conversation with the author, August 17, 2011.

140 Ma Jian, *Beijing Coma,* trans. Flora Drew (New York: Farrar, Straus and Giroux, 2008), 125.

141 Lawrence Weschler, "David Hockney's iPhone Passion," *New York Review of Books,* October 22,
 2009, 35.

142 Lee Bontecou, quoted in Diane Calder, "Lee Bontecou," *ArtScene,* http://artscenecal.com/
 ArticlesFile/Archive/Articles2003/Articles1003/LBontecouA.html (accessed October 4, 2011).

143 Margalit Fox, "Simon Hantaï, Painter of Silences, Dies at 85," *New York Times,* September 30, 2008,
 http://www.nytimes.com/2008/09/29/arts/design/29hantai.html (accessed October 30, 2011).

INDEX

Please note: Page numbers in italics indicate illustrations.

ILLUSTRATION CREDITS

Fig. 1: V & A Images, London / Art Resource, NY. Fig. 2: French Ministry of Culture and Communication, Regional Direction for Cultural Affairs—Rhône-Alpes region—Regional department of archaeology. Fig. 3: © John Baldessari. Photo: © Christie's Images / The Bridgeman Art Library. Fig. 4: © VG Bild-Kunst, Bonn 2013. Photo: © Dirk Reinartz, Richard Serra, "Bellamy," Siegen 2001, Courtesy Galerie m Bochum, Germany. Fig. 5: © The Willem de Kooning Foundation, New York / VG Bild-Kunst, Bonn 2013. Fig. 6: © VG Bild-Kunst, Bonn 2013. Digital Image © The Museum of Modern Art / Licensed by SCALA / Art Resource, NY. Fig. 7: Photo: Gérard Blot / Christian Jean . © RMN-Grand Palais / Art Resource, NY. Fig. 8: © VG Bild-Kunst, Bonn 2013. Fig. 9: Photo: © Christie's Images / The Bridgeman Art Library. © 2013 The Andy Warhol Foundation for the Visual Arts, Inc. / Artists Rights Society (ARS), New York. Fig. 10: © Succession Picasso / VG Bild-Kunst, Bonn 2013. Photo: © Christie's Images / The Bridgeman Art Library. Fig. 11: © Kate Rothko-Prizel & Christopher Rothko / VG Bild-Kunst, Bonn 2013. Photo: Todd Heisler. Cover: Courtesy of *Art + Auction* magazine, used by permission. Fig. 12: © Succession H. Matisse / VG Bild-Kunst, Bonn 2013. Digital Image © The Museum of Modern Art / Licensed by SCALA / Art Resource, NY. Fig. 13: © Succession H. Matisse / VG Bild-Kunst, Bonn 2013. Photo: Vladimir Terebenin, Leonard Kheifets, Yuri Molodkovets; © The State Hermitage Museum. Fig. 14: © Succession Alberto Giacometti (Fondation Alberto et Annette Giacometti, Paris + ADAGP, Paris) 2013. Photo: © Ezra Stoller / Esto. Fig. 15: The Bridgeman Art Library. Fig. 16: © Succession Picasso / VG Bild-Kunst, Bonn 2013. Image courtesy of the National Gallery of Art, Washington. Figs. 17–18: © Succession Picasso / VG Bild-Kunst, Bonn 2013. Photo: © Christie's Images / The Bridgeman Art Library. Fig. 20: © VG Bild-Kunst, Bonn 2013. Photo: © Christie's Images / The Bridgeman Art Library. Fig. 21: Photo: Henry Groskinsky / Time & Life Pictures / Getty Images. Fig. 22: © Kienholz. Courtesy of L.A. Louver, Venice, CA. Digital Image © The Museum of Modern Art / Licensed by SCALA / Art Resource, NY. Fig. 23: The Royal Collection © 2013 Her Majesty Queen Elizabeth II / The Bridgeman Art Library. Fig. 24: © VG Bild-Kunst, Bonn 2013. Photo: Courtesy of Sotheby's, Inc. © 2007. Fig. 25: Photo: © Philadelphia Museum of Art. Fig. 26: Nicolas Sapieha / Art Resource, NY. Reproduced by permission of the Henry Moore Foundation. Fig. 28: © Salvador Dalí, Fundació Gala-Salvador Dalí / VG Bild-Kunst, Bonn 2013. Fig. 29: © Succession Picasso / VG Bild-Kunst, Bonn 2013. Fig. 30: Photo: Peter Willi / The Bridgeman Art Library. Fig. 31: Photo: Jens Ziehe / bpk Berlin / Nationalgalerie, Museum Berggruen, Staatliche Museen, Berlin / Art Resource, NY. Fig. 32: Photo: Gene Meyer. Fig. 33: © Succession Picasso / VG Bild-Kunst, Bonn 2013. Photo: Peter Willi / The Bridgeman Art Library. Fig. 34: Photo: © Christie's Images / The Bridgeman Art Library. Fig. 35: © Succession Picasso / VG Bild-Kunst, Bonn 2013. Photo: Erich Lessing / Art Resource, NY. Fig. 36: © Bridget Riley, 2013. Fig. 37: Image copyright © The Metropolitan Museum of Art. Image source: Art Resource, NY. Fig. 39: Man Ray Trust, Paris / VG Bild-Kunst, Bonn 2013. © Succession Marcel Duchamp / VG Bild-Kunst, Bonn 2013. Digital Image © The Museum of Modern Art / Licensed by SCALA / Art Resource, NY. Fig. 40: Photo: © Christie's Images / The Bridgeman Art Library. Fig. 41: © John Currin. Courtesy of Gagosian Gallery. Fig. 42: © Succession Alberto Giacometti (Fondation Alberto et Annette Giacometti, Paris + ADAGP, Paris) 2013. Photo: © 2013 Carnegie Museum of Art, Pittsburgh. Fig. 43: © The Lucian Freud Archive. Photo: The Bridgeman Art Library. Fig. 44: © VG Bild-Kunst, Bonn 2013. Image copyright © The Metropolitan Museum of Art. Image source: Art Resource, NY. Fig. 45: © VG Bild-Kunst, Bonn 2013. Photo: Courtesy of Acquavella Galleries. Fig. 46: © Zhang Huan Studio. Fig. 47: © David Hockney. Fig. 48: © Shirin Neshat. Courtesy of Gladstone Gallery, New York and Brussels. Fig. 49: © Kara Walker. Photo: © Richard-Max Tremblay, Courtesy of Sikkema Jenkins & Co., New York. Fig. 50: © Lee Bontecou. Courtesy of FreedmanArt, New York / The Bridgeman Art Library. Fig. 51: Photo: Lewandowski / LeMage / Gattelet. © RMN-Grand Palais / Art Resource, NY. Fig. 52: © Succession H. Matisse / VG Bild-Kunst, Bonn 2013. Digital Image © The Museum of Modern Art / Licensed by SCALA / Art Resource, NY. Fig. 53: Photo: © National Gallery, London / Art Resource, NY.